D0265888

Design History and the

History of Design

Brooklands College
Library
WITHDRAWN FROM STOCK
057460

Design History and the History of Design

JOHN A. WALKER

WITH A CONTRIBUTION BY JUDY ATTFIELD

BROOKLANDS COLLEGE LIBRARY
WEYBRIDGE, SURREY KT13 8TT

PLUTO PRESS

First published in 1989 by Pluto Press
345 Archway Road, London N6 5AA
and 5500 Central Avenue, Boulder,
Colorado 80301, USA

Copyright © 1989 John Walker

British Library Cataloguing in Publication Data
is available from the British Library

ISBN 0 7453 0274 2 hbk
 0 7453 0522 9 pbk

98 97 96 95 94

9 8 7 6 5 4 3

Printed in the EC by J W Arrowsmith Ltd

Contents

Acknowledgements

Much of the material presented here is based on the historiography unit of the three-year, part-time MA course in the history of design at Middlesex Polytechnic. I am grateful to all past students for their comments and criticisms during seminars which have enabled me to eliminate errors and strengthen arguments. I must also thank Middlesex Polytechnic, in particular the staff of the School of Art History, for releasing me from teaching duties so that I could complete this book. Finally, I would also like to express my gratitude to Judy Attfield for agreeing to contribute to the text.

Introduction

Design is an increasingly popular subject in schools, colleges, industry, retailing and the mass media. After many years of lukewarm support, the British Government too is now promoting a greater consciousness of design because it realizes that its 'added value' is a vital factor in the economic success of businesses and nations.[1] Not only has design come to be regarded as crucial in economic terms, but also as a means of social control and harmony: design against crime and vandalism; new housing designs and the re-design/renewal of city centres such as Belfast as a way of countering the effects of civil strife. Furthermore, it would seem an obsession with design and style among so many in Britain during the 1980s is a mask or compensation for a spiritual lack. In the absence of social unity and a sense of community, people seek relief from alienation in the hedonistic pleasures of consumerism. The motto appears to be: 'Living well, with style, is the best revenge.'

Disasters of all kinds occur with monotonous regularity in humanly devised systems. This impresses upon us the fact that good design is not simply a question of taste or style, it is literally a matter of life and death. The sheer number of failures indicates that design is too important to be left to designers or to politicians who think of it as merely a means of achieving higher profits for commercial companies or as a way of revamping their image to win elections.

As the crowded shelves of the bookshop in London's Design Centre testify, publications on design are becoming ever more numerous and wide-ranging. Many of them are histories of design but, as yet, there is only one introduction to the discipline of design history – *Design History: a Students' Handbook* (1987) edited by Hazel Conway – and it is aimed at the beginner. This text is also intended as an introduction to the discipline

but the level assumed is that of final year undergraduates and postgraduates studying for an MA qualification.

Conway's anthology consists of short essays by different specialists devoted to particular sub-categories of design: dress and textiles, ceramics, furniture, interior design, industrial design, graphics and environmental design. To divide the subject in this way is a perfectly valid, if conventional, procedure and it matches the way it tends to be organized in educational establishments; however, this is not how the subject is tackled in this text. No doubt historians do encounter differences between the study of dress and graphics but, arguably, these differences are minor compared to the basic theoretical issues common to both. The disadvantage of dividing the subject into separate fields is that discussions of these basic issues are bound to be scattered. Furthermore, despite the wide range of subjects featured in Conway's anthology, it still fails to encompass design in its totality. For instance, architectural, engineering, theatre, military and transportation design are not discussed in their own right.

The aim of this book is to raise questions rather than to reproduce conventional wisdom. It begins with an account of the discipline of design history, it then problematizes the concept of design and, after reviewing the general difficulties of history-writing, it considers the various kinds of histories of design being produced with particular reference to the methods of analysis employed. Finally, it looks at certain important concepts such as style and taste.

This book seeks to provide an overview of design history and its conceptual and methodological problems. Because the potential range of the material is so vast and complex, it aims to be a guide to orientate the novice historian, so that, for example, some discussion of the relevance of structuralism and semiotics to design history is included but no attempt has been made to treat either of these topics in any depth or detail. I have assumed that anyone intrigued by these modes of analysis will read the published introductions and the key works in those fields.

Any survey of such a diverse and heterogeneous subject as design history is bound to be, to some degree, eclectic or plural in the sense that various methods and approaches have to be

considered as objectively as possible. However, my own inclin-
ation is towards a critical theory/materialist approach to the
writing of the history of design.

In the course of this text a wide range of literature on the
history of design is analysed. This literature varies from the
scholarly–scientific to the popular–journalistic. In bookshops
the latter type predominates. Design is a subject which most
publishers feel requires large-format surveys on glossy paper
with full-colour picture spreads. The texts of such books tend
to be short and superficial. Nevertheless, this kind of material
has not been excluded because it is often here that the theoret-
ical issues and problems facing the discipline are most glaringly
obvious. Criticisms of other writers should not be taken as a
sign that I am unaware of the commercial pressures which limit
what can and cannot be published and of the real intellectual
difficulties standing in the way of an improvement in the stan-
dards of design history-writing. I am only too conscious of the
fact that many of the faults I identify I have been guilty of
myself in the past.

Design is a particularly fertile and challenging subject for the
historian because it occurs at a point of intersection or medi-
ation between different spheres, that is between art and indus-
try, creativity and commerce, manufacturers and consumers. It
is concerned with style and utility, material artefacts and human
desires, the realms of the ideological, the political and the econ-
omic. It is involved in the public sector as well as the private
sector. It serves the most idealistic and utopian goals and the
most negative, destructive impulses of humankind. The task of
the design historian is a daunting one requiring as it does famili-
arity with a multitude of topics and specialisms. This makes a
guide all the more necessary.

Complementary Reading

A bibliography of all the books cited is provided at the end of
the book, together with notes and references at the end of each
chapter. However, there are certain publications which merit
mention here as complementary reading or sources of reference.
Undergraduate students, for instance, may well be uncertain

about the meaning of such words as 'ideology', 'materialism' and so forth. Besides standard English dictionaries, certain specialist glossaries and encyclopedias are helpful in this respect.

Raymond Williams, *Keywords: a Vocabulary of Culture and Society* (1983). This paperback does not include 'design' but it does feature 'class', 'empirical', 'ideology', 'industry', 'consumer', 'taste' and 'materialism'. Williams' discussion of keywords is most useful because it is historical.

D. Runes (ed), *Dictionary of Philosophy* (1960). This one-volume book contains short articles by various scholars on individual philosophers, schools of philosophy and key concepts.

David Sills (ed), *International Encyclopedia of the Social Sciences* (1968–79). This 18-volume work is stocked by most major reference libraries and includes lengthy articles on questions of theory and method including 'content analysis', 'typology', 'historiography', 'values', 'culture', 'mass society', 'technology', 'fashion', 'culture', 'crafts', 'aesthetics' and 'advertising'.

The Encyclopedia of World Art (1958-68). This standard work includes articles on 'design', 'designing' (in art), 'graphic arts', 'industrial design', 'publicity and advertising'.

T. O'Sullivan and others, *Key Concepts in Communication* (1983). Although concerned with media and cultural studies rather than design, this paperback is of value to the novice design historian. Among the concepts featured are: 'gender', 'functionalism', 'hegemony', 'discourse', 'determination', 'pluralism', 'base and superstructure'.

Adam and Jessica Kuper (eds), *The Social Science Encyclopedia* (1985). A one-volume reference work which includes entries on 'advertising', 'Annales school', 'business cycles', 'consumer behaviour', 'institution', 'mass media', 'nationalism', 'structuralism' and 'subculture'.

For more sophisticated readers with an interest in questions of theory and method in relation to material culture, I would recommend David L. Clarke, *Analytical Archaeology* (1978), a

mainly systems theory approach to archaeology, and Marvin Harris, *The Rise of Anthropological Theory* (1968), a critical and detailed survey of anthropological thought.

Note

1. In 1982 the British Prime Minister Margaret Thatcher, head of a Conservative administration, held a design 'seminar' at 10 Downing Street. Government spending on the promotion of design was subsequently increased from £4 million to £12 million.

 A 1987 report by the Design Council estimated that the rapidly expanding British design consultancy business was worth over £1 billion a year and employed 29,000 people.

 Most of the examples cited in this book refer to a London/British context because this is the situation I know best. However, it is assumed that the points being made have a general validity.

A modern empirical discipline ought to be able to aim at more rewarding results than piling up data and a steady output of imitation history books.

David L. Clarke, *Analytical Archaeology* (1978)

It cannot be said too often that the progress of intellectual life requires confrontation between the widest possible variety of theories and hypotheses. The penalty of provincialism is always the same: errors are piled upon errors, because everyone is tolerant of similar faults.

Marvin Harris, *The Rise of Anthropological Theory* (1968)

1

Design History and the History of Design

It is vital at the outset to distinguish between *design history* and the *history of design*. It is unfortunate that the same words 'design' and 'history' have to be employed, albeit in a different order, to refer to different things. In other fields the problem does not arise: the science of astronomy is clearly distinct from what it studies: the universe. Design history, it is proposed, shall be the name of a comparatively new intellectual discipline, the purpose of which is to explain design as a social and historical phenomenon. It follows that the expression 'the history of design' refers to the object of study of the discipline design history. Like art history, its immediate forbear, design history is a branch of the more general academic discipline, history. And like history itself, design history has close links with other disciplines such as anthropology, archaeology (especially industrial archaeology) and sociology.

What constitutes a discipline may be hard to grasp. It can be described briefly as the ensemble of assumptions, concepts, theories, methods and tools employed by a particular group of scientists or scholars. During the early stages of a discipline, most of these assumptions, etc., will be implicit and unconscious. When they become explicit the discipline attains self-awareness. Also, of course, disciplines are defined by the particular body of material or field of research they claim for themselves. Problems relating to the character and limits of the subject matter of design history will be discussed shortly.

The awareness that a distinct discipline exists occurs when a sufficient number of practitioners become self-conscious about their activities and begin to join together to discuss common problems and interests. It is usually at this critical conjuncture that a professional organization is formed. In Britain the Design

History Society was established in 1977 even though, of course, histories of design were being written long before that date. Once an organization exists, the trappings of an academic discipline soon follow: elected officers, a newsletter, a scholarly journal, an annual conference.

Although the phrase 'the history of design' implies that there is a single, homogeneous object of study, in practice design history never supplies us with a single, complete, homogeneous account upon which we can all agree. There are always multiple histories, various histories of design. These histories are the output, the product of the discipline design history. They are physically embodied in various languages, media and forms of presentation, for example, lectures with slides, diagrams, articles, books, radio and television programmes, exhibitions.

Although various histories exist, this does not mean that there is more than one material reality – as many worlds as there are individuals. One difficulty all historians experience is that the past can never be reconstructed in its totality and completeness; every history is, therefore, a partial or simplified representation of a past situation. Selection is inevitable in history-writing. Histories differ not only because scholars tackle different facets of design but also because one historian will select and emphasize certain facts and events while another will select and emphasize different facts and events.

Two historians approaching the same subject will therefore in all likelihood produce two different accounts. For example, a survey of design since 1900 written by an Italian would, in all probability, feature Italian design more prominently than a comparable study written by an American. Similarly, a history of Soviet design is likely to vary according to whether it is written by a Marxist or an anti-Marxist. (One of the aims of design historiography is to make such differences visible and explicit by analysing texts using techniques like content analysis.) An analogy with map-making may be helpful: several maps can be drawn of the same country each of which focuses upon different features of the terrain. The various maps do not contradict one another, instead they complement one another. Taken together they provide a more complete account of the terrain

than taken singly. However, if two maps by different map-makers are produced to show transportation routes, they can be compared to the terrain in order to judge their accuracy and one map could be found more true to reality than the other. Histories can be similarly compared and evaluated, though in their case the task of estimating their truthfulness is more difficult because the terrain – the past reality they represent – no longer exists as a totality.

Design History's Problematic

'Problematic' (*problématique*) is a term employed by several French philosophers, most notably Louis Althusser, to describe the theoretical or ideological framework within which a concept or a discipline gains its specific meaning and value.[1] Besides referring to the consciously recognized theoretical problems and themes of a discipline, the term also encompasses its 'unconscious' – the problems, absences, silences which it does not acknowledge. The 'unconscious' of a discipline or a text is revealed by what is called 'a symptomatic reading', that is, attention is paid to what is *not* said rather than to what is said. For example, if a symptomatic reading of an encyclopedia of world architecture showed that African and Chinese buildings were not mentioned, then the Euro-American bias of the compilers would be revealed.

The Work of Design Historians

Rather than attempting to define design history further at this stage, it may be more useful to itemize what design historians do, the kind of work they perform:

Empirical study: design historians study and photograph designed artefacts and any drawings, models, plans or prototypes associated with them. Wealthy individuals and public museums form collections of such artefacts; however, most of the items which interest design historians exist outside museums.
Research and information gathering: design historians study

documents and images preserved in archives, libraries, museums and private collections in order to accumulate information about all aspects of the production, distribution, marketing and consumption of designed goods. Some scholars establish data banks and libraries; some interview living designers, manufacturers and consumers. All read articles and books in order to increase their knowledge of design and of its socioeconomic context.

Theoretical work: design historians categorize, classify, compare, interpret and evaluate designed artefacts. They develop concepts, theories and methods specific to design history and they also borrow ideas from other academic disciplines. They reflect upon the limits and aims of design history.

Writing and communication: design historians compile inventories, catalogues and indexes. They write scholarly treatises and more popular articles and books. They also organize exhibitions and write catalogue introductions. They give lectures and assist in the making of radio and television programmes and films about design. Their aim is to make their findings available to other researchers and to the general public.

Professional activities: design historians form organizations and hold conferences to further their discipline. They establish journals and serve on the editorial boards of scholarly periodicals and on the committees of various public bodies and educational institutions.

Employment: a few design historians are private scholars or self-employed, freelance writers or journalists. Some work as curators in museums or large firms with archives. The majority, however, teach the history of design in polytechnics, art and design colleges and universities.

The advantage of such a listing is that it suggests design history is not a unitary and homogeneous 'thing' whose being or essence can be defined once and for all, but a set of cultural practices engaged in by a specific group of intellectuals. Let us now consider some of the above topics in more detail.

Empirical Research

Empirical research involves direct experience and observation, the first-hand study by sight and touch of concrete examples. It is essential for design historians to examine designed goods and buildings 'in the flesh' whenever possible because this almost always reveals information secondary sources such as photographs fail to communicate. Furthermore, since *function* is a key aspect of design, ideally goods should be *used* as well as scrutinized. Later on, however, we shall question the conventional wisdom that the designed object is the main focus of design history.

Normally, empirical research is undertaken in respect of a pre-defined body or corpus of material, usually artefacts of some kind. Once such a corpus has been assembled, examined, described, categorized, classified and compared, the historian may feel confident about making some generalizations derived from the material, that is, induction rather than deduction.

Perhaps the most famous empirical enterprise in twentieth-century architectural history was Nikolaus Pevsner's systematic survey of the notable buildings of England. (Theoretical issues clearly arise in the criteria for distinguishing 'notable' buildings from the mass of unremarkable ones.) Some preliminary work was done in libraries by assistants, then Pevsner and his wife set out by car to survey selected buildings shire by shire, doing two shires per year. To complete the project took a quarter of a century (1949–74)! Findings were published in Penguin Books' *Buildings of England* series, a total of 46 volumes.

Clearly, the chief value of Pevsner's books is the detailed recording and characterization of individual buildings. This celebration of particular, unique examples is often considered to be the distinguishing feature of the discipline of history as against the physical sciences. The latter, it is argued, are only interested in concrete examples in so far as they exemplify general laws.

In the case of the *Buildings of England* series, its nature and limits were decided by Pevsner and his assistants. Museums, it could be argued, supply historians with 'readymade' bodies of

material because they usually contain several collections of arte-facts. Assuming that access can be gained to them, private col-lections too – whether of pre-1939 wireless cabinets, scooters, 1950s' furniture, plastic products of Beatles' memorabilia – can make the historian's task much simpler.

Yet another 'readymade' source is the archives of large companies and design studios. Besides documents, such archives can include samples or prototypes of whatever the company or studio produced. Middlesex Polytechnic is fortunate to possess the contents of a designer's studio – the 'Silver Studio Collection' – which includes samples of wallpapers and textiles designed by the Silver family who practised from the late nineteenth century to 1963. The London firm of Sanderson, a furnishing fabrics, bedding and wallcoverings manufacturer founded in 1860, also maintains an archive which serves as an inspiration for its de-signers. Nearly 100 collections of material constitute the Archive of Art and Design, part of the National Art Library, at the Vic-toria and Albert Museum. Included are the papers of individual designers and craftpersons, plus the archives of relevant societies and businesses.

Exceptionally conscientious scholars include in their histories descriptions of the archive material they have used in the course of writing them. Professor Michael B. Miller, for instance, in his thorough study *The Bon Marché: Bourgeois Culture and the De-partment Store 1869–1920* (1981) devotes several pages to the private archives of the famous Parisian *grand magasin*. He notes the gaps in the store's records and he also lists other archives in Paris which he consulted.

Besides studying artefacts and documents, historians can gather additional information by means of oral history – at least in respect of the design of the present and recent past – by inter-viewing designers, clients and consumers. A major twentieth-century source of observations and comments by members of the public about everyday life – the Mass Observation archive stored at the University of Sussex – is a useful resource in this respect.

Empirical research is crucial to design history but it is depen-dent upon a pre-existing conceptual framework of some kind. The

information it yields also gives rise to a host of questions which can only be answered by investigations conducted in other fields, for example economic history, and by theoretical work.

Classification

Categorizing and classifying are the intellectual operations by which natural scientists seek to reduce the sheer quantity of natural phenomena to manageable proportions and to impose order on infinite variety. Such operations are equally essential in regard to human material culture. To see the advantages of classification, one has only to imagine how impossible it would be to find anything in a department store if goods, rather than being organized in departments, were randomly distributed. If design historians and museum curators had to see every designed product as a unique item, they would be overwhelmed by the vast numbers and diversity of things modern industry generates.

Any complex artefact possesses a number of attributes (shape, colour, size, purpose, etc.) which means that it can be placed in several categories according to the attribute or set of attributes singled out by the scholar. Clearly, the choice of category depends upon the objectives of the historian. Often the aim is to establish a group of similar items so that comparisons can be made. Three categories have been particularly favoured by design historians: material, type and style (to be discussed individually later).

As an example let us consider the organization of artefacts in the Pitt-Rivers Museum, Oxford. This museum houses a substantial collection of ethnographic and archaeological arte-facts – tools, weapons, clothing, ornaments, ritual objects, and so on – collected by General Pitt-Rivers (1827–1900). The General's interest in this material was aroused as a consequence of a study of firearms which made him curious about cultural evolution. The collection was intended to illustrate how arte-facts develop over time, hence items serving similar purposes, such as weapons, from the Stone Age to the more recent past and from different places were displayed together (instead of being arranged geographically), so that progressions from simple to complex, from the homogeneous to the heterogeneous, would

be revealed. Representative rather than exceptional items were required for this purpose, so ordinary and typical specimens were acquired rather than rare, beautiful or valuable ones.

Pitt-Rivers believed that artefacts, like plants and animals, could be classified into genera, species and varieties. In the museum's classification scheme a category such as weapons is subdivided into defensive and offensive, then subdivided into kinds such as archery, blow guns, bolas, boomerangs, clubs, firearms, etc., some of which are then further subdivided into sub-types or by materials or place of origin. Overall a development can be witnessed from a simple, crude weapon such as a club to a more sophisticated, complex weapon such as a flint-lock gun. The scheme is described in greater detail in Beatrice Blackwood's *The Classification of Artefacts in the Pitt-Rivers Museum, Oxford* (1970).

Those who have visited the museum will recall the fascination of its crammed display cases. At a glance the collection demonstrates the extraordinary inventiveness of humanity, the tremendous variety of artefacts which we have created over the centuries.

Charles Jencks, the architectural historian, is another theorist willing to apply biological ideas of evolution to his object of study. In his book *Modern Movements in Architecture* (1973) he situates all architecture from 1920 to 1970 within one of six species which he calls 'traditions' or 'movements'. They are: logical, idealist, self-conscious, intuitive, activist and unself-conscious. He claims that the last-named accounts for 80 per cent of the built environment. The basis for this classification seems to be the ideas and attitudes of architects. Jencks provides a diagram or 'evolutionary tree' which, in fact, represents the various species as streams which swell and narrow and, at times, flow into one another. Within each stream the labels of various styles and types of architecture appear along with the names of famous architects in chronological order and in differently-sized typography to signal relative importance.

Jencks acknowledges the dangers of comparing the evolution of human achievements with that of plant and animal species and admits that, unlike the latter, architectural movements never become altogether extinct because they can always be revived.

Although Jencks' classification scheme is highly questionable, it does at least enable an inclusive, comprehensive treatment of the subject; his 'plural' approach provides a more complex account than earlier, 'single strand' histories.

Taxonomy and the logical problems associated with it is too large a topic to discuss any further here. It is hoped that the two examples cited above will have been sufficient to demonstrate the advantages of classification in design history but also to indicate the disadvantages which follow from the application of any one scheme.

Theory and History

Design historians apply existing theories – such as the Marxist theory of commodity fetishism – and engage in theoretical work. The theory which concerns them is that which is going to help them to write history better, to understand design better. It is not, therefore, theory *for* design – the kind of theoretical knowledge designers themselves may use or generate – though, of course, this is of interest to design historians.

An organization which engages in theoretical deliberations about design without special reference to history is the Design Research Society, founded in 1967. Although one can distinguish between theory and history, the opposition between them should not be exaggerated because they are in fact interdependent.

In my list of design historians' work, theory and empirical research were cited separately. Such a separation is, of course, highly problematical. Philosophers of science have argued that all empirical research is theory-laden. Even if data could be gathered in the absence of theory, some theory would be needed to interpret it. David Brett, criticizing the improvised nature of design history research, writes:

> The essence of my criticism is that empirical research cannot provide explanatory structures of thought. The stress on empirical research arises *because we lack explanatory structures.* It is a sign of intellectual insecurity. In a healthy discipline, logical and conceptual enquiry starts at one end, and the

empirical research at another, and both act reciprocally upon one another.[2]

Resistance to theory is widespread among design historians impatient to practise despite the fact that one cannot begin a history of design without immediately encountering theoretical issues such as 'What criteria will limit the corpus and determine periodization?' Refusal to engage in theoretical reflection results in simplistic, crude histories which fail to do justice to the complexities of reality.[3] It is possible, however, to sympathize with those who find theory difficult and/or tedious. Theory is often extremely demanding and couched in alien vocabularies. Furthermore, while there are many theories pertinent to design, applying them is not a straightforward matter because they frequently contradict one another.

We should, perhaps, not overestimate the difficulties. What is refreshing about the writing on design and style of a cultural historian such as Dick Hebdige is his willingness to go beyond conventional modes of writing history. (Walter Benjamin's reflections on history-writing are a key source of inspiration.) The question of method is part and parcel of his way of researching and composing: he usually foregrounds methodological issues at the beginning of his articles and pauses now and then during the course of them to consider theoretical problems. Furthermore, the abstract and the concrete, the social and the personal are dialectically related in his rich and stimulating texts. His example demonstrates that theory can be combined in an exciting way with empirical research.

Language, Representation, Images

Human language (spoken or written) is, of course, the principal medium of communication used by design historians and its concrete embodiments are texts and recordings of various kinds. However, language is usually supplemented by graphic and pictorial media: slides, still photographs, diagrams, drawings, plans, films and videotapes. Most design historians generate a mixed-media discourse of words and images.

What kind of writing ought design historians to cultivate?

According to French literary theorists, a *readerly* text is one in which language aspires to a condition of transparency: language effaces itself in order to communicate a content or describe a referent. A *writerly* text, on the other hand, openly acknowledges the medium of representation (sometimes at the expense of the represented). Readerly texts, it is argued, are consumed unproblematically by the reader, while writerly texts demand work from the reader thereby turning him or her into a producer of meanings. As examples, consider the contrasting styles of writing used by Fiona McCarthy in *All Things Bright and Beautiful* (1972) (a readerly text) and by Roland Barthes in *Mythologies* (1972) (a writerly text).

Most writing on design is readerly in character. This is a sign of the unreflective nature of so much design history-writing. However, foregrounding language in the extreme way that some avant garde texts do is clearly not appropriate for an academic discipline wishing to do justice to its object of study and to communicate with an audience. Writerly writing should not serve as an excuse for confused thought and tortured expressions.

In the field of design the boundary between history and criticism is blurred. Leading design historians usually engage in topical discussions of design trends, consequently there is a marked contrast in writing style according to whether the text is a PhD thesis or a short article for a design magazine. Some writers on design – Tom Wolfe and Peter York, for example – strive to achieve a mode of writing that is as popular, witty and ironic as the design they analyse.

Most design historians aim for an impersonal, third person mode of writing – what French literary theorists call *histoire* as against *discours*, which is the immediate, personal mode in which the presence of the writer is indicated.[4] They also aim for realism in the sense that an accurate account of past events is desired. And the basis of the realist style is the patient accumulation of small, precise details.

A basic problem for any realist writing is the representation of visual/tactile artefacts in terms of a non-visual medium of expression. No visual object can be represented/described in language without loss or transformation. Objects, or rather the perceived qualities and characteristics of objects, are 'translated' in terms

of a determinate means of representation – language. As with all such representations, the question then arises: 'How truthful to reality, how accurate is this description?' Of course, design historians frequently resort to slides and illustrations to overcome this problem and to economize on lengthy descriptions. Even so, comparable problems arise when three-dimensional objects are drawn or photographed. Images are equally 'translations' of objects in terms of particular media.

A map is perhaps the ideal model for the representation of design in words and images: a map is a highly selective and schematic representation intended to serve particular human purposes. Map-makers certainly try to represent the world truthfully but without feeling compelled to include every detail; also, the sign systems they employ do not have to resemble what they represent in order to function as representations.

The role of images in a history of design book may seem a small matter. Nevertheless photographs of chairs, cars, typewriters and so on tend to enforce a particular notion of design history as the study of discrete designed objects rather than other possibilities such as designers, context and processes. Like the museum pedestal or glass case, such photographs isolate the designed object and endow it with a cult value. Furthermore, photos of objects necessarily privilege surface appearances – so, form, style and ornament are foregrounded at the expense of function or internal structure. (An exploded diagram could, of course, be used to show the interior workings of a machine or a building.)

Images are vital sources of information but, as with all representations, they form part of ideological discourses. In a slide lecture using two projectors, a design historian can alter the emphasis merely by means of the montage effect produced by different juxtapositions.

As an example of the impact of illustrations consider Reyner Banham's accusations of 'crooked argument' levelled against Le Corbusier, whose book *Towards a New Architecture* (1923) juxtaposed photographs of ancient Greek temples and modern motor cars:

Its crookedness is disguised by the fact that the argument is

partly verbal and partly visual. The hinge of the verbal argument is the virtue of standardization, sustained over several pages, between automobiles and the Parthenon, and the totality has been read by two generations of architects and theorists as meaning that a standardized product like a motor-car can be as beautiful as a Greek temple. In its context this is how it must be read, but the *tertium comparationis* of the argument is a disingenuous pretence – none of the motor-cars illustrated is a standardized mass-produced model; all are expensive, specialized, handicraft one-offs which can be justly compared to the Parthenon because, like it, they are unique works of handmade art.[5]

Not only are images one of the means of communication of design historians, they are also part of their object of study. Images can be studied as designed artefacts in their own right or for their depicted content. For example, few clothes from the distant past survive the ravages of time; consequently costume historians are especially dependent upon visual representation – pictorial and sculptural – as sources of information. While such images are useful, their secondary nature has certain inevitable drawbacks. In the case of a portrait in oils, for example, only a partial, frontal view of the sitter's clothes will be visible.

Today, millions of full-colour, glossy photographs of consumer goods appear in the advertising sections of illustrated magazines. These images play a crucial role in selling goods and in planting brand or corporate 'images' in the public's mind. Often these photos do not simply publicize products, they communicate a whole lifestyle and a specific set of values. Judith Williamson's *Decoding Advertisements* (1978) is a perceptive guide to the mechanisms of such images and their implicit ideologies.

Unlike those scientific disciplines which take aspects of nature as their object of study, design history is concerned with certain products of human culture. Therefore the discipline uses words and images to 'speak about' artefacts which are themselves signs, that is, statements couched in various media, forms and languages. It follows that in order to interpret the meaning of an individual designed object the historian must be familiar with its 'language',

or at least have the ability to break its code. This is the point at which the analytical tools of semiotics – the science of signs – will prove useful.

Discourse and Meta-language

Linguistics regards a discourse as a unit of language longer than a sentence. In common usage it is day-to-day communication and conversation. Design may be metaphorically described as a 'discourse' in the sense that a flow of objects, documents and talk is generated by the daily activities of designers, clients and design institutions. Designers can, therefore, be said to be engaged in 'a discursive practice'.

A meta-language is any language or sign system which is used to speak about another language or sign system; the latter is called 'the object [of study] language'. Meta-language is a relative concept: in a French guide to English, French is the meta-language and English the object language, whereas in an English guide to French the relationship would be reversed. In a book written in English about English the difference between meta-language and object language is maintained by devices like quotation marks or italics. An infinite regress of meta-languages can also be conceived, that is, meta-meta-languages, meta-meta-meta-languages, etc.

'Meta' – meaning 'beyond', 'transcending' – can be linked to 'discourse'. Thus one can conceive of a hierarchy of discourses in which level one is the discourse of design; level two is the meta-discourse of writings and photos representing design in publicity, design magazines, etc.; level three is the meta-meta-discourse of writings by design historians which encompasses levels one and two; level four is the meta-meta-meta-discourse of writings about writing the history of design (e.g. this text).

These distinctions may seem unnecessarily cumbersome at first sight, but in the interests of conceptual clarity it is important that they be grasped.

Figure 1: *The Various Levels of Discourse*

4	Meta-meta-meta-discourse of writings about the writing of histories of design	Design historiography
3	Meta-meta-discourse of writings by design historians about levels one and two	Histories of design
2	Meta-discourse of writings and images about design	Journalism about design, advertisements, consumer reports, trade magazines
1	The discourse of design	Designed goods, concepts, methods and theories used by designers

It may, perhaps, be stretching the concept of discourse to apply it to the physical artefacts generated by the design process, but it can be argued that objects embody ideas and theories: a telescope, for instance, depends upon and embodies in its structure certain laws of optics which, presumably, could be deduced from a close examination of its parts. Nevertheless, it is the case that most writers who study discourses tend to concentrate upon texts rather than artefacts because the former are more explicit than the latter.

A number of designers and architects have written theoretical articles and books about their own practice or about issues in

design generally. This type of writing does not slot into the hierarchy of discourses very neatly. In so far as it *informs* the process of designing it belongs to level one, but in so far as it *comments* upon designing it belongs to level two.

Discourse analysis is a procedure associated with certain French philosophers, most notably Michel Foucault. Although he regards himself as an archaeologist and genealogist of knowledge rather than a historian, much of Foucault's work is highly relevant to design historians. In particular his analysis of the discourses of power in society – the formation of modes of discipline, punishment and surveillance – explain the design of penal institutions in ways conventional histories of prison architecture cannot.[6]

Roland Barthes' *The Fashion System* (1985) supplies us with an example of a second level of meta-discourse analysis. This sophisticated, semiological study of fashion is based not upon the 'language' of clothes as directly perceived but upon 'written fashion', that is, the text and captions accompanying fashion illustrations in a year's issues of two French magazines.

A third example of discourse analysis relevant to design history is Necdet Teymur's *Environmental Discourse* (1982), a complex, critical examination of the concept 'environment' as it occurs in the discourses of architecture, planning, design, ecology and the mass media.

As explained earlier, this text is concerned primarily with the meta-meta-discourse of design history rather than the discourse of design itself. This means that our principal object of study will be existing published histories of design.

The History of Design History

A detailed account of the origins and development of design history is beyond the scope of this book. Several histories would, in any case, be needed because the story varies markedly from country to country – in some places considerable numbers of design historians exist, while in others there are only isolated individuals struggling to gain recognition for the subject. All such histories would have to take into account two aspects: the

intellectual development and the institutionalization of the subject.

Britain has more design historians than any other country and the subject is, therefore, most highly developed here. Very briefly, the subject emerged in Britain as an extension of art history and was prompted largely by demands within art colleges and polytechnics in the 1960s and 1970s for courses on the history of industrial and graphic design, fashion and mass media to supplement those on architecture, painting and sculpture.

Another key impetus was provided by the establishment, in 1972, of the Open University's course on the history of modern architecture and design from 1890 to 1939. The course team, led by Tim Benton, eventually produced 16 course books plus audiovisual material in the form of radio and television programmes. A university level study of modern design thus reached a considerable audience and enhanced the prestige of design history.

Two years later the Association of Art Historians was founded and design historians met as a subgroup of this organization at its annual conferences until 1977 when they decided to establish their own society. Certain specialisms within design anticipated this development. For instance, in 1964 a Furniture History Society was formed. By the 1970s architectural history had existed as an independent subject for several decades: the Society of Architectural Historians was founded by scholars in the United States in 1940.

Various articles describe the origins of design history in Britain.[7] The most comprehensive analysis and survey of the state of the discipline is in Clive Dilnot's two papers published in the American journal *Design Issues*. They are essential reading for anyone interested in this topic.

Since design history is such a young discipline, it necessarily depends upon other, more established ones for most of its basic concepts and methods. At the beginning there was an acute shortage of publications on design to serve as student textbooks and to act as models for aspiring design historians. One of the few available texts – Nikolaus Pevsner's *Pioneers of the Modern Movement* (1936) – indicated the intellectual roots of the discipline

in German art and architectural history. There is now no shortage of books on design but the subject is still in its formative stages and hence suffers periodic identity crises.

At the annual conferences of the Design History Society it is not unusual for much time to be spent comparing design history to architectural history, or discussing the implications for the discipline and museum curating of the various connotations of the terms 'costume', 'dress' and 'fashion'. To outsiders such debates may seem trivial and pedantic but beneath the surface, different conceptions of the subject are at stake.

Clearly, design is an aspect of human culture. For this reason it could legitimately be considered part of the subject matter of cultural studies. In terms of the development of design history in certain British institutions of higher education, the parallel growth of cultural studies courses has been an important intellectual stimulus. Cultural studies tends to be a hotbed of theories drawn from the discourses of philosophy, political economy, sociology, linguistics and psychoanalysis. The main weakness of cultural studies, as far as design historians are concerned, is the narrowness of its historical perspective: studies tend to be confined to the present and recent past. Although the interchange between cultural studies and design history has not always been productive, on the whole it has been a fruitful one. A magazine such as *Block* (Middlesex Polytechnic, 1979-), whose editors teach both design history and cultural studies, has challenged traditional divisions between subjects by publishing articles on fine art, design, mass culture, photography, feminism and historiography.

Design History, a Neutral Discipline?

Historians generally subscribe to the ideals of scholarship, independence, disinterestedness, objectivity and truth. This implies that they are non-ideological and politically neutral. Honest scholars may strive to set aside their personal beliefs, but the degree of objectivity that can be achieved is relative, not absolute. Design historians are members of society and hence their mental frameworks and attitudes are determined, to a large

extent, by their social environment. There is no escaping the fact that different design historians subscribe to different political ideologies and these inevitably affect their writings whether subtly or blatantly. The divisions evident in society at large are reflected within the discipline itself. To cite an example: since the advent of the women's movement in the late 1960s, various academic disciplines including design history have been subjected to feminist critiques which revealed a male bias. Self-consciously political, the feminist design historian of today seeks to reconstruct the discipline to take account of women's needs and interests.

Besides gender, the issues of race and wealth are also relevant. To a black person from a developing country, design history appears to be a white, middle-class profession of the world's affluent, advanced nations. As James Woudhuysen remarked in 1985: 'one of the great passions of the early 1970s – the Third World – is almost completely absent from contemporary discussions of design.'[8] Although the situation is slowly changing, Britain's ethnic minorities too are poorly represented in art and design education and in the design history profession. The role of design in the culture of ethnic minorities also receives little attention.

In the light of this, any definition of design history is likely to be temporary. The discipline is not static; indeed one could say it is a site of contest between different factions.

Design history is not netural in respect of design either because although historians may think of themselves as detached observers of design, their histories are read by practising designers and students (the influence of theory and history is particularly evident in the field of architectural design). In other words, histories of design have a feedback effect: for instance, they may unwittingly encourage stylistic revivalism and eclecticism. Realizing this, some historians write in a polemical way precisely in the hope that they will influence the direction of the future of design.

The Value of Design History

Design history's main value should be to deepen and strengthen

the writing of histories of design. It should benefit design historians by identifying, naming and discussing theoretical problems and issues.

By posing fundamental questions such as 'For whom are histories of design written?', 'Whose interests do they serve?', design history also fulfils a critical role in respect of the discourse of design. Such a critical function is all the more necessary in a period when design historians and journalists find their historical knowledge and expertise being harnessed by government and business to achieve goals they may not share.

As an example of the economic and ideological uses to which a design historian can be put by business, consider the advertisement on the back page of *The Face* magazine for June 1987: a smiling Stephen Bayley, curator of Terence Conran's Boilerhouse Project and museum of design, endorses an expensive leather sofa and fabric from the London store Liberty's. Simultaneously, he advertises one of his own books. The copy plays on the word 'liberty' and defines it in terms of the consumer's freedom of choice. Evidently, in this instance a design historian lends his authority and charisma to the selling of goods and the selling of ideas.

Whatever opinion one holds of Bayley's complicity with commerce, the fact that a design historian should be sufficiently well known to feature in an advertisement is a sign of how fashionable design history has become in the 1980s.

Notes and References

1. See B. Bewster, 'Glossary' in L. Althusser and E. Balibar, *Reading Capital* (London: New Left Books, 1970) p. 316. On the use of problematic applied to architectural discourse see D. Porphyrios, 'Notes on method', *Architectural Design* 51 (6/7) 1981 pp. 96-104.
2. D. Brett, 'Directions in design history today' in *The Teaching of Art and Design History to Students of Art and Design* (Dublin: Association of Irish Art Historians, 1986) pp. 13-23.
3. For a devastating attack on blind empiricism see T. Adorno, 'Sociology and empirical research' in P. Connerton (ed), *Critical Sociology* (Harmondsworth: Penguin, 1976) pp. 237-57.
4. See C. McCabe, 'On discourse', *Economy and Society* 8 (4) August 1979 pp. 279-307.

5. R. Banham, 'The machine aesthetic', *Design by Choice*, ed. P. Sparke (London: Academy Editions, 1981) pp. 44-7.

6. See M. Foucault, *Discipline and Punish* (London: Allen Lane, 1977).

7. A. Forty, 'Design history: a politique and a pedagogy', *Architectural Association* 5 (4) Oct/Dec 1973 pp. 48-9; T. Benton, 'Past should be looked at through well-designed spectacles', *THES* 10 Oct 1975 p. 7; B. Wilkins, 'Teaching design history', *Bulletin of the Association of Art Historians* (2) Feb 1976; M. Whitbread, 'Art and design history in polytechnics and art colleges', *Bulletin of the Association of Art Historians* (3) Oct 1976; D. Jeremiah, 'History of design: a problem of source material', *Art Libraries Journal* 2 (1) Spring 1977 pp. 33-9; C. Ashwin, 'Art and design history: the parting of the ways?', *Design History: Fad or Function?* (London: Design Council, 1978) pp. 98-102; J. Blake, 'The context for design history', *Design History: Fad or Function?*, pp. 56-9; B. Smith, 'Design history and the visual language of design', *Information Design Journal* (1) 1979; F. Hannah and T. Putnam, 'Taking stock in design history', *Block* (3) 1980 pp. 25-34; T. Fry, 'Design history: a debate?', *Block* (5) 1981 pp. 14-18; C. Dilnot, 'The state of design history: part one, mapping the field', *Design Issues* 1 (1) Spring 1984 pp. 4-23. 'Part 2', *Design Issues* 1 (2) Fall 1984 pp. 3-20; J. Attfield, 'Defining the object and the subject', *THES* 1 Feb 1985 p. 26; R. Kinross, 'Design history's search for identity', *Designer* Nov 1985 pp. 12-13 (this issue also lists courses in UK institutions); D. Brett, 'Directions in design history today', pp. 13-23; Toni Del Renzio, 'Mistaken identities in the history of design', *THES* 4 Feb 1977; P. Madge, 'Design analysis and design history', *Information Design Journal* 3/1 (1982) pp. 23-9.

8. James Woudhuysen, 'A new kind of nationalism in design', *The Listener* 12 September 1985 pp. 11-12.

2

Defining the
Object of Study

Specifying the object of study, establishing the boundaries of
the subject, are the first tasks of any new intellectual discipline.
By so doing, it differentiates itself from other, rival disciplines.
Although drawing a circle around a certain body of material
may be essential in order to found a discipline, the very act gives
rise to arguments about limits. Necessarily, it also disrupts the
totality and continuity of reality and thereby prompts questions
about the relations between inside and outside.

Design historians agree that their object of study is the history
of design, but there is not yet a consensus concerning the mean-
ing and scope of the term/concept 'design'. For example, does
design include architecture? Is architecture part of the object
of design history or art history or is architectural history an in-
dependent discipline in its own right? Similar uncertainties arise
in respect of the crafts, the minor or decorative arts and the
mass media. In relation to the latter, design is undoubtedly a
part of film-making, television production, pop music and ad-
vertising but these are also the concern of film, media, cultural
studies and sociology. Consequently, there is plenty of scope
for territorial disputes.

What is certain is that the boundary line of any discipline is
fuzzy rather than sharp and that it overlaps the circles of several
other disciplines.

The Word/Concept 'Design'

'Design' is a word which occurs in many contexts: a design,
graphic design, fashion design, interior design, engineering design,
architectural design, industrial design, product design, corporate
design, design methods. It is not immediately obvious that a

common essence underlies all these different usages. Ludwig Wittgenstein's notion of family resemblance may be more appropriate as a linking concept than the idea of a single essence.[1] Like all words and concepts, 'design' gains its specific meaning and value not only because of what it refers to but also differentially, that is, via its contrast with other, neighbouring terms such as 'art', 'craft', 'engineering' and 'mass media'. This is one reason why definitions of 'design' which purport to encapsulate an essential meaning tend to be so unsatisfactory. And, like most other words, 'design' causes ambiguities because it has more than one common meaning: it can refer to a process (the act or practice of designing); or to the result of that process (a design, sketch, plan or model); or to the products manufactured with the aid of a design (designed goods); or to the look or overall pattern of a product ('I like the design of that dress').

Another reason why definitions are inadequate and provisional is that language, like everything else, is subject to historical change. The word 'design' has altered its meaning through time: during the Renaissance '*disegno*' (which in practice meant drawing) was considered by art theorists such as Vasari to be the basis of all the visual arts; consequently these were often referred to as 'the arts of design'. At that time *disegno* described the inventive, conceptualizing phase which generally preceded the making of paintings, sculptures and so forth. All artists engaged in design as part of their creative activities, hence design was not yet considered the exclusive concern of a full-time professional. Designers as such only emerged later as a result of the growing specialization of functions which occurred in Europe and the United States as part of the industrial revolution of the eighteenth and nineteenth centuries. At least this is the generally accepted story. A different view is held by Simon Jervis whose ideas will be considered shortly. Thus, eventually, design came to mean a full-time activity undertaken by trained specialists employed or commissioned by manufacturers. The designer did not normally make the product he or she designed.

It is clear from the above that any comprehensive history of design ought to include a history of the evolution of the concept 'design' as well as a history of designers and designed goods. Such

a history would need to explain the emergence of design as distinct from art and craft, and trace its subsequent development in relation to the changing status of the latter as a result of the transition from a feudal to a capitalist mode of production and the growth of industry, engineering, technology, mass production and mass media/communication. It would also need to clarify the meanings and usages of older expressions such as 'art manufactures', 'the industrial arts', 'the applied arts', 'commercial art', 'ornament' and 'the decorative arts'. An examination of the fluctuating fortunes of these terms would be valuable because changes of nomenclature are one sign of changes in material reality.

During the 1980s, when design was promoted as the solution to Britain's industrial decline, the words 'design' and 'designer' took on a new resonance. They became values in their own right. For example, people spoke of 'designer jeans' (and even 'designer drugs', 'designer socialism'). Since all jeans are designed, the adjective was redundant but its use demonstrated how 'the design' was being perceived as a desirable attribute rather than the product as a whole. One journalist described 'designer' as a marketing trigger word. Part of the same process was an emphasis on the names of particular designers – a Katherine Hamnett T-shirt, a James Stirling museum, an Ettore Sottsass sofa. This habit derived from the fine arts where the signature of the artist was the guarantee of uniqueness, authenticity, individuality and creativity. In the end what counted was not the suitability and practicality of the designed object but merely the fact that it was by such and such a famous name. The designer's label on the product became more important than the product itself.

The Scope of the Subject

Novice design historians can be intimidated by the sheer number and variety of topics with which they are expected to be familiar. As an indication of the range and heterogeneity of the field, consider the subjects covered by the volumes displayed in London's Design Centre Bookshop: graphics, packaging, cinemas, streamlining, design for the disabled, the grammar of form and colour, signs and symbols, ergonomics, human factors

engineering, anthropometry, town planning, textiles, ceramics, fashion, office lighting, interior design, modelmaking, transportation, arts and crafts, engineering, consumerism, copyright, safety standards, solar energy systems, patenting, shops and shopping, theories and methods of design, famous designers, art and design schools and academies, the design of nations and epochs, the styles of design, housing, landscape design, computers, computer-aided design, typography, histories of invention and industrial processes ... the list is apparently endless.

Of course, some of these topics can be considered more central than others. It would be possible to arrange them in an order: central, closely related, marginal. The boundaries between design, art, craft, engineering and mass media are not sharply defined and some subjects, such as architecture, appear to overlap several realms. (Architecture can involve art, engineering, craft methods and industrial production.) As human knowledge develops both quantitatively and qualitatively, an increasing tendency towards fragmentation and specialization occurs. Whereas, initially, architectural history included design – because the discipline was based on great modern architects who also designed furniture and fittings – design history is now a separate field. Similarly, one finds that the subjects of art, craft, design, architecture, photography and film all have their separate museums and institutions. In part, these divisions represent real, material conditions: in the twentieth century the various arts have tended to go their separate ways. At the same time, such divisions have their disadvantages: mixed-media forms, for example, tend to be neglected because they cut across several categories and thus appear to belong to none of them. Pop music, for example, involves music, singing, clothes, make-up, hairstyling, musical instruments and sound systems, stage sets, lighting, record covers, posters, promotional goods, still photography, film, video and television. In London it is the National Sound Archive and the Theatre Museum which take most responsibility for collecting and preserving material in this field.

As yet London does not have a museum of industrial design. One is due to open at Butler's Wharf in 1989, but even then the design historian will still need to visit many other places and

institutions if the full range of design is to be scanned. For instance, London has museums of the applied arts, science and engineering, furniture, aircraft, transport, weapons of war, plus several eighteenth-century stately homes and a William Morris museum, all of which contain examples of designed artefacts. As far as architecture is concerned, the whole city provides a conspectus of design through the ages. In terms of consumer goods, no design museum, however large, is likely to be able to match the quantity of contemporary examples to be found in large department stores like Selfridges and Harrods.

While theorists strive to draw ever sharper boundaries around the realms of art, design, craft and so forth, their efforts are constantly undermined by practitioners who delight in working in the gaps between realms or who combine them in unexpected ways. (Creativity appears to flourish at margins and interfaces.) Design historians thus find themselves confronting hyphenated beings called 'artist-designers' and 'designer-craftpersons' and hybrid artefacts which are half furniture and half sculpture. A cross-section of this kind of experimental work is gathered together in the volume *New British Design* (1986) edited by John Thackara. By celebrating the 'strange, impractical and uneconomic artefacts' of a number of advanced designers this text reproduces the avant garde versus the mainstream, minority/majority, syndrome so familiar from the history of modern art.

Design historians can limit their object of study by concentrating upon examples of good or exceptional design. Hence the popularity of texts about the work of famous architect-designers or about so-called design classics or cult objects. This approach is derived from art history and architectural history. In the latter, for example, a qualitative distinction is often made between distinguished and undistinguished structures: a cathedral is an example of architecture, whereas a bicycle shed is a mere building. Since, in most cases, high quality structures are those designed by professionally-trained architects, the high/low distinction is equivalent to the professional/amateur distinction.

While some design historians ignore anonymous, vernacular design on the grounds of low quality or because there is too

much of it, others, influenced by the anthropologist's concept of material culture as embracing all the artefacts of a society, seek to encompass all designed goods – good, bad and indifferent – whether by professional designers or not. The quantity problem, they contend, can be overcome by selecting representative examples. Good design histories are problematical, they argue, because of the contentious issue: whose taste or preference determines good and bad? Are the tastes and value judgements of the historian or design world experts to prevail over those of other social groups? A negative answer does not mean, however, that the issue of the historian's value judgements and the question of quality can be dispensed with altogether. In this regard it would be helpful if design historians distinguished between their personal assessments and those of others and tried to explain any divergence of views. It would also be useful to examine changes in value judgements over time.

While design historians may agree that the central focus of their research is the designer, the design process and designed goods, other topics such as style, taste, the role of clients, management, marketing and consumers also need to be investigated. Furthermore, these topics cannot be studied in isolation because they are aspects of a dynamic system which itself is part of a larger social and historical process. (See Chapter 5.) It is for this reason that however sharply the boundaries of the subject are drawn, sooner or later the design historian has to address external factors.

Definitions of Design

Many texts on design include a definition on the assumption that the theoretical problems of specifying the discipline's object of study can be solved in this way. Scepticism concerning the value of such definitions has already been expressed, but we can review a small sample to assess their strengths and weaknesses. Three definitions of industrial design will be considered. (As far as many scholars are concerned, design *is* industrial design.)

Design is what occurs when art meets industry, when people

begin to make decisions about what mass-produced products should look like.[2]

This definition, by Stephen Bayley, locates the origin of design with the advent of industrialization and mass production methods. (The idea that design is the result of a marriage between art and industry was common in the 1930s when design was often referred to as 'industrial art'.) Bayley does not supply a time or place for the union and he seems to think design is limited to issues of visual appearance and style – function and utility are not mentioned. The use of the word 'people' is vague: it does not reveal who has the power to make design decisions.

> Industrial design is a process of creation, invention and definition separated from the means of production, involving an eventual synthesis of contributory and often conflicting factors into a concept of three-dimensional form, and its material reality, capable of multiple reproduction by mechanical means. It is thus specifically linked to the development of industrialisation and mechanisation that began with the Industrial Revolution in Britain around 1770 . . .[3]

Clearly, this is a more complex and sophisticated definition. The advent of design is located both historically and geographically and it is differentiated from craft production. One weakness is that the role of the consumer or the market in influencing the design process is not mentioned. The definition describes an impersonal process – designers do not appear. By specifying 'three-dimensional form' the author appears to exclude two-dimensional products such as advertisements.

> The industrial designer is a technical specialist in visual appeal . . . [he] is retained by a manufacturer with one object only: to increase the demand for his products through their increased attractiveness to the consumer. He is paid by the manufacturer according to his success in achieving that object. The industrial designer stands or falls upon his ability to create and maintain profitable trade. He is first and foremost an industrial

technician and not primarily an educator of public taste. Under existing conditions his business must be to make profits for his employers.[4]

This description has the merit of frankness about the role of the twentieth-century designer as a servant of capitalism ('existing conditions'). Designers are employees, they sell their mental labour-power to manufacturers in return for wages or fees; the primary motive of their employers is private profit. Four weaknesses can be detected: first, design is limited to visual appearance (function is not cited); second, the fact that designers are also employed in the public sector where the ethos is often social utility rather than profit, is ignored; third, only men appear to be designers; fourth, the industrial designer is conceived of as the sole 'author' of the products in question, though the role of consumers is hinted at.

These three definitions necessarily exclude other design activities taking place outside the industrial context, that is, designing undertaken by non-professionals. (For example, someone who designs and makes their own clothes or someone who customizes their scooter.) For this reason it would be unduly restrictive to equate design solely with industrial design.

Among contemporary design historians the dominant definition is the modern one, that is, design as a specialist activity associated with the industrial revolution, mass production manufacture, the modern movement in architecture, and the consumer society. There are, however, a few dissenting voices. One is Simon Jervis, a furniture expert, museum curator and author of *The Penguin Dictionary of Design and Designers* (1984). He is critical of the modern definition on the grounds that it excludes so much design dating from the period 1450 to 1800 and because it is anti-ornament like modernist design theory. Jervis' conception of design can be called, therefore, 'pre-modern' or 'anti-modern'. Jervis ingenuously admits that 'the question of the definition of design is begged'. Nevertheless, even if it is not explicit some concept of design must be implicit in the book by virtue of what it includes and excludes.

Jervis gives most attention to ceramics, furniture, glass, interior

decoration, ornament and textiles. Graphics, consumer durables and typography are touched upon to a lesser extent while heavy industrial, theatre and dress design are 'almost wholly excluded'. Jervis sees design as closely linked to art and architecture hence he features biographies of many artists and architects. Premodern design, he argues, was the province of goldsmiths, engravers, sculptors, painters and architects. They produced engraved designs and cartoons for making such things as furniture, metalwork and tapestries. These designs were chiefly concerned with decoration and ornament. A clear distinction is made between designers and craftsmen. The former are judged to be superior in status and are regarded as generating luxury goods for the ruling strata, the wealthiest sector of society.

This dictionary proved controversial within the design history profession. An acrimonious exchange of letters occurred in the *Design History Society Newsletter* following a critical review.[5] Polytechnic historians felt that Jervis was unduly narrow in his definition of design and lamented the exclusion of fashion and engineering. They also considered that the emphasis in any dictionary of this kind should be on the modern design of the past 200 years and also that more women designers should have been featured. Jervis responded by claiming that the polytechnics' concept of design history had been 'created by committee'. No doubt to outsiders the dispute will seem a storm in a designer teacup. However, it did illuminate the fact that different institutions - museums, polytechnics - tend to generate different, antagonistic conceptions of design based upon their separate histories and social functions.

As the dispute between Jervis and his critics revealed, engineering is a bone of contention among design historians. While on the one hand the subject has more to do with science and technology than with design, craft and the decorative arts, on the other hand design *is* undertaken by engineers. In fact, in many cases they design the machines which make the products other designers design. Because engineering design is highly technical in character and primarily concerned with function, it lacks the visibility and glamour of other kinds of design. Furthermore, the huge size of some of their structures precludes their display

in shops or design exhibitions. Gui Bonsiepe once criticized a design show on precisely these grounds and regretted the domestic bias of its organizers: 'There was a total absence of producers of capital goods such as agricultural equipment and tools, manufacturing and building machinery. The narcissistic preoccupation with the perfection of the living room predominated.'[6]

Another dissenting voice is that of Victor Papanek (b. Austria 1925), a professional designer and ex-dean of the school of design at the California Institute of the Arts. His polemical book *Design for the Real World: Human Ecology and Social Change* (1972) is a sustained critique of modern industrial design and a plea for a different kind of design serving the needs of the poor, the sick, the handicapped and the peoples of Third World countries. Papanek's conception of design is also, to a certain extent, antimodern but, unlike Jervis', his outlook is not traditionalist. His conception of design can be called 'libertarian', 'alternative' or 'ecological'.

His book begins with an all-embracing definition:

All men are designers. All that we do, almost all the time, is design, for design is basic to all human activity. The planning and patterning of any act towards a desired, forseeable end constitutes the design process ... Design is composing an epic poem, executing a mural, painting a masterpiece, writing a concerto. But design is also cleaning and reorganizing a desk drawer, pulling an impacted tooth, baking an apple pie, choosing sides for a back-lot baseball game, and educating a child ... Design is the conscious effort to impose meaningful order.[7]

The problems inherent in this definition are obvious and multiple.

Feminists will note the absence of women. Apparently, design includes art, poetry, music, dentistry, cooking, sport and education! It is also motivated by a utopian socialist perspective: the truism that design is a process all human beings engage in to some extent ignores the specialized, professional character of design in modern society though, in fact, Papanek later attacks the design profession for failing to meet the real needs of

humanity. He also observes: 'The ultimate job of design is to transform man's environment and tools and, by extension, man himself.' This remark is valuable because it highlights the fact that design has a feedback effect upon human beings: it is not merely environmental change that is taking place but also self-transformation – for good or ill.

Design, for Papanek, is primarily a problem-solving activity. He provides a much more precisely defined notion of design via a diagram which he calls 'the function complex'. Around the central core of function are clustered six interlinked concepts – use, need, telesis, method, aesthetics, association.

It should be clear by now that the various definitions of design discussed above are inflected by the different ideological-political positions of those who devise them. Materialist historians of industrial design may argue: 'Our definition is the most objective, we simply try to describe the world as it is.' No doubt Papanek would respond by saying: 'It is not sufficient to accept the world as it is, our conception of design ought to encompass the world as it might be.'

The Concept 'Design': Open or Closed?

Who determines what the concept 'design' encompasses? Is design, like art, an 'open' concept in the sense that it can be extended, revised, changed? In answer to the first question: it is primarily the design world (that is, those professionally concerned with design – designers, critics, historians, museum curators, clients and associated institutions) who determine the contemporary meanings of the term 'design'. However, the fact that design has changed its meaning historically suggests that it is possible for individuals and groups to propose new definitions, new objects of study. Whether the design world and society as a whole accepts these new proposals is another matter.

Given the fact that design history is a new discipline, it is somewhat surprising that concepts of design have so quickly become conventional and orthodox. For example, new research on design usually focuses upon an extremely narrow range of

topics: consumer goods, public transport, advertising, the home, etc. 'Safe' topics predominate. Why are design historians so unimaginative? Why are they so reluctant to consider military weapons, police equipment, scientific instruments, sexual aids, space vehicles, engineering machines, computer hardware and software, the role of the state in promoting design, the relation of design to pollution, profit and exploitation, as topics worthy of analysis? There appears to be a deeply-entrenched conservatism among design historians, an unwillingness to confront the relationship between design and politics, design and social injustice. Regrettably, a great deal of design in the twentieth century has been directed towards anti-social and anti-human ends: the design of concentration camps and gas chambers; the design of instruments of torture, surveillance and repression; the design of all kinds of dangerous products. What would we think of general histories which only described good people and happy events?

Even within the limits of present popular topics there is a need for a more sceptical, questioning and critical approach: are there not disadvantages to the ever-expanding production of goods? Is the continual redesign of 'old' products essential in all cases? Are the values promoted by design and advertising socially beneficial or socially detrimental? Is the design historian's function merely to celebrate and reinforce a particular kind of commercial culture?

It could be argued that design, in its most general sense, is a form of politics: humanity struggles to shape its environment and society in order to satisfy its needs. It follows that design historians could, legitimately, extend their object of study to include the design of political structures and ecological systems.

External Factors and Interdisciplinary Perspectives

The design historian's task is complicated by the fact that besides issues internal to design, external factors also have to be considered. This is because design is affected by wars, revolutions, economic booms and slumps, technological innovations and so forth. At this point the problem of limiting the object of study becomes acute. To what extent, for example, should design

historians study the economy of a society? They might decide to take a crash course in economics but they would quickly discover that there is not one economic theory which can be speedily grasped but a variety of competing theories about how the economy works. Attempting to apply the findings of another discipline is thus not a straightforward matter. Furthermore, it is surely impractical to expect design historians to master all the related fields of knowledge that impinge on design.

A solution would be to establish criteria of relevance, that is, taking into account only those factors directly influencing the character of design. For example: the Arab–Israeli War of 1973 caused a reduction in the supply of oil reaching the West; this in turn caused an increase in the price of petrol and cars became more expensive to run; hence a need arose for cars to be redesigned so that their engines achieved more miles to the gallon and so that their shapes caused less air resistance. This seems a clearcut chain of events: a political/military clash – an economic consequence – a design change.

A second example will serve to illustrate the difficulty of establishing links between economic and stylistic changes. In 1987 a fashion reporter from New York observed that while the value of shares on the stock exchange plunged, the hemlines of women's dresses rose to heights not seen since the mini-skirts of the 1960s. It seems unlikely that in this case there was a correlation between the two events. In all probability, activities in parallel spheres were travelling in opposite directions. This is not to say, however, that a Wall Street crash might not at some stage have an impact upon the economy of the fashion industry or upon people's ideas about how they should dress. But how that impact would be manifested in terms of the style of clothes is hard to predict because designers could respond in several ways.

The general theoretical problem here is one of determination. In most cases events are overdetermined, that is, various factors or forces determine them. Once these have been identified the task then is to decide what weight to assign to the individual factors involved.

In regard to the economic determinants of design, a materialist

theorist such as Necdet Teymur would be critical of the idea that it is simply a question of identifying outside forces or of taking account of the economic constraints imposed by the design brief. Quite rightly, Teymur argues that the activity of design is imbricated within particular economic systems – certain modes of production and exchange – which permeate it through and through.[8] He contends that because-the economic determinant is integral to design it is largely invisible to those in the profession and those in design education.

In the light of this we can perhaps distinguish between those general economic conditions which underpin design in the long term and those exceptional economic events – breakdowns, crises – which influence it in the short term.

'Interdisciplinary' is a word increasingly associated with design. For instance, the activity of design is regarded by members of the Design Research Society as interdisciplinary in two respects: first, it occurs in various arts and industries (fashion, architecture, engineering, etc.); and second, it synthesizes information derived from a range of disciplines (ergonomics, sociology, psychology, etc.).

The word 'interdisciplinary' is also being applied to design history. Design historians envisage that they will use concepts, theories and methods drawn from other disciplines such as sociology, anthropology, linguistics, art history and economics. While it is perfectly proper that design historians should learn as much as possible from other disciplines, the importation of 'foreign' concepts is problematical because the objects of study and goals of such disciplines differ from one another. (A synthesis of, say, Marxism, feminism, psychoanalysis and semiotics is extremely difficult to achieve; and what may result is a deformed hybrid.)[9] A critical, discriminating attitude towards all ideas no matter what their source is essential.

Furthermore, there is a problem of compatibility: ideas drawn from different disciplines may well contradict one another. Advocates of the multidisciplinary approach rashly assume that the greater the plurality of perspectives the better, but this ignores the problems of how fundamental ideological differences between various perspectives are to be reconciled.[10] Critics of

pluralism argue that not all accounts of reality are equally valuable; some, they insist, are better, more truthful than others. (Marxists, for example, argue that historical materialist approaches to design are superior to idealist approaches.) A mere accumulation of different perspectives will tend to produce a relativistic confusion; again, discrimination is essential. In short, there is a danger that design history could suffer from scholarly eclecticism and become an incoherent ragbag.

Also, unless the object of study of design history is precisely defined the sheer magnitude of its possible subject matter will reduce the researcher to impotence. The young discipline could dissipate itself among a thousand topics and find itself disputing the roles and territories of a dozen existing academic disciplines.

None the less, academic disciplines often share certain characteristics: for example, empirical methods of study and theories such as functionalism. In such areas of overlap the results obtained by different disciplines may well be commensurable. Even when two disciplines are far apart, new insights may be gained by applying the theories of one to the object of study of the other in an analogical fashion. For instance, some historians have found the biological theory of evolution useful in thinking about the temporal development of art and design.

Perhaps the most effective way in which design historians could benefit from a multidisciplinary approach would be to establish teams of scholars from different disciplines to work collaboratively on common themes and problems.

Notes and References

1. On the notion of family resemblance see L. Wittgenstein, *Philosophical Investigations* (Oxford: Blackwell, 1953) pars 66-7.
2. S. Bayley, *Art and Industry* (London: Boilerhouse Project, 1982) p. 9.
3. J. Heskett, *Industrial Design* (London: Thames & Hudson, 1980) p. 10.
4. F. Mercer, *The Industrial Design Consultant* (London: The Studio, 1947) p. 12.
5. Hazel Conway (book review), *Design History Society Newsletter*, (23) November 1984 pp. 13-15. Plus letters: from Jervis, (24) 1985 pp. 6-7; D. Greysmith, (25) 1985 pp. 4-6.

6. G. Bonsiepe, quoted in, J. Bicknell and L. McQuiston (eds), *Design for Need* (Oxford: Pergamon Press, 1977) p. 16.

7. V. Papanek, *Design for the Real World: Human Ecology and Social Change* (London: Thames & Hudson, 1972) p. 17.

8. N. Teymur, 'Design without economics? The economic blindness to the materiality of design' in R. Langdon and P. Purcell (eds), *Design Theory and Practice* (London: Design Council, 1984) pp. 75–80.

9. Possibly these remarks are too pessimistic. Sut Jhally's book *The Codes of Advertising* (London: Pinter, 1987) draws upon Marxism, psychoanalysis and anthropology; it also undertakes empirical research using the social science method of content analysis. These different elements are successfully combined to generate new insights into the nature of television advertising. One reason why this works is that the concept of fetishism - which Jhally foregrounds - is common to all three disciplines cited above.

10. Terry Eagleton remarks: 'Pluralists believe there is a little truth in everything.' He adds: 'This theoretical pluralism also has its political correlative: seeking to understand everybody's point of view quite often suggests that you yourself are disinterestedly up on high or in the middle, and trying to resolve conflicting viewpoints into a consensus implies a refusal of the truth that some conflicts can be resolved on one side alone.' *Literary Theory: an Introduction* (Oxford: Blackwell, 1983) p. 199.

3

Craft and Design

Although craft and design are two different concepts, they are closely linked: craftpersons generally engage in design and the mass production of designed goods frequently relies upon craft processes. The word 'craft' means 'skill', particularly the manual kind, hence 'handicraft'. It also means 'trade' or 'occupation'. Familiar, traditional crafts include: pottery, furniture-making, leatherwork, metalwork, stone masonry, jewellery, glass-blowing, stained glass, embroidery, knitting, weaving, tapestry, book-binding, basketry and toy-making.

Historically, craft preceded both art and design. During the Middle Ages in Europe, art and design had not yet emerged as separate specialisms, but were subsumed within the broad range of workshop skills. In the modern period one of the key differences between craft and design is that in the former, the making process from conception to execution is undertaken by the same person or a small team of people. A division of labour between designers and makers, in other words, does not exist – or not to the same extent – as it does in industry. A second difference is that the handicraft mode restricts output to one-off artefacts or small batches of goods. Craft production usually takes place in studios or workshops (even in kitchens and garages), whereas designed goods are generally made in factories. Craft objects generally exhibit the mark of the hand, whereas industrial goods generally exhibit the mark of the machine. (This is not to say that craftpersons don't use machines; potters use wheels and kilns, knitters use knitting machines, and so on.) Divisions of labour also occurred in medieval and ancient workshops. It was the gradual introduction of more intensive labour divisions, power-driven machinery, assembly lines, and growing auto-mation which brought about the separation of craft and design and which prompted the well-known debates about the fate of

art and craft in the age of mechanical production and repro-
duction.

Factories enabled the mass production of millions of identical
units and since this mode of production is the dominant one
within contemporary developed countries, the crafts necessarily
appear today as residual phenomena, anachronisms or survivals
from the past. The less a society is developed industrially and
technologically, the more it relies upon crafts in everyday life,
hence they continue to play an important role in Third World
countries. Within advanced societies, in sharp contrast, crafts
tend to be part of the luxury and gift markets. First and Third
worlds come together in the craft products made by the poor
for affluent foreign tourists, that is the so-called 'ethnic', 'tourist'
or 'airport arts'.

It might seem that the destiny of the crafts is to vanish
altogether. One category of craft – the so-called 'rural' or
'country' crafts based upon the agricultural way of life – has
certainly been virtually eliminated. However, the crafts are un-
likely to disappear completely because they continue to play a
useful role during the preliminary stages of industrial production,
as in the case of model-making which is used to generate proto-
types. Furthermore, craft revivals take place periodically as a
consequence of reactions against cheap, standardized, machine-
made consumer goods. Expensive, individualistic items hand-
made from fine materials have a strong appeal, particularly to
that middle-class sector of society which can afford the higher
prices and which wishes to distance itself from the majority
dependent upon the mass market. To be fair, the attraction of
craft is not simply social snobbery. A different set of values can
be involved: truth to materials, a desire for natural as against
synthetic materials, a respect for skill or workmanship, the role
of the imagination and the unity of mental and manual labour.
Nostalgia for a simpler, smaller-scale, more rural existence is
also part of the appeal of craft.

David Drew, a basket-maker, lives in a thatched cottage in
Somerset. He grows 20 varieties of the willows which serve as
his raw material. He learnt basket-making like an apprentice

from another craftsman. The almost mystical quality of craft-work is indicated by the following quotation:

> My baskets have to be strong and neat, made from willow alone, and then, if they are well treated, they can last 40 years. I have to have the design clear in my head before I start because I can't unpick - it's not like knitting. From the first cut to the last trim the work should be carried out with total concentration; it should proceed in one movement and if it's not clean and good I destroy it.[1]

It appears from these remarks that Drew does not design on paper. Craftspeople are obviously inventive and design is a vital stage in the craft process but it is also the case that precedent is crucial: traditional patterns, types and forms are followed - with minor variations - time and time again. Copying other people's designs has also been a common practice in many trades.

Within the spectrum of the crafts a hierarchy can be discerned. At the bottom there are the trades of building - bricklaying, plastering, plumbing and carpentry - and at the top crafts aspiring to the condition of fine art. In the former there is normally little scope for creativity and self-expression, whereas in the latter these flourish. A bricklayer's status is usually that of an employee, while an artist-craftperson's status is that of someone who runs a small, independent business. Akin to the lowly building trades are those crafts and hobbies associated with the house and housewives: sewing, knitting, curtain-making and so on. Domestic crafts tend to be part-time and amateur, though in some cases they develop into full-time, professional activities.

Artist-craftpersons think of themselves above all as creative, inventive beings. Like fine artists, they experiment with materials, techniques, forms, colours and imagery. Since the aesthetic dimension is all important, the functional aspects of their arte-facts tends to have a lower priority. Like the portrait painter, much of their work is undertaken on the basis of individual commissions. In Britain many such people studied at art school and then acquired a postgraduate qualification at the Royal College of Art. As a sign of their different status from producers

for the mass market, they hold one-person exhibitions in public and private art galleries and they sell their wares via specialist, upmarket stalls (like the ones in the covered spaces of London's Covent Garden) and shops. One such shop exists within London's museum of the applied arts – the Victoria and Albert. There are also several specialist magazines which review craftwork in much the same manner as art magazines review fine art. In Chelsea a crafts fair, organized by Philippa Powell, takes place annually which serves as a showcase for contemporary British crafts. Some craft objects become collector's items and end up in auction houses being sold for high prices. George Daniels, a British clockmaker, takes a year to construct one of his watches; they cost over £50,000 each. Even he acknowledges that they are 'rich men's toys'.[2] However, most professional craftpersons have annual incomes lower than the national average.

As Peter Dormer explains, many people – more women than men – have been attracted to the crafts in recent years because they wanted an alternative lifestyle, one with a high degree of work satisfaction and self-determination. However, he also points out that 'in reality craftspeople are dependent upon state patronage via the Crafts Council and the regional arts associations, school teaching and a clientele of salary earners or professional workers. The autonomy, like that of any small-scale entrepreneur, is fragile, albeit greater and more enviable than that available to most people.'[3]

Mention of the Crafts Council reminds us that various organizations and institutions are active in the promotion of the crafts. Others include the Cornwall Crafts Association and the British Toy Makers' Guild. The presence here of the word 'guild' is a sign of the link between present-day craft and the medieval past.

It is the small scale of craft production which ultimately distinguishes it from industrial manufacture. Achieving the right scale for economic viability is, however, difficult. A business run by one person is very demanding: the same person has to make, distribute and market the wares and keep accounts. Low output means high prices and lengthy production times. The goods may prove too expensive to sell. Increased production can reduce unit costs but by enlarging the workforce, introducing

further divisions of labour, and making use of machines, the high quality and uniqueness of the craft object may be put at risk. If expansion is too great the special appeal of the craft can be lost as production comes closer and closer to outright industrial manufacture. Nevertheless, there are a number of successful artist-craftpersons who generate designs for others – outworkers or workshops – to make up. (This was the kind of production William Morris engaged in.) There are also ceramics factories where craft skills – handpainting, for example – still persist. In short, in the space between craft and industry various intermediary stages of manufacture are to be found.

Although the crafts are much less important in economic terms than industry, their contribution to national economics is not insignificant. It varies, of course, from country to country. Germany has a tradition of encouraging what is called the 'Handwerk' sector; consequently, its contribution to the German economy was two and a half times the size of its British equivalent, employing about 3.4 million people and making up 11 to 12 per cent of gross national earnings (1984 estimates).

Craft has been regarded as a half-way house between art and industry. At times it manifests uncertainty about its identity and its public image can be a negative one. This is because so much craftwork is of poor quality – tat or kitsch – and because it can also suffer from whimsy and preciousness. To enthusiasts of the city and the machine age, the taste for crafts appears regressive and elitist. More recently, however, the development of computer-aided design and manufacturing has suggested to some observers that a new kind of product responsive to consumer demands, capable of economically viable small batch or even one-off production, is now possible and that this will finally resolve the conflict between craft and industry.

Contemporary design historians tend to be ambivalent towards the crafts. Those inclining towards a strict definition of industrial design ignore them altogether. Historians of the Modern Movement, like Pevsner, feature crafts – that is, William Morris and the British Arts and Crafts Movement – as a stage in the development of modern design. A substantial body of literature on Morris and

the Arts and Crafts Movement exists in its own right, and a separate history of the crafts has been written by Edward Lucie-Smith (he has also written a companion volume on industrial design).[4]

Perhaps the most famous and delightful account of an English craft - wheelwrighting - is George Sturt's *The Wheelwright's Shop* (1923). The author's family ran a small business in Farnham, Surrey, making and repairing waggons for local farmers and tradespeople throughout the nineteenth century. Sturt was not himself trained to be a wheelwright but he undertook many of the tasks about the workshop. Having literary ambitions, he was an acute observer and his descriptions of the materials and tools used, the methods employed, and the habits of his eight workmen is detailed and perceptive. His story also traces the slow decline of the trade and its associated lore and skills with the availability of factory-made and foreign goods, and the advent of tractors and the motor car. Particularly valuable for the design historian are Sturt's characterizations of the craft as an unscientific folk industry based upon practice, experience and ancient, local customs: 'The conditions in which a waggon grew into a thing of beauty' were, he thought, 'comparable to a fiddle or a boat. Necessity gave the law at every detail, and in scores of ways insisted on conformity. The waggon-builder was obliged to be always faithful, to know always what was imposed on him, in wheels, shafts, axles, carriages, everything. The nature of this knowledge should be noted. It was set out in no book. It was not scientific. I never met a man who professed any other than an empirical acquaintance with the waggon-builder's lore.'[5] Sturt and his craftsmen knew from past examples and knowledge that their waggons had to be designed in very specific ways if they were to function properly but frequently they did not understand why that was the case.

In addition to first-hand accounts such as Sturt's, there are studies of craftwork in 'primitive' societies by anthropologists and scholarly accounts of aspects of folk or peasant crafts. The latter generally appear in obscure journals of local history and material culture.[6] The feminist movement of recent years has

led to an upsurge of writings about the work of craftswomen through the ages. (Sexism has not been so evident in the crafts as in the fine arts.)

Information on contemporary crafts is supplied by the craft magazines and by the catalogues to exhibitions held at such venues as the Crafts Council and the Victoria and Albert Museum.

Notes and References

1. 'David Drew, basket-maker', *Sunday Times Magazine* 28 Sept 1986.
2. N. Guitard, 'The greatest clockmaker in the world', *Observer Magazine* 18 April 1982.
3. P. Dormer, 'Post-war craft', *Marxism Today* July 1982, pp. 36-7.
4. E. Lucie-Smith, *The Story of Craft: the Craftsman's Role in Society* (Oxford: Phaidon, 1981); *A History of Industrial Design* (Oxford: Phaidon, 1983).
5. G. Sturt, *The Wheelwright's Shop* (Cambridge University Press, 1923) p. 73.
6. See, for example, *The Winterthur Portfolio*. This quarterly is sub-titled 'a journal of American material culture'. It has featured articles on the design of dams, furniture, wrought iron, stoves, cemeteries, houses, prints, folk art, musical instruments, interior design and textiles.

4

Designers and Designed Goods
– the Proper Objects of Study?

Initially, the agenda for design history was set by the precedents established by art and architectural history. And since art and architecture historians tended to construct their narratives around famous artists and masterpieces, many design historians followed suit. Hence the assumption that the proper object of study of the discipline was either designers or designed objects (or a combination of the two). Let us examine these topics to identify their strengths and weaknesses.

The Designer as the Object of Study

At the outset it is necessary to distinguish between monographs and biographies. A monograph is taken to be a study of the *work* of an individual artist, while a biography is taken to be an account of the *life*. Of course, in practice there is an overlap, but one can perhaps differentiate between those texts which foreground the work and those which emphasize the life.

A cursory examination of the stock of a specialist art bookshop will confirm that the monograph and the biography are extremely popular forms of presentation among art historians. They are not quite so popular among design historians though there are, of course, many books and exhibition catalogues celebrating the achievements of such famous architects and designers as William Morris, Adolf Loos, Le Corbusier, Frank Lloyd Wright, Charles Rennie Mackintosh, Eileen Gray, Ettore Sottsass, Gordon Russell, Walter Gropius, Harley Earl, Terence Conran, Christian Dior, Mary Quant and so on. Closely related to such books are the memoirs and autobiographies of designers themselves (some of which are boastful accounts and/or public relations exercises written by industrial designers).

It is easy to understand the appeal of the monograph/biography: to write or read about the life and work of one person is reassuring because the subject matter is limited and sharply defined; the story has a clear beginning, middle and end; the hero or heroine serves as a fulcrum around which everything else revolves. This type of text has a compelling unity.

Yet there are problems. Since identification with the central figure is more or less inevitable, it is difficult for writers and readers to maintain a critical and objective attitude. Also, the author has two objects of study: 'the life' and 'the work'. Few texts treat both with equal success. If 'the life' is given priority, 'the work' suffers and vice versa. Furthermore, the relationship between the two is problematical: the incidents and traumas of a designer's private life do not necessarily map neatly on to the development of his or her professional career. (A recent biography of a leading British architect contained a good deal of information about his adolescent sex life; what precisely this had to do with his architecture remained obscure.) Many designers lead routine lives; the excitement is in their creative and intellectual life which the biographer often finds difficult to convey. In those cases in which individuals led melodramatic lives, 'the work' is all too frequently swamped by the biographical saga.

Even supposing the biographer manages to cope with both life and work adequately, there still remain vexed questions concerning the relationship between the designer and the society of which he or she was a member.

Nicos Hadjinicolaou has argued that the monographic approach to history-writing entrenches two notions, both of which he rejects: first, the idea that individuals make history; and second, the idea that the history of art and design is the history of great artists and designers.[1] It is difficult for us to see that these notions are peculiar to our age and culture, an age in which the ideology of individualism is so pervasive, but their inadequacy can be revealed by considering projects which are clearly social and collective in character: the American and Soviet space programmes, major civil engineering works, modern motor car production, and so on. Such projects are impossible to ascribe to the genius or labour of a lone individual.

Further objections to biographies have been voiced by George Kubler: 'In the long view, biographies and catalogues are only way stations where it is easy to overlook the continuous nature of artistic traditions. These traditions cannot be treated properly in biographical segments. Biography is a provisional way of scanning artistic substance, but it does not alone treat the historical question in artists' lives, which is always the question of their relation to what preceded and to what will follow them.'[2] In other words, such studies, however numerous and thorough, do not constitute a history of art or design because they are too atomistic and narrowly focused. Texts recounting the story of design in terms of chronologically-arranged summaries of the careers of individual designers can encompass longer spans of time but are similarly of limited value because they present mountain peaks without foothills and, to change the metaphor, offer a single line of development akin to the progress of the Olympic torch from runner to runner which cannot cope with the multiple, parallel (and cross linking) strands taking place in reality.

For these reasons, and others, recent design historians have searched for an alternative to narratives centred upon individual designers. The favourite alternative – the social history approach – will be discussed later.

Anonymous Design

Before going any further it should be acknowledged that not all art historians have conceived of the history of art as the story of great artists. When, for instance, the Swiss scholar Heinrich Wölfflin proposed 'an art history without names' he undermined the artist-centred approach. Some writers have taken Wölfflin at his word, for example Bernard Rudofsky's books, *Architecture without Architects* (1965) and *The Prodigious Builders* (1977), focus upon the work of anonymous builders. Wölfflin's candidate for the object of study of art history in place of artists was *style*. A number of design historians have agreed and privileged the styles of design in their histories. In this context, the subtitle of Siegfried Giedion's *Mechanization Takes Command* (1948) – 'a

contribution to anonymous history' – is relevant. Significantly, Giedion was once a student of Wölfflin; however, unlike his mentor, Giedion's approach was not stylistic but typological. Art historians, archaeologists and anthropologists have frequently been confronted by collections of pots, carpets, icons, etc., whose individual makers were unknown. In this situation the approach to material culture based upon the life stories and personalities of exceptional individuals (the biography/psychology approach) becomes patently inadequate. Those design historians who believe that the history of design should encompass vernacular design are also faced by objects whose creators are unknown or about whom very little is known. They too, therefore, are compelled to seek an understanding of design based upon the behaviour of social groups rather than that of named individuals. Of course, in the modern period the names of designers – professional ones at least – are known or can be discovered. Even so, the ascription of design achievements to individual genius is much too simplistic. There is no doubt that individuals *do* make unique contributions to design but the magnitude of this element is generally exaggerated out of all proportion as a result of the ideology of individualism which has been so powerful in the West since the Renaissance.

Auteur Theory

At this point it is necessary to consider the concept of authorship. According to common sense, the designer is the person wholly responsible for the form and style of a designed artefact, in other words its author. In practice, however, authorship is much more complicated. For example, the film theorist Richard Dyer has distinguished four kinds of authorship in the cinema: (1) *individual* (a single person is identified as the sole originator of the film); (2) *multiple* (several people have cooperated to produce a film but individual 'voices' are still evident within it); (3) *collective* (a group or team of people have collaborated to make a film in such a way that individual contributions can no longer be identified); (4) *corporate* (organizations, firms or social

structures – e.g. film studios, Hollywood, capitalism – for which, or within which, many individuals work, are regarded as 'the author' of the film).[3]

Clearly, type one is the most personal and type four the most impersonal. Type one is primarily associated with the practice of the fine arts, and type four with large-scale, highly industrialized forms of production typical of the mass media and industrial design.

The film-making undertaken by major Hollywood studios is a clear-cut instance of collective cultural production: hundreds of different specialists combine together for months at a time to make films for the commercial cinema. But even here the ideological pressure to attribute manifestly collective products to the genius of a single individual is overwhelming; hence the habit of treating the director as the 'artist' responsible for the film. Before the 1950s only a few directors were treated as great artists. However, in that decade French film theorists associated with the magazine *Cahiers du cinéma* began to promote previously little regarded American directors of 'B' movies to the status of *auteurs*. By examining a series of films by one director the theorists began to discover recurrent themes and motifs which, they thought, could only be ascribed to the influence of the director's personal vision. In this way directors came to be regarded as authors comparable to those who write novels.

Intellectual fashions are subject to rapid change, especially in Paris. In the 1960s the author theory was abandoned and superseded by its exact opposite: the 'death of the author' was announced. (This marked the liberation of the reader or viewer.) Works of art, it was now considered, were structures of meaning independent of their creator's intentions.

Clarity was introduced into the debate by Michel Foucault in his 1969 paper 'What is an author?'.[4] As Foucault explains, the positive aspect of the critical approach that attempts to dissolve the author is that it highlights the various roles which the 'author-function' plays in Western culture. In other words, authorship is a function of specific social and historical circumstances, economic systems, institutions and discourses (e.g. the legal one

relating to copyright). It is a role or place certain individuals occupy at particular times while others who write and paint do not. The same can be said of designers.

The Social Production of Design

Underpinning the ideology of individualism is a simplistic conception of the human subject: a unitary monad which somehow develops and functions independently of, or even in opposition to society. This view of the subject has been challenged by theoretical developments in several systems of thought since the mid-nineteenth century: Marxism drew attention to the economic and ideological determinants of human behaviour and thinking; psychoanalysis showed that the mind of the individual is divided (conscious and unconscious) and at the mercy of various hidden drives and complexes; twentieth-century linguistics, anthropology and sign theory have demonstrated the extent to which the subject is constituted by social structures, languages and codes.

One of the negative side-effects of the ideology of individualism has been to obscure the *social* nature of the production of art and design. Artists and architects have often been presented as the archetypal rebels against society. A vivid depiction and advocacy of such absolute artistic individualism is to be found in Ayn Rand's popular novel about an ultra-modern architect *The Fountainhead* (1943), later made into a movie directed by King Vidor and starring Gary Cooper. Marx, in contrast, contended that: 'production by an isolated individual outside society ... is as much an absurdity as is the development of language without individuals living *together* and talking to one another.'[5]

Various non-individualistic kinds of authorship have already been identified and these will be discussed in more detail shortly, but even when designing is undertaken by a single person alone in a studio it can be regarded as social for the following reasons: first, most designers have the benefit of education/training in design and engineering colleges provided by society as a whole; second, contemporary influences (few designers escape the influence of their peer group or current trends and fashions); third,

the power of tradition and precedent (new design is always dependent to some degree upon the accumulated knowledge and achievements of previous generations); four, the social character of design 'languages', codes and styles (these are the product of groups and classes, they develop over many centuries); five, the dependence of the designer upon clients and consumers without whom any large-scale production would be impossible.

An American sociologist once described the designer as 'the man in the middle', that is, a figure mediating between manufacturers and the public. It follows that the designer's creative freedom is limited by a series of pre-conditions and constraints – financial, technical, temporal, aesthetic, etc. – imposed by the client and the market. Designing usually involves many compromises. It also means performing work upon determinate materials in relation to specific problems. Often, the task set is not the creation of something new but the redesign of an old product. Perhaps the unique ability of the designer is to synthesize. It is in this context that the qualities of imagination, inspiration, invention and intuition play their part.

When emphasizing the social nature of human beings there is a danger of giving the impression that 'the social' is a kind of straitjacket, when of course what limits also *enables*: it is the shared, social phenomenon of language which enables people to communicate and to write poetry. Even as social beings individuals vary; they are capable of dissent and creativity, consequently it would be wrong to present designers as either completely free agents or as robots whose actions are totally determined by external powers. The historian's task is to analyse the degree of freedom enjoyed by designers in practice; and this varies from place to place, from time to time, and from commission to commission.

A final point about 'the social'. Since it embraces all human behaviour, it necessarily includes the bad as well as the good, that is, the kind of behaviour we call 'anti-social'. While all design takes place within society, it seems essential to preserve a distinction between *socially beneficial* and *socially detrimental* design (hence 'anti-social' or 'anti-human design') even though, of course, people disagree as to what is beneficial and what is detrimental.

When the word 'social' occurs within the discourses of design and design history it is invariably used in the sense of socially beneficial. A debate about the social nature of design and the social responsibilities of the designer took place in April 1976 at the Royal College of Art at a symposium organized by the International Council of Societies of Industrial Design. The proceedings were published as *Design for Need: the Social Contribution of Design* (1977). The idea of human needs or demands is equally problematical: can one distinguish between true and false needs, between real, authentic needs and those fostered by modern marketing and advertising? Peter Lloyd Jones, one of the contributors, writes of a group of designers 'who reject the idea that design should be, as it usually is now, "a secondary activity responding to the needs of governmental and industrial organizations who are largely responsible for the initiation of design and the formulation of briefs". They claim that many human needs, even some of the most important ones, are ignored by industry and government alike. The problems they want to solve simply never turn up in the briefs they are given. These designers, who see themselves as itinerant problem-solvers to society at large, feel that designers themselves must initiate design activity in direct response to their own perception of human needs.'[6] Another contributor, Mike Cooley, described ideas for new, socially useful products generated by the workforce of the British company Lucas Aerospace. The workers in this company were faced by structural unemployment. Cooley writes: 'we saw that when society doesn't want the products that you make, the morale of a workforce making those items very quickly declines. We therefore evolved the idea of a campaign for the right to work on socially useful products.'[7] In this instance, therefore, there was a grassroots attempt to fulfil the human needs of both producers and users.

Marketing the Designer

One reason for the tenacity of the 'great designer' syndrome in the discourse of design, despite endless critiques of it, is that the ideology of individualism and the Romantic conception of the

artist remain potent in business and the mass media, amongst designers and consumers. Designers are thus promoted as charismatic figures as a means of selling goods. Batches of products are endowed with labels carrying the name of an individual 'author' (the equivalent of the artist's signature on a series of canvases) even if the label is, in reality, a trademark, even if the products in question are the work of a team, a fashion house or a corporation.

Modern industry's mass production capability makes available to the populace large quantities of identical consumer goods. This means that many people will drive the same type of car, wear the same type of clothes, etc. For supporters of individualism this poses a problem because they associate commonality of dress and lifestyle with totalitarian regimes hostile to personal freedom. They value what differentiates people, not what they share. They desire an exclusivity incompatible with mass prodution and consumption. (The only truly individual goods are, of course, those which are one-off, tailor made, and which depart from all existing styles and conventions.) Manufacturers and designers negotiate this problem in various ways, one of which is designer-named goods.

Meanwhile, on the consumer's side, advertising seeks to persuade customers that by *choosing* certain goods they will be expressing themselves and exercising individual taste even though thousands of other customers may be making the same 'individual' choice. Such paradoxes arise because there is a deep-seated refusal in our culture to recognize the contradiction between the ideology of individualism on the one hand, and the mass production and democratization of goods, on the other.

Designers as a Professional Group

In one sense the concentration upon the designer which has hitherto been criticized is justified, because although all human beings participate in design to some extent, only a tiny minority become professional, full-time designers. The existence of designers as a particular occupational group is, of course, the consequence of centuries of development, the division of labour,

and the specialization of function associated with the growth of human knowledge, industry and the emergence of ever more complex societies. In the person of the designer the power of planning and conception which all humans possess has been concentrated. Once could say the designer has virtually monopolized this power and by so doing has diminished the ability of the majority to influence the design of goods, services and environments. Concerned professionals periodically attempt to overcome this alienation – by means of public participation, community architecture, and so on – but it remains a difficult problem to solve.

While there are sociological studies of artists and art students, so far as I am aware comparable studies of designers (as a particular social group) have yet to be undertaken.[8] One category of designers has, however, attracted the interest of design historians, namely the consultant designer. Witness F. Mercer's 1947 book *The Industrial Design Consultant* and P. Sparke's 1983 book *Consultant Design: the History and Practice of the Designer in Industry*. Texts such as these are not concerned so much with individual designers as with the particular social role or function they fulfil in relation to industry.

Histories of Design Teams

In the twentieth century design has often been the result of a team effort rather than an individual achievement. Small groups of young designers and architects have repeatedly joined forces to found agencies, partnerships and practices. In this way they can offer clients a wider range of skills and specialist knowledge, they can share office and advertising expenses, and they can handle larger volumes of work. Several accounts have been written about a famous British example – Pentagram – founded in 1972 by five designers: Theo Crosby, Colin Forbes, Alan Fletcher, Mervyn Kurlansky and Kenneth Grange.[9]

A text devoted specifically to the topic of group practices is Michael Middleton's *Group Practice in Design* (1967). After a general discussion of the benefits and problems of such collaborations, the author reviews a number of examples which

range from the design of tractors to buildings, from the interiors of ocean liners to the production of a television serial. Middleton believes that designers cannot work successfully in teams unless they share 'a common language of appearances' (an aesthetic programme?). He also makes the point that distinct design teams from different specialisms can combine forces to tender for particular projects, for example, a team of engineers and a team of architects.

During major projects small architectural practices can expand considerably. Richard Rogers Associates, for instance, employed 30 to 40 architects and engineers while designing the Lloyd's Building in London. A structure designed by such a large number cannot surely be credited to the creative genius of a single individual – Rogers – however dominant he may have been. One presumes that in such cases the chief designer's contributions involve a major input into the overall conception and, later, synthesis and coordination.

Teams of designers have also been established by large industrial companies, particularly motor car manufacturers. For instance, the American giant General Motors once had five design studios (one for each division of the company). As Stephen Bayley's *Harley Earl and the American Dream Machine* (1984) records, Earl took charge of 50 staff when he was appointed 'Head of Art and Color' in 1927; when he retired in 1959 that figure had risen to 400.

Any design historian who regards the issue of individual contributions to team projects as crucial is faced with the task of discovering exactly who did what. Essentially, this is the venerable skill of connoisseurship and art history: making correct attributions.

Entrepreneurial and Company Histories

Within the discipline of art history, patronage is an important subject. It is one which undermines the idea that artists are totally independent beings because patrons have frequently contributed to the decision-making involved in the production of art. Patrons can be wealthy individuals or groups of people (organizations

and institutions). In the realm of craft, architecture and design there are still individual patrons but the majority of commissions derive from commercial firms and public bodies. Sometimes, the latter are led by enlightened entrepreneurs who are enthusiastic supporters of design. A well-known example is Frank Pick (1878-1941), the commercial manager of the London Passenger Transport Board, who did so much to improve the design of the city's underground system in the 1930s, as C. Barman's *The Man who Built London Transport* (1979) recounts. Histories of such entrepreneurs and of companies who employ designers are, therefore, the equivalent in design history of studies of patronage in art history.

The company history is a genre of history-writing which shifts the emphasis from the individual designer to a more collective design process. A large company may employ teams of 'in-house' designers and/or a succession of freelance, consultant designers, and as a consequence its design profile and corporate image are not individual achievements but collective ones which evolve and change over time. Examples of such histories include: Alfred Sloan, *My Years with General Motors* (1965); L. Whiter, *Spode: a History of the Family Factory and Wares* (1970); G. Rees, *St Michael: a History of Marks & Spencer* (1969); B. Phillips, *The Habitat Story* (1984); Akio Morita and others, *Made in Japan* (1986) (the Sony Corporation); P. Kleinman, *The Saatchi Story* (1987).

Texts such as these generally blend some social and economic history with the history of trade, business, management, marketing, invention and product innovation. Well-researched company histories can provide the design historian with essential contextual information but they can suffer from two limitations: first, a lack of critical evaluation and objectivity (some accounts are little more than public relations exercises which flatter the company and ignore its failures and any anti-social or corrupt activities; they are often commissioned by the firm or written by its managing director; they are even, at times, published by the firm in question); second, a dearth of information about the role of design in the success or failure of the company (unless, of course, the company concerned was founded

by a designer: Terence Conran's 'Habitat' chain of stores is a case in point).

It is perhaps necessary to distinguish between the design of a company's products and the design of its corporate image, that is, the difference, say, between the goods manufactured and the company's logo, letter headings, truck liveries, and so on. Of course, the two are usually intimately linked because the firm's visual identity is normally stamped on all it produces. Nevertheless, corporate design is a topic in its own right, as books such as *Design Co-ordination and Corporate Image* (1967) by F. Henrion and A. Parkin, and *The Corporate Personality* (1978) by W. Olins and M. Wally, testify.

Officially commissioned company histories will almost inevitably represent the company from the point of view of its owners or management. A very different perspective of the same organization may emerge if one descends to the shop floor and listens to the experiences of employees. To cite just one example: in 1978 *History Workshop*, a journal of socialist historians, published the memories of Arthur Exell, a car worker for 48 years, of life in the Morris Motors factory, Oxford, during the 1930s. Such accounts may include little that is directly about design, but the historian can glean many details of factory layout, assembly methods and management/labour relations from them.

Studies of particular trades encompass the histories of many companies and their employees. A notable recent example was the exhibition 'Furnishing the World: the East London Furniture Trade 1830–1980' held at the Geffrye Museum, London, in 1987 (a book by Pat Kirkham was published to accompany the exhibition). This show was particularly valuable for its documentation of the conditions of production and employment in the many small workshops of the East End, of the several crafts involved in the making of cheap furniture, of the various types of poorly paid labour – skilled and unskilled – upon which the trade depended. A trade of this kind was half-way between craft and industrial manufacture; it could survive only for a limited period while certain geographical, economic and technological conditions prevailed. Designers as such were not normally

employed. Designs were based on past examples and copied from photographs, other firms' catalogues and West End shops.

While it is essential to establish the context within which design occurs, there is a danger in trade histories that so much attention will be given to economic, social, labour and market issues, that little space remains for questions of design and style in their own right.

Designed Goods as the Object of Study

> It is obvious that the new Citroën has fallen from the sky inasmuch as it appears at first sight a superlative *object*. We must not forget that an object is the best messenger of a world above that of nature: one can easily see in an object a perfection and an absence of origin, a closure and a brilliance – a transformation of life into matter ...[10]

Roland Barthes' remarks concerning the impact of a new car call attention to the aura with which goods can be endowed when displayed under spotlights at motor shows. Many advertisements and illustrations in design books convey the same impression. They present industrial products as if they were precious works of art: isolated from people and the everyday environment, surrounded by a halo of light, the designed object becomes a fetish. In design history too a fetish is made of the designed object as indicated by books such as *One Hundred Great Product Designs* (1970) and *Cult Objects* (1985). Goods, products and appliances of all kinds are, undoubtedly, of major importance to design historians. The appeal of washing machines, cars, shoes, chairs, telephones and so forth is easy to understand: they are discrete, concrete entities which make highly convenient research materials. Unlike the thoughts of a designer, the tastes of a consumer or the influence of a design institution, they can be seen, touched and photographed.

Nevertheless, it would be mistaken to equate *the study of a designed object* with *the object of study of design history* for the following reasons. First, in order to understand a product the historian's research has to extend well beyond the limits of

the object itself, to the design process of which the object is simply the end-result, for example. Second, design historians are interested in such phenomena as styles and while these are perceived as qualities of objects, they cut across the autonomy of individual items. Also, in the fields of architectural and environmental design, historians often study not single buildings but extended areas such as housing estates, shopping malls and whole cities, which consist of a disparate assembly of things. The historian, in these cases, is concerned with design as diffused throughout the whole system rather than as distilled in a solitary artefact. Third, design historians are concerned not so much with single objects as with groups of objects arranged in types and series and in the relations *between* those objects and the people who make, use and profit from them. Four, since design historians are *historians* it is the *history* of designed objects which concerns them, that is, objects in particular periods and social contexts, objects undergoing changes through time.

To elaborate on point four: the complexity of the task of describing and explaining change in design can be discerned even if we restrict ourselves to the example of a single product type. A type of artefact can alter over time in several respects both quantitatively and qualitatively:

(1) A product-type can be invented; it can also cease to be made.

(2) It can increase in numbers, then remain in a steady state, or decline in numbers. A 'population' of objects can oscillate in size, alternately growing and declining.

(3) Products can remain in one area or they can be dispersed ever more widely.

(4) A type can change its form by means of gradual, cumulative additions, variations and improvements or by means of more drastic periodic revisions. Such revisions may transform the type to such an extent that it crosses a threshold and becomes a new product-type. By the addition of features products can become more complex; they can also be simplified. They can oscillate between the poles of complexity and simplicity.

(5) A product can be combined with others so that it becomes an element in a larger assembly.

What archaeologists and anthropologists have tried to do when considering artefact populations over long periods of time is to identify any patterns or regularities in the data, such as cycles or increases in the pace of change, and then to seek explanations of them. This process has at times involved the use of graphs and charts to present the data and plot any results. Since most design historians have been trained in the humanities rather than the social sciences, the techniques for manipulating data routinely employed by social scientists are unfamiliar to them.

It follows from the above that the designed object is simply the nexus of a whole series of relationships which it is the task of the design historian to explore. The designed object is one starting point or focus for research, not its ultimate destination. This view is shared by Jean Baudrillard, who writes:

> The empirical 'object', given in its contingency of form, colour, material, function and discourse ... is a myth ... the object is *nothing*. It is nothing but the different types of relations and significations that converge, contradict themselves, and twist around it, as such – the hidden logic that not only arranges this bundle of relations, but directs the manifest discourse that overlays and occludes it.[11]

There is no intention here to deny the materiality of designed goods, but I would argue that artefacts are more than physical things: they are also ideological phenomena. They are ideological in two respects: (1) a designed product consists of materials which have been *organized* in a specific way to serve specific human purposes, its organization or form or design is not a substance in the same sense as the physical materials from which it is made (it is also worth adding that if the materials humans need are not to be found ready-made in nature, new ones can be invented); (2) immediately products are bought and used they gain symbolic or signifying dimensions, they begin to communicate meanings and values. For instance, people who own the

most expensive cars not only tell the world what kind of transportation they possess, they also indicate their high social status and/or wealth. Any departures from the standard product, such as additional decoration, will communicate further information about the owner's individual tastes. To capture the doublesidedness of artefacts the Soviet literary theorists P. Medvedev and M. Bakhtin devised the expression 'object-sign'.[12] Appropriately, the word 'design' includes the word 'sign'.

Depending upon the nature of the economic system within which they are produced, designed goods acquire yet further non-physical characteristics. Within capitalism, for instance, the majority of goods enter a marketplace where they gain *exchange-values* in addition to their *use-values* dependent upon their physical attributes. In other words, they become *commodities*. At first sight it might seem that this economic fact has nothing to do with the design of consumer goods, but when manufacture takes place with the marketplace in mind, then this can indeed influence how they are designed.

In *The Codes of Advertising* (1987) Sut Jhally observes that when goods appear in the marketplace, information about how they were designed and manufactured is not normally available, with the result that the social relations of production which gave rise to the artefacts in the first place are concealed. (The Barthes' quote made the same point.) Our perception of such goods and our behaviour towards them could certainly be changed if we learnt from other sources that they were, say, made by exploited child labour in a Third World dictatorship, that they used up scarce non-renewable resources, and so on. One valuable function the design historian could perform is precisely to reveal such hidden relations. Jhally goes on to argue that the lack of information about production creates a meaning-gap which in consumer societies is filled with *advertising*, hence the real is hidden by the imaginary.

When the whole spectrum of products generated by a modern industrial society is considered, it becomes evident that design historians feel more at home with some kinds of designed objects than others. They manifest a preference for consumer durables. These are artefacts which last several years, so one can understand

why scholars tend to concentrate upon them rather than upon the multitude of non-durable products also generated by modern consumer societies. Ignoring the latter causes a lop-sided account of design. Contemporary snack foods, for example, are as much the consequence of research and design as more permanent goods, and they too deserve the historian's consideration.

Making a fetish of the *physical* object also unnecessarily limits the discipline's potential subject-matter. Besides physical artefacts there exist what have been called 'mentefacts', that is, conceptual systems and structures (logic systems, computer programs, educational courses, stacking structures for aircraft above airports, etc.) which also involve design. Mentefacts are frequently ignored by design historians because they lack the tangibility of objects like typewriters and chairs.

Object-centred histories or guides can be linked to two social developments. First, the growth of design museums and exhibitions which find objects convenient things to collect and display. Curators want to document their collections as fully as possible, so research accretes around the objects. Secondly, the growth in the market for second-hand designed goods, especially those which can be attributed to famous designers. This tendency reproduces the connoisseurial tradition of art history which serviced private collecting and the antique trade. The collecting/connoisseurial approach to design concerns itself with questions of aesthetics, attribution, monetary value and the pleasures of collection and possession. It can generate much useful information but no adequate history of design can be based on this approach.

The Canon

Once a number of histories exist which celebrate more or less the same set of 'great' or 'pioneer' designers and their 'classic' or 'cult' objects it is fair to say that a *canon* has been established comparable to those canons of great artists and masterpieces found in literature, music and the visual arts. Critics of such histories do not wish to deny that there are qualitative differences

between designers and between products, but they argue that the geography of a mountain range cannot be understood in terms of peaks alone. (It is surely necessary to include bad and mediocre examples in order to reveal qualitative differences by comparing them to the best.) Also, they question the process by which the canon comes into being: it is a historian's construction not a natural phenomenon and some wonder why, for example, the pantheon of designers includes so few women.

Critics of the canon suspect, too, that a simplistic conception of history underlies it, that is, the 'relay race' conception: the baton of genius or avant garde innovation passes from the hand of one great designer to the next in an endless chain of achievement.

Few design historians have reflected on the nature of the canon and studied the critical labour involved in its reproduction. One who has is Juan Bonta. His book *Architecture and its Interpretation* (1979) traces, via a case-study of the critical reception of Mies van der Rohe's 1929 Barcelona Pavilion over several decades, the process of canonization in action. To generalize from this example: the first stage, Bonta demonstrates, is pre canonical: the work is increasingly mentioned, praised and predictions are made in the professional literature as to its future canonical status. When a single positive interpretation/evaluation crystallizes within the scholarly community, the work attains canonical status. Bonta argues that pre-canonical interpretations are the most creative. Once the work is fixed in the canon initial insights tend to be lost or blurred as they are regurgitated by commentators at some distance from the original. Works which fail to achieve canonical status are weeded out and forgotten; they then become invisible. Canonization is followed by a dissemination phase in which the authoritative interpretation of the specialists is conveyed to a wider public via popular articles and textbooks. After this there are three possibilities: the work may become a cultural monument beyond the reach of criticism, or it may suffer a decline in reputation and be forgotten, or it may be subject to re-interpretation and re-evaluation by a younger generation of critics examining it from new perspectives.

The Design Process as the Object of Study

A plausible case could be made for the contention that the central focus of design historians ought to be *the process of designing* because designing is the heart of the subject. Any process is, of course, much harder to observe than a finished product. Processes take time - perhaps years in the case of a major architectural project - and they are, to some extent, hidden from view: the ideas and unconscious inspirations of designers are not readily accessible to the historian. Also, in the case of certain sensitive products - military weapons for instance - official secrecy may prevent access to the necessary information and personnel. None the less, pictures of industrial design processes can be built up from clients' briefs, notes of product planning meetings, sketches, working drawings, models, interviews with designers and so forth.

In some cases the design process relating to particular products has been documented from start to finish. An exhibition was mounted at the Boilerhouse, London, for example, in 1983 which traced the evolution of the Ford Sierra car from inception to completion: 'The Car Programme: 52 months to job one or how they designed the Ford Sierra'. Similarly, Graham Robson's *Metro: the Book of the Car* (1982) recounts the story of the British Leyland £270 million project which culminated in the launch of the Metro in October 1980. (Robson, incidentally, is not an academic historian but a motoring journalist and motor sport enthusiast.) Bryan Appleyard's sophisticated 1986 biography of the British architect Richard Rogers also contains a great deal of detail and insight into the long-drawn-out design processes involved in the construction of major structures such as the Pompidou Arts Centre in Paris and the Lloyd's building in the City of London.

Even better than exhibitions and books for recording processes are, of course, the moving-image media of film and video. Hence the value of films and TV programmes about design.

Relevant to any historian interested in the design process is the growing body of literature on what is termed 'design methods'. This literature represents the reflections of practitioners and

theorists on designing. Their aim in making the methods used explicit and discussing their various strengths and weaknesses is, of course, to make designing more effective and scientific.

Design Institutions as an Object of Study

Institutions are organizations founded to promote particular purposes. They can be formal structures with premises and permanent staff or they can be more informal networks of like-minded people. Within the field of design several types of institution exist and there is a small body of literature devoted to them. Writings on design institutions are relevant here because they extend the object of study beyond designers, products and processes.

There are histories of museums with design collections such as the Victoria and Albert Museum and the Museum of Modern Art in New York; histories of schools of design (in general) and of single educational establishments such as the Bauhaus, Ulm and the Royal College of Art; and histories of organizations concerned with the promotion of design such as the Design Council in Britain and the Deutscher Werkbund in Germany. In addition there are more wide-ranging surveys, for instance, Richard Stewart's *Design and British Industry* (1987). This book concentrates on the efforts of institutions to improve the quality of design of British products. It includes accounts of the Royal Society of Arts, the Design and Industries Association, the British Institute of Industrial Art, the Council for Art and Industry and the Design Council. As minor themes it also discusses design education and the role of exhibitions in promoting design.

Three dangers beset institutional histories: (1) boredom – accounts of the doings of bureaucrats and officials can be very tedious; (2) an uncritical identification with the assumptions and policies of the institutions under review; and (3) a failure to situate them in the larger context of social and economic change.

Necessarily, the study of institutions shifts the emphasis away from products and individuals, though this is not to deny that

certain forceful individuals have a strong impact upon the direction or policies of institutions. Institutions are run by groups of people cooperating and/or disputing. Relations of power usually exist between them and the organizations of the state. Some carry out government policies but others pursue different ideals. During the 1930s a conflict arose between the aims of the Bauhaus and those of the Nazi regime, with the result that the design school had to close.

Institutions - especially public ones - have to define and make known their objectives and policies. They tend, therefore, to generate many documents. These records can provide the historian with valuable sources of information about changing attitudes towards design. Hans Wingler, for example, established a Bauhaus archive in 1961 which is now housed in a purpose-built museum, designed by Walter Gropius, in West Berlin.

Measuring the success or failure of an institution remains problematical: has the Design Council and its exhibition centre in London really managed to improve the standard of British design and public taste? In the absence of a control, how can one tell? The case of the Bauhaus is more clear cut. No design historian is likely to disagree with the opinion that it has had a tremendous influence upon twentieth-century art education, architecture and design. It is easily the design school with the greatest volume of books, articles and memoirs devoted to it.

Aside from official institutions, significant contributions to the discourse of design can also be made by informal, short-lived groups such as the so-called 'Independent Group' (IG) - British artists and intellectuals - who met at the ICA, London, for a time in the early 1950s. Their small discussion meetings and later articles on design and mass media were to have a surprising impact upon the development of British visual culture. (Reyner Banham was a member of IG, as was Richard Hamilton, the pop artist. Hamilton wrote a series of papers on aspects of design and mass media that were as intelligent and perceptive as those of any professional design critic.)[13] As a result, the IG has been the subject of intensive research on the part of certain scholars for a number of years.[14]

It is clear from the above that the overriding interest of design

institutions is their role as ideological battlegrounds, as the sites where different ideas about design are made explicit and struggled over. Institutional studies are to be welcomed because they add another layer of complexity to the object of study but, even so, they only represent a step in the right direction. A comprehensive picture, it is proposed, can only be achieved by situating studies of designers, goods and institutions within a broader field of research, one capable of displaying, systematically, the relationships between all the various elements involved. Accordingly, it is to such a model that we now turn.

Notes and References

1. N. Hadjinicolaou, *Art History and Class Struggle* (London: Pluto Press, 1978) pp. 35-43.
2. G. Kubler, *The Shape of Time: Remarks on the History of Things* (New Haven: Yale University Press, 1962) p. 6.
3. R. Dyer, *Stars* (London: BFI, 1979) pp. 172-81.
4. M. Foucault, 'What is an author?', *Screen* 20 (1) Spring 1979 pp. 13-33.
5. K. Marx, *Introduction to the Critique of Political Economy* (1857-9). See also Janet Wolff, *The Social Production of Art* (London: Macmillan, 1981).
6. P. L. Jones in J. Bicknell and L. McQuiston (eds), *Design for Need* (Oxford: Pergamon Press, 1977) p. 91.
7. M. Cooley in *Design for Need* p. 96.
8. See, however, Peter York's humorous account of graphic designers or 'gridniks': 'Chic graphique', *Modern Times* (London: Heinemann, 1984) pp. 26-37. See also Andrew Saint, *The Image of the Architect* (New Haven: Yale University Press, 1983).
9. See *Pentagram: the Work of Five Designers* (London: Lund Humphries, 1972) and P. Gorb (ed), *Living by Design: Pentagram* (London: Lund Humphries, 1978).
10. R. Barthes, *Mythologies* (London: Cape, 1972) p. 88.
11. J. Baudrillard, *For a Critique of the Political Economy of the Sign* (St Louis: Telos Press, 1981) p. 63.
12. P. Medvedev and M. Bakhtin, *The Formal Method in Literary Scholarship* (Baltimore: Johns Hopkins University Press, 1978).
13. See R. Hamilton, *Collected Words* (London: Thames & Hudson, 1982).
14. See A. Massey and P. Sparke, 'The myth of the Independent Group', *Block* (10) 1985 pp. 48-56; and A. Massey, 'The Independent Group', *Burlington Magazine* CXXIX (1009) April 1987 pp. 232-42.

5

Production-consumption Model

The bulk of the literature on design consists of 'partial' studies in the sense that there are books on designers, products, styles, design education, etc., but what is lacking is a general account of how all these specific studies interrelate and, taken together, constitute a coherent totality. A general model of the production, distribution and consumption of design can be presented diagramatically. Such a systematic representation makes clear the logical relationships and connections between the various elements. One advantage of this kind of model is that it enables us to see at a glance where a particular study belongs and to identify those topics which currently receive little attention.

A general model is necessarily highly abstract. No doubt it would need modifying when applied to any particular country. The model is not completely a-historical: it was designed with modern Western society in mind (1700-1980s), the era of the capitalist mode of production, so it would need to be changed drastically to apply to a tribal or feudal society. (Some degree of applicability to the latter is presumed because of the fundamental importance of production and consumption to human life.) How applicable it is to non-capitalist societies such as Cuba, China and the Soviet Union is also a moot point.

In Figure 2 the processes of design, production and consumption are treated as a fairly autonomous system, although it is obvious that these processes take place within a wider social environment. (Therefore we should always speak about design *within* society, rather than design *and* society.)

Any specific application of the model would need to take account not only of the boundaries which ensure design's relative autonomy but also the interactions between the microsystem and its encompassing macrosystem. A general economic recession or boom would affect the sphere of design, as would more minor changes such as revisions in the laws relating to safety standards.

Within the capitalist mode of production more than one type of production occurs and some of these depart from the dominant mode. For instance, the handicraft mode typical of feudalism to some extent persists in the era of mass industrial production, even though its status *vis-à-vis* the dominant mode is anachronistic and marginal. Design in terms of an industrial system of manufacture, rather than craft production, is the subject of the illustration.

Orthodox Marxism employs a base/superstructure model to account for the structure of society in which a material foundation supports an ideological superstructure:

SUPERSTRUCTURE $\left. \rule{0pt}{40pt} \right\}$ <u>ideology, culture</u>

BASE economics, technology

In the final analysis, Marxists argue, it is the base which determines what happens in the superstructure. Design cuts across the divide between these two realms because it is clearly part of the economy, part of industrial production and technology, but, equally clearly, it is an ideological phenomenon involving ideas, feelings, creativity, tastes, styles and so forth.

In Figure 2, for the purposes of exposition and clarity, the two processes of production and consumption are treated separately in a linear, sequential order, but it should be recognized that in practice the two processes are interdependent. As Marx explains in *Grundrisse*, production and consumption, together with distribution and exchange, are simply separate moments in a totality, a cyclical system. Their reciprocal nature is indicated by Marx as follows:

Without production, no consumption; but also, without consumption, no production; since production would then be purposeless ... Production mediates consumption; it creates the latter's material; without it, consumption would lack an object. But consumption also mediates production, in that it alone creates for products the subjects for whom they are products. The product only obtains its 'last finish' in consumption ...

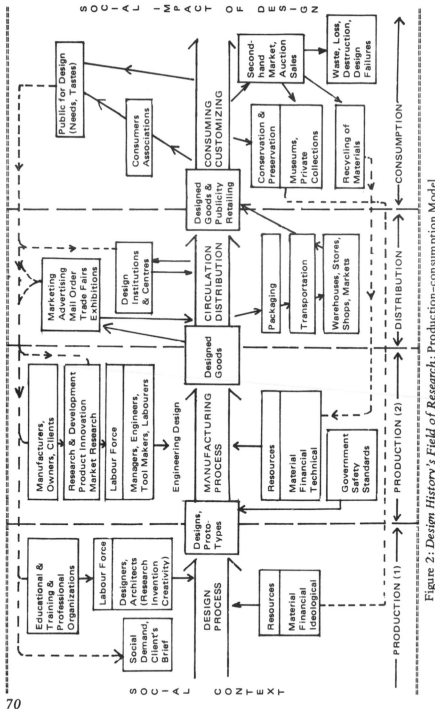

Figure 2: *Design History's Field of Research*: Production–consumption Model

70

Notes

1. Figure 2 is divided vertically into four sections representing different phases: production of a design; production of designed goods; distribution; consumption. The horizontal axis is thus one of time. Each process takes time and the sequence of events is logically ordered. One cycle of events is represented by the diagram. The actual length of cycles depends, of course, on the type of product being manufactured.

2. The dotted lines indicate the relative autonomy of the design realm. This signals the permeability of the boundary between micro and macro systems.

3. The reciprocal nature of production and consumption is indicated by various feedback lines which reveal, for example, the influence of the tastes of consumers upon the design process.

4. Figure 2 begins with the assumption that there is a social demand for design, otherwise it would not exist. This demand may be manifested by a specific commission to a designer or design team by a manufacturer, public utility or government department, or it could be a private initiative in which a designer devises a design or invention speculatively.

5. During the phase of production two labour processes occur. At the end of the first there is a design and, at the end of the second, a designed product. Both processes mobilize various forces and resources.

6. The particular labour force – designers – brought into existence by the division of labour and specialization of knowledge need to be trained, hence the inclusion of art and design colleges, architectural schools and so on. Architects and designers also form and join various professional and trade organizations which promote and regulate their activities.

7. Resources can be divided into three categories: (1) material (premises, plant, machines, tools, raw materials); (2) financial (fees, capital, loans, income); (3) aesthetic-ideological (skills, techniques, image banks, graphic conventions, styles, earlier designs, theories such as functionalism and modernism).

8. In Figure 2 the design process is separate from the manufacturing process. This represents the situation where a firm commissions a freelance designer or design team to undertake a specific task. However, in large firms such as motor car companies, design may be 'in-house', though even these usually have separate design departments. In car manufacture it is not only the

vehicles which have to be designed but also the machines, the tools and the factories to make them – so engineers employed by the company or other subsidiary companies also engage in design.

9. Design is not mentioned in the distribution phase even though, of course, advertisements have to be designed, as do transportation vehicles and systems, exhibitions, shops, stores, supermarkets and mail order catalogues. This indicates that a great deal of design takes place between manufacturers, between different businesses, rather than for the public directly.

10. The consumption or reception phase. Consumers and users of designed goods are not a homogeneous mass – people are differentiated according to sex, age, race, class, religion, politics, nationality, region, occupation, language, family status, education, wealth, tastes, interests, etc. Manufacturers generally seek to 'target' potential consumers and their marketing departments use various systems of classification to assist this process, for example, crude categories AB, C1/2, DE, representing social groups according to a descending scale of income and social status.

During the consumption and use of designed goods a process of 'reading', interpreting and critical evaluation can be said to take place (decoding the meanings, stylistic references, connotations and practicality of the design). Perceptual, aesthetic and emotional responses are involved. It follows that the insights of aesthetics, psychology and psychoanalysis could be fruitful at this point.

11. Finally, it is assumed that design has an effect, for good or ill, on society as a whole. Design's total impact on the quality of life is, of course, very difficult to measure, though it becomes obvious in particular instances especially when poor design results in a disaster of some kind.

12. Since Figure 2 represents a 'steady-state', cyclical model, it does not explain how innovation and radical change comes about. Such changes are the result of either alterations in the external environment – wars, revolutions, economic crises – or those internal to commodity production – saturated markets, customer boredom, falling sales due to the competition of rival firms.

13. Since the model only concerns itself with professional design, the designing which all people do to some extent is ignored, apart from the inclusion of customizing in the consumption phase.

because a product becomes a real product only by being consumed.[1]

Furthermore, each process includes its opposite; that is, in the course of production, labour-power, tools and raw materials are used up, 'consumed' (Marx calls this process 'productive consumption'). And in the course of consuming (e.g. food) human beings produce themselves (hence the term 'consumptive production').

A material which is the culmination of one process of production often serves as the raw material for a second process of production in which it is used up. It follows that whether something is regarded as production or consumption depends upon the viewpoint adopted: a computer, from the point of view of the designer, is a design tool, an aid to production; but from the point of view of the computer manufacturer, the designer is a consumer or user of computers. Despite the duality of the two processes, Marx is inclined to assign priority to production, in part because production 'produces not only the object but also the manner of consumption'. Whether this remark still applies today is debatable. recent design and production is often said to be 'consumer led'.

Note

1. K. Marx, *Grundrisse: Foundations of the Critique of Political Economy* (Harmondsworth: Penguin Books, 1973) pp. 90–4.

6

General Problems of
History-writing

Since design history is a branch of the discipline history, design historians encounter in their practice the same basic methodological and theoretical problems as do all historians. The study of these problems is known as 'historiography'. Historians have been reflecting on their discipline for a long time, so a mass of literature and a complex body of theory now exists.[1] All that is feasible here is a summary of some of these fundamental issues.

History and Histories

From the point of view of clarity it is unfortunate that the word 'history' has two meanings: first, those events which actually happen and secondly, writings about those events. History (in the second sense) is a discipline whose object of study is the behaviour of human beings, human societies through time. Natural forces and events have also to be considered, to some extent, because they clearly shape human action.

Historians writing about times before living memory must necessarily rely for their information on objects, documents and other kinds of evidence surviving from the past. Using this material as a basis, historians attempt to reconstruct what happened and why. This activity has been called 'retrodiction' (i.e. the opposite of 'prediction'). Since the historical reality described in such reconstructions can never be known to the scholar or reader directly, judging the truth or accuracy of histories is highly problematical. Even when two historians agree upon the facts, they may not agree about the significance to be attached to them.

Although historical reconstruction is based upon evidence which has survived destruction, the aim of that reconstruction is, of course, to describe people, events and social formations which

no longer exist. The first responsibility of design historians is, therefore, to reconstruct the meanings and significances which designed goods had for those for whom they were made. However, their task does not end there because it is also important to trace their subsequent history and consider what meanings, if any, they have for people now.

Only some of the artefacts which a society produces survive into the future. Some survive in greater numbers than others – because they were made of precious metals, more durable materials, or were habitually hidden underground – thus creating, at a future date, a partial picture of the original culture. Similar kinds of 'distortion' can occur if the authority of ancient documents and their authors is not regarded sceptically. Furthermore, documents can lie; they may even be later forgeries. The unavoidable reliance of the historian upon the artefacts of the past has always to be tempered by a sense of the inevitable gaps and biases in the record. Wherever possible, evidence should be cross-checked.

Facts and History-value

Every recorded item of information, however trivial, is a fact surviving from the past. Billions of facts are available to scholars but not all can be cited in a history, not even a history of the world. A drastic process of selection has to take place. In order to be selected a fact must be considered significant in some way and significance varies according to the conceptual framework and objectives of the historian. Facts do not speak for themselves, they have to be contextualized, evaluated and interpreted. Speculation and theories about what happened in the past drives historians to search for further information to confirm or refute their ideas. And the discovery of new facts modifies or overturns existing theories. It is a continuous, reciprocal process. All conclusions reached are provisional in the sense that new evidence may cause them to be revised.

Incidents considered important enough to be reported by the daily press are said to have news value. It is obvious from the varying amounts of space allocated to different stories within

the same newspaper, and by different newspapers, that the news values of particular stories varies enormously. A similar process is at work in history-writing: different scholars assign different history values to the same facts or events. Although historians assign history values as they write, this does not mean that any construction will carry conviction. Some events are so cataclysmic they are recognized as important by virtually everyone. A general history of the twentieth century which omitted the two world wars and the Russian revolution, for instance, would be regarded as perverse, to say the least.

The Past/Present Distinction

Most historians assume that the dimension of time is uni-directional and irreversible, like the flight of an arrow. They also assume that the passage of time can be divided into three phases: past, present, future. (The idea of the present is, of course, relative to the observer: we think of this period as the present age while the people of Renaissance Italy thought of their time as the present.) What concerns us here is the past/present distinction.

This distinction is often used to justify the division of labour between critics and historians: the present is the concern of the critic, and the past the concern of the historian. Historians are generally thought incapable of writing the history of their own times because the closeness and involvement of historians in the material precludes scholarly objectivity. There is certainly a problem here but there are also advantages: the easy access to information; the fact that the historian can draw upon first-hand knowledge and subjective experience of people and events. Since design history is a relatively new discipline and tends to focus upon the industrial design of the modern age, design historians frequently write about the present and the recent past.

If one asks 'When does the past begin – five minutes ago, five years ago, fifty years ago?', the arbitrariness of past/present distinction becomes obvious. It is also a line which is constantly being shifted forward as today becomes yesterday. The general

ideological function of the past/present distinction appears to be that it enables historians to situate themselves in an a-historical vantage point called 'the present' from which they can observe a historical realm called 'the past'.

What is valuable about this distinction is that it marks a recognition of difference: that human life was different then from now. Knowledge concerning the past can thus serve as a critique of present conditions; it can make the present seem less immutable. A disadvantage of the distinction is that it can deceive historians into thinking that their vantage point is outside history whereas, in fact, the present is part of an ongoing historical process; indeed the present is the culmination of a historical process. It follows that the present is not a privileged position which by itself can guarantee absolute objectivity. Historians writing about any period predating their own are, of course, remote from those periods, but since preceding epochs contributed to the very intellectual apparatus the historians are deploying, a total separation of the present from the past is impossible. What the historian needs to be conscious of are those differences which separate the past from the present, and simultaneously, those continuities which link the two.

The main advantage enjoyed by historians over critics may be called 'the hindsight advantage'. As the Belgian historian M. J. Dhont explains:

The historian never sees the facts in the way that the *contemporaries* saw them. He sees their development as an infallible prophet; what distinguishes the historian completely from any category of people who were contemporaries to the facts about which he speaks rests precisely in that the historian knows the future. This deprives him completely of the possibility of looking at the facts with the eyes of the contemporaries ... It follows from this remark that the historian always writes history as a function of the point of arrival of development. This will incline him to interpret as important those events which constitute a line of development towards

that result, events, which in a majority of cases, did not make the least impression on their contemporaries.[2]

Evidently, hindsight is a mixed blessing. It makes it difficult for historians to put themselves in the place of historic peoples, to judge how the conjunction of forces appeared to them at the time.

Chronology and Narrative

One of the earliest forms of history-writing – the chronicle – was based upon the idea of chronology: the arrangement of certain facts and events in a temporal sequence. Even today history books often include chronologies which take the form of charts listing events in date order. The chief drawback of such 'one damn thing after another' accounts is that a context and rationale for the listed items is missing. Readers are left with the impression of a random succession of events which seem to have no causes, meanings or connections.

Significantly, the word 'history' includes the word 'story'. The idea of narrative seeks to overcome the limitations of chronology by weaving brute facts and events into a coherent line of development and fleshing them out with sufficient contextual material so that the reason why things happen as they do becomes clear.

Hayden White, in his book *Metahistory* (1973), calls the process 'emplotment'. What the historian does, White maintains, is to arrange 'the events in the chronicle into a hierarchy of significance by assigning events different functions as story elements in such a way as to disclose the formal coherence of a whole set of events considered as a comprehensible process with a discernible beginning, middle and end'.[3] Some events, therefore, are characterized as 'inaugural motifs', some as 'transitional' and some as 'terminating'. As White points out, 'the same event can serve as a different kind of element of many different historical stories, depending on the role it is assigned in a specific motific characterization of the set to which it belongs.'

Because of the similarities between the techniques and devices of writing history, fiction and story-telling in films, the critical

examination of narrativity taking place in literary and film theory is being extended to history-writing.

What critics object to about the narrative mode is that it appears to depend upon an omnipotent storyteller whose single, linear tales with their clear beginnings, middles and ends are too coherent and comforting. Stories with transparent meanings, in which conflicts are resolved, seem to mystify the reality of human history. Other ways of writing history have thus been sought. Walter Benjamin, for example, advocated a discontinuous approach employing fragments ('the fragment is the gateway to the whole'), pastiche, aphorisms, quotations and 'constellations' (i.e. striking juxtapositions of images). Benjamin rejected the Rankean conception of history-writing as 'telling it the way it really was'; his alternative was 'to seize hold of a memory as it flashes up at a moment of danger'.[4] He also proposed a kind of archaeological excavation partly dependent upon a plan and partly a matter of chance: 'for successful excavators, a plan is needed. Yet no less indispensable is the cautious probing of the space in the dark loam ... remembrance must not proceed in the manner of the narrative or still less that of a report, but must ... assay its spade in ever-new places, and in the old ones delve to ever deeper layers.'[5]

For a brilliant application of Benjamin's notion of excavation see Dick Hebdige's essay on the history of post 1945 British culture and design, 'Digging for Britain' (1987).[6]

Synchronic/Diachronic

Historians have been characterized as those concerned with developments taking place through time. However, all historians have to pause now and then to describe what was happening simultaneously with the particular fact or event under review. In other words, historians tend to alternate between the diachronic (time, or chronological-evolutionary) and the synchronic (space, or descriptive-systematic).

These two terms were introduced by the linguist Ferdinand de Saussure in his influential text *Course in General Linguistics* (1916). A language, Saussure maintained, can be studied in two

ways: first, by looking at changes taking place through time; and secondly, by looking at a language as a logical system. The two modes of analysis are different ways of dissecting the same object of study. They are generally visualized in terms of a diagram with two axes (see Figure 3).

Figure 3: *Synchronic and Diachronic*

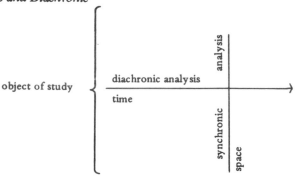

Nevertheless, Saussure held that the two perspectives were radically different: 'One is a relation between simultaneous elements' (the synchronic); and 'the other the substitution of one element for another in time, an event' (the diachronic).[7] Each approach, Saussure believed, generated different truths and therefore demanded different disciplines; scientific rigour would be lost if the two approaches were conflated or confused. He assigned priority to the synchronic perspective and as a result has been accused of neglecting history, even though his book includes a section on historical linguistics. One can argue that the two modes of analysis are interdependent. Only by comparing synchronic analyses of British society in, say, 1900 and 1950 would it be possible to judge what changes had occurred between those two dates.

Saussure's interest in the synchronic mode of analysis was based upon the premiss that to understand how any system works one only needs to examine the relationships between parts and the whole at a particular moment in time. A garage mechanic could certainly explain the operation of a modern car's engine to a customer without bothering to recount the history of the

evolution of motor car engineering. Historians need to know how systems function but they are also curious about their development. Books about design with a diachronic emphasis are common enough. Less common are synchronic ones. Michael Farr's *Design in British Industry* (1955) can perhaps be considered an example of this: it is a systematic survey of British industrial design and design institutions undertaken at a specific moment – the midpoint of the twentieth century. A text directly influenced by the linguistics of Saussure which is explicitly and self-consciously synchronic in its conception and method is Barthes' *The Fashion System* (1985). Wishing to analyse a particular state of fashion without having to consider the extra complication of change over time, Barthes confined his study to the written matter appearing in the magazines *Elle* and *Le Jardin des Modes* between June 1958 and June 1959. In his introductory reflections upon method, he remarks: 'the synchrony of fashion is established by fashion itself: the fashion of the year' (that is, the 'line' laid down annually).

If the diachronic can be said to be concerned with change and the synchronic with system or structure, then it is not simply a question of the historian alternating between the two modes of analysis but of explaining the relation between change and structure. As Peter Burke remarks: 'Change is structured, and structures change.'[8]

The Prague Prism

A tourist visiting a long-established European city will notice that although all the buildings exist in the present, they differ in their ages and styles. Ancient Gothic piles stand next to ultramodern office blocks. Such cities can be regarded as a spatial display of the history of architecture.

To represent the way in which material from the past is carried forward to be experienced subjectively as simultaneous and coexistent J. Mukařovský (of the Prague school of structuralism) devised a diagram called 'the Prague prism' (Figure 4) to supplement the cross-design of Saussure.

Figure 4: *The Prague Prism*

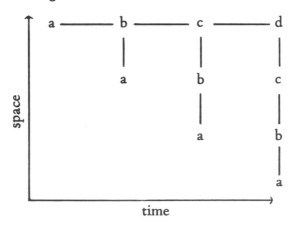

time

One misleading feature of the diagram is the assumption that as time passes all elements from the past are carried forward, whereas of course many disappear from the record altogether. Also, the fact that a medieval building survives today does not mean that it is exactly the same building for a modern person as for a medieval person.

The value of the diagram is that it highlights the density and complexity of any historical moment: a multiplicity of styles, designers at different stages of their careers, a mixture of the old and the new, the ascendent and the descendent, all coexisting.

An awareness and acceptance of the simultaneous existence of the styles of many ages has been one of the factors leading to the eclecticism of post-modernist architecture and design.

Periodization

Few historians are foolhardy enough to tackle the history of the world; most of them focus upon segments of time. The questions 'When to begin and end? Should historians impose limits upon the material or should the limits arise naturally from the material itself?' are the problems of periodization.

Units of time such as centuries used as the basis for histories are purely arbitrary impositions; the course of history does not alter just because the date changes. As a way of coping with the

art, design and fashion of the twentieth century, a 'decades'
approach has proved popular. Almost invariably 'decades' his-
torians feel compelled to detect a unique style or spirit of the
age in each decade whether there was one or not.·

Historians who decide to periodize according to the material
of history are faced with an embarassment of riches: natural
disasters, wars, revolutions, economic crises, technological
changes, political reforms and so on. The design historian can
elect either to use general economic/technological/political
segments such as 'the era of capitalism', 'the epoch of the indus-
trial revolution', 'the Victorian age' (assuming their limits can
be agreed), or to use boundaries more specific to design itself,
for example, the lifespan of a particular style.

Each branch of history-writing tends to periodize the past
differently according to the relative autonomy of their chosen
subject. In some instances, massive economic and political
changes will affect all aspects of a society; in others, develop-
ments will occur in one field which are 'out of step' - more
advanced or retarded - than in society as a whole. (The latter is
an instance of what Marxists call 'the law of uneven develop-
ment'.)

An inevitable concomitant of singling out a period is the dis-
ruption of the continuity of history. Of course, dramatic rup-
tures and watersheds in human society occur but however
extreme these may be, there are also continuities which span
them. A period has a beginning and an end, and therefore there
is a strong temptation to impose a neat storyline. Yet no matter
how firmly the line is drawn at the beginning and the end, most
historians find it necessary to review what preceded and what
followed their chosen period. But how far backwards and for-
wards should they range? The search for origins can be highly
problematic since there always seems to be an earlier cause
which could be cited. In the case of histories of the immediate
past - those which come right up to date - terminating dates
tend to be completely arbitrary: the narrative simply breaks off
at the moment the typescript is due at the publishers.

It is not infrequent to find a design text whose title cites very
specific limits - 1750-1980, for example - only to discover that

no explanation of why these dates were chosen is provided. In contrast, Nigel Whiteley, the author of *Pop Design* (1987), does consider the vexed question of periodization. At first sight his book is a 'decades' example (the 1960s) but, in fact, the span of time in which he finds it necessary to define pop design extends from 1952 to 1972. Also, instead of arguing that during the 1960s there was a single, uniform style of pop design, he divides pop into three phases: early pop (1952-62), high pop (1962-6), and late and post-pop (1966-72). Whether one agrees with this periodization or not, or with the grounds upon which it is based, it is refreshing to find the issue explicitly discussed in his book's introduction.

Causation and Determination

Whenever design historians ask 'Why is this product the way it is? How do we explain the emergence of this style of design?', they raise questions of conditions, causes and determinants. In the case of a building or designed object the number of causal factors tends to be multiple. (Hence the value of Freud's concept of 'overdetermination'.) This makes the design historian's task difficult: need they all be cited? In what order of importance should they be ranked? Is primacy to be given to factors external to design or those internal to design?

Some early scholars felt compelled to be systematic and comprehensive in their descriptions of causes. For example, Banister Fletcher in the early editions of his history of architectural styles, was in the habit of citing six 'influences' upon the character of a style, namely, geographical, geological, climatic, religious, social and political, historical.

Enumerating conditions, causes and determinants render the role of the designer's will problematic. Are designers simply the agents or bearers of forces beyond their control? On earth the force of gravity restricts human action; it is a constant background condition. However, it has not prevented us from inventing machines - space rockets - capable of overcoming it. This example suggests that humans are not simply the victims of conditions and forces. In the case of a natural force such as the

wind, humans can use it to speed the passage of an aircraft, or they can fly into it. Alois Riegl's theory of *Kunstwollen* similarly suggested that artists can decide to work with or against the natural propensities of the tools and materials they employ. Human thought and action can thus overcome natural forces or turn them to our advantage. There are, however, always limits to our powers (though these vary from age to age). Most individuals find they can only change the world in minute ways. Collectively, of course, we exercise much more power, but the very forces we unleash as a species – economic ones, for instance – usually strike the individual as alien and inexorable. Millions of people take millions of piecemeal decisions. They may all be rational and reasonable ones and yet the end result may be unplanned, unwanted crisis. In short, our control over our collective destiny is still far from perfect. Even rational decisions are fraught with uncertainty and actions are constrained by factors of which humanity has only partial understanding or control.

If a theorist repeatedly cites one cause – such as the economy – as the dominant one, then what is being proposed is what Pitirim Sorokin called 'a main factor' theory. What needs to be guarded against in such discussions is an economistic reductionism, that is, reducing design, in Raymond Williams' words, 'to a direct or indirect expression of some preceding and controlling economic content'.[9] This is because design has a relative autonomy from the economic base and the effects of this are always mediated via the practices specific to design. Furthermore, since a new design can increase sales, it is not merely passive in respect of economic forces.

Karl Popper and E. H. Gombrich have argued for a 'situational logic' in which humans are constrained by time, place and circumstance but even so have a degree of freedom to pursue alternative directions.[10] Certainly, whatever the limits imposed on a designer by money, technology, the brief, and so on, there is usually more than one way of solving a design problem.

Normally, natural factors such as the climate are taken as read when discussing design but in the case of architecture, for example, climate and geography are relevant. (Nature's determinations, it is worth adding, are more final even than the

economy's.) Some theorists, for instance Hippolyte Taine, have resorted to biological factors (race, heredity) to explain the character of the design of particular peoples. In his case the racial factor was modified by two others: milieu and moment. Despite the suspicion in which racial theories are generally held, the theory of biological determination still seems to underpin discussions of the type 'the Englishness of English art and design'.

Since the preceding discussion has been highly generalized, let us consider two examples. The first concerns 'primitive' cultures while the second concerns an emergent industrial society.

James Fitch and Daniel Branch's article 'Primitive architecture and climate' (*Scientific American* 207, 1960) is helpful in regard to the environmental determinants of design. 'Primitive' peoples, such as the Eskimos and the North American plains Indians, depend upon the natural materials specific to their homelands: snow in the case of Eskimos and animal skins and branches in the case of the Red Indians. To survive they must construct shelters with materials which are appropriate to their local climates.

Fitch and Branch tabulate a range of different regions throughout the world. The combination of different geographies/materials, climates and peoples gives rise to a wide variety of types of shelter which, the authors argue, achieve a high level of performance and comfort, higher indeed than many contemporary buildings. Performance, they claim, is a function of both form and material: the hemispherical dome shape of the Eskimos' igloo offers maximum resistance and minimum obstruction to Arctic gales; in a region of heavy seasonal rains, steeply sloping roofs and water-shedding materials are needed.

'Primitive' architecture, it seems, is the result of pragmatic wisdom evolved over many centuries. For the native peoples there is only one way to build - the traditional way - hence the modern idea of choosing from a spectrum of types and styles is inconceivable to them. Although climate and materials are the central themes of the article, the authors acknowledge the influence of additional factors such as the cultural: warfare between tribes could add walls and moats to a village; the practice of polygamy could result in a space set aside for a harem; a nomadic

culture could require portable rather than permanent structures; and so forth.

Modern architects, Fitch and Branch argue, could learn much from the principles of 'primitive' buildings because our assumption that the same skyscrapers are suitable for all climates results in inefficiency, discomfort, a waste of energy resources and a sterile uniformity of design. The major difference between 'primitive' and modern cultures is that Western technology has enabled the mass production of a huge range of materials and goods which are distributed around the globe. In other words, the link between design and place, design and the natural environment, has been broken. On the one hand, this means the choice of materials, forms and styles available to the designer has expanded immeasurably; on the other, it means an organic relationship to place and necessity has been lost.

Our second example concerns the eighteenth-century British pottery manufacturer Josiah Wedgwood. Adrian Forty, in his book *Objects of Desire* (1986) accounts for Wedgwood's success as follows: a growth in Britain's population and colonies increased the potential market for pottery. The new popularity of drinking hot tea created an increase in the demand for ceramic cups. Forty also cites a taste for classicism amongst the British upper classes.

So far, then, Forty identifies demographic, social and aesthetic factors. One could add there must have been economic growth to sustain the increased population. These general preconditions existed for all British pottery manufacturers. How then does Forty explain Wedgwood's exceptional achievements? Wedgwood, he argues, rationalized production methods in his factory, devised new, imaginative advertising and marketing techniques, introduced new products and new glazes, improved the quality and consistency of his wares, gave a high priority to design and employed artists as designers, used and developed a neo-classical style that appealed to upper-class customers whose taste for the antique was an antidote to disturbing aspects of change in early industrial Britain.

Evidently, Wedgwood exploited existing conditions better than his business rivals but he also went far beyond those

conditions in his active innovations and experiments. Forty's explanation for the appeal of the neo-classical style – a reaction to progress, an ideological response to change – is an interesting one even though, in his text, no supporting evidence is given.

What Forty's account of Wedgwood takes for granted (it is discussed elsewhere in the book) is the socioeconomic system within which the manufacturer's activities took place, that is, the free market, private property, capital/labour system; in short, the capitalist mode of production. The particular relevance to design of this reference is as follows: underlying socioeconomic systems crucially influence the character of design taken as a whole. For example, under the conditions of capitalist competition, design is one of the ways an excessive variety and differentiation of products is achieved. In a non-competitive, socialist, planned economy such undue variety is unnecessary, and as a consequence design's role is different.

The example suggests a solution to the external/internal problem. Design historians need to take account of the general conditions within which design takes place, but in particular how those conditions, forces and determinants are exploited and overcome in the design, production and marketing processes.

Theories of Change

If societies did not change as time elapsed historians would be redundant. Change is the *raison d'être* of history. Yet, describing and explaining change is highly complex because it pervades every aspect of nature and society (though it takes place at different rates – fast or slow, suddenly or cumulatively – in different spheres). Because human life on earth is a total ecological-cultural system in which every part interconnects, every change has its effects and these in turn prompt further changes. Where then should the historian's explanations begin and end?

Natural processes – ageing and decay – necessitate the periodic renewal of goods and the built environment but, also, certain human economic systems have a built-in propensity for change. In other words, such systems do not simply respond to external change, they instigate it. The free-market system, for

example, is based upon the struggle/competition of individuals and companies, ever-expanding production and the maximizing of profits, by means of creating new wants and new products to fulfil them. Devices like planned obsolescence and periodic style changes ensure that a constant renewal and upgrading of goods, images and expectations takes place.

So far the neutral word 'change' has been preferred to terms like 'development' and 'progress' because of the controversial connotations of betterment and improvement associated with them. When art historians describe the 'lifecycle' of a style in terms of phases like early, middle and late, it is hard to escape evaluative or even moralistic implications, e.g. a late phase equals decline, decay and decadence.

Another problematical word is 'evolution'. Can the theory of natural selection based on random mutations formulated by such scientists as Charles Darwin and Herbert Spencer in respect of nature's processes be used to explain change in a human cultural activity such as design? Is the development of design, like that of nature, a process of ever-increasing complexity and differentiation? A text exploring these possibilities is Philip Steadman's *The Evolution of Designs: Biological Analogy in Architecture and the Applied Arts* (1979).

In traditional craft cultures, Steadman argues, change can take place in a way directly analogous to natural evolution: an artefact is copied by successive generations of artisans and since the copying process is never perfect, small variations and adaptations occur which in the long run cause significant alterations in the artefact's form and decoration. It is assumed that the process is unselfconscious, that later artisans will be unaware of the degree of change which has taken place. Changes which prove impractical or are disliked by their users will be rejected, hence a 'survival of the fittest' type of selection takes place. As Steadman acknowledges, design in modern societies is different: it is self-conscious, deliberate; change is actively pursued and often the design challenge is not to copy something which already exists but to solve new problems by means of new designs.

One could argue that evolutionary change is not historical even though it takes place over time. Evolution in the crafts is a

process internal to design: it assumes a stable social and physical environment within which minor changes occur naturally over long periods. Historical change, on the other hand, is induced from within by self-conscious decision and from without by radical alterations in the world beyond design.

Just as it seems inappropriate to assign history values to the minor changes in the evolution of a craft, so it seems inappropriate to assign them to the myriad fluctuations of modern fashion (even though these are decidedly the result of conscious human decision). Fashion only seems to become historical, Barthes has argued, in the long term: 'Changes in fashion appear regular if we consider a relatively long historical duration, and irregular if we reduce this duration to the few years preceding the time at which we place ourselves ... Fashion thus appears to possess two durations: one historical, the other what could be called *memorable* ...'[11] He then cites the work of Alfred Kroeber and Jane Richardson – 'Three centuries of women's dress fashions' (1940) – which detected rhythms and cycles occurring at 50-year intervals. Barthes comments: 'History cannot act on forms analogically' (he is making the disconcerting claim that there is no correlation between, say, the Napoleonic era and high waistlines in women's dresses), 'but it can certainly act on the rhythm of forms, to disturb or change it. It follows that, paradoxically, fashion can know only a very long history or no history at all; for as long as its rhythm remains regular, fashion remains outside history; it changes, but its changes are alternative, purely endogenous' (that is, growing from within) '... in order for history to intervene in fashion, it must modify its rhythm, which seems possible only with a history of very long duration.'[12] Annual fashion variations he characterizes as 'micro-diachrony' and says that within it 'no law of change is perceptible'. Economic factors give rise to 'neomania', this in turn produces random, arbitrary variations in hemlines, and so on (it does not matter what changes are wrought so long as they are different from what went before).

Given Barthes' dependence upon the article by the two American anthropologists, Richardson and Kroeber, it deserves consideration in its own right. An ambitious study, it set out to

define stylistic change in a quantitative manner – the article abounds in tables and graphs. Women's evening or formal dress was taken as the object of study because it had served a fairly constant decorative function for several centuries and was free of utilitarian motivation. The authors regarded the style of this dress – a slender waist, a long skirt ample at the bottom, a low neckline – as a kind of ideal-type or archetype. Fashion they conceived of as the endless fluctuations to which the ideal-type was subject over time: 'fashion . . . demands change, and, when it has exhausted the possibilities of material, colour, and accessories, goes on to alter fundamental proportions, in other words the basic aesthetic pattern. With such alterations there comes strain, simultaneously pulling forward and back; violent jumps in opposite directions within one or two or three years . . .'[13]

For practical reasons the authors did not study actual dresses but fashion plates depicting them. The time span was from 1787 to 1936. Having assembled as many images with exact dates as possible, six dimensions of the dress were measured, that is, such things as length of skirt, depth of decolletage and width of waist. (It was the silhouette of the dress they were focusing upon, so changes of material, accessories and decoration were ignored.) Once the figures had been tabulated it was possible to construct graphs recording the changes in dimensions through time. An immediate conclusion was that each dimension of the dress had a more or less independent history. As indicated earlier, cyclical patterns or periodicities in, for example, the narrowing or widening of skirts were detected at 100- and 50-year intervals. Richardson and Kroeber observed: 'Women's dress fashions change slowly, as regards the fundamental proportions of the silhouette or contour. On the average, any one proportion is a half-century swinging from its extreme of length or fullness to extreme of brevity or narrowness, and another half-century swinging back.'

According to their figures, there were long periods of relative stability in the form of the dress, and shorter periods when it became more volatile. 'Was this the result of changes taking place in society at large?' they wondered. Tentatively, they suggested that unsettled times could unsettle fashion, thereby

increasing its variability. But, they added, there was nothing to show that disturbances external to design would cause a particular change, such as shorter skirts, to occur.

Regarding periodicities, Richardson and Kroeber were unwilling to claim that they had discovered any general laws of cultural evolution. They remarked: 'There is no reason why style in general, or even dress style should necessarily swing rhythmically back and forth. Our findings apply only to the material analysed.' In a postscript addressed to his critics, Kroeber also denied the study enabled any predictions about the future to be made.

Richardson and Kroeber recognized that individual designers do contribute to fashion change and that psychological factors such as imitation, emulation and competition may have been at work, but they excluded these factors from their study on the grounds that they were not amenable to their scientific method. Furthermore, they took a proto-structuralist position when they argued that in the long term styles transcended individual consciousness and will; the general drift of change was not perceived by the participants. According to Kroeber: 'As far as individuals are concerned, the total situation seems overwhelmingly to indicate that their actions are determined by the style far more than they can determine it.' He also cited large-scale economic trends and argued that no one attributes these to individual initiatives.

One could argue that by taking a type of dress worn by upper-class women, one likely to remain stable over a long period, Richardson and Kroeber took an exceptionally simple example. Would their methods work equally well with the complex gamut of clothing worn by all classes - some items of which appear and disappear with great rapidity? In spite of the questions the article poses, it remains an important landmark in the attempt to apply social scientific methods of analysis to an obdurately enigmatic cultural phenomenon.

Another writer who has commented upon women's dresses is the British zoologist Desmond Morris. In a popular book about human behaviour and body language called *Manwatching* (1977) he records changes taking place in the length of skirts between

1921 and 1977. He then claims that there has been a 'rather precise correlation' between skirt-length and economic conditions, namely: 'Short skirts appear at times of high national production and long skirts during periods of austerity and recession' (i.e. the opposite to what functional logic would suggest). That the relatively autonomous realm of fashion should respond so directly to economic fluctuations seems farfetched and certainly Morris is vague as to the causes of the phenomenon: 'Exactly why females should want to expose more of their legs when the economy is healthier, it is hard to understand, unless a sense of financial security makes them feel more brazenly invitatory towards males. Perhaps the general atmosphere of financial activity makes them feel more physically active . . .'[14] He adds that many fashion trends are no more than 'novelty changes' based on the need to signal up-to-dateness. Such minor changes modify or reverse the fashion of the previous season.

There is no attempt in this account to investigate the micro-economy of the British fashion industry to see how it responded to the more general economy, nor to compare the female fashions of other similar countries to see if they demonstrated the same pattern. Nor does Morris pay attention to other aspects of female attire: is it only one feature – hemlines – which correlates with economic conditions? If so, why?

Both Morris and Barthes seem to agree that explanations of change can vary according to the span of time under review: those appropriate for the short term may be inadequate for the long term. The French historian Fernand Braudel (of the Annales' school) has identified three levels in which change takes place at different rates: (1) *events* (the short term, a rapid rate of change, the concern of traditional history); (2) *conjunctures* (intermediate, a slower rate of change involving cyclical movements and rhythms in demographics, trade and economics operating at, say, five, ten, twenty or fifty years); (3) *long duration* (a very slow rate of change taking centuries to accomplish, the domain of biological, geophysical and climatic processes).

Braudel thinks of long-duration phenomena as 'structures'. His mode of history-writing explores the interrelationships between structures and events. However, in his view structures are

much more significant than events (if history is a sea, then events are the waves, and structures the tides), because they are the decisive factors in human affairs.[15]

Most design historians concern themselves with events and conjunctures. The discipline has yet to generate a historian capable of the magisterial overview of impersonal forces Braudel demonstrates in his volumes on the history of *The Mediterranean in the Age of Phillip II* (1972-3) and *Civilization and Capitalism* (1981-2).

Certain historians have considered that the development of human history is governed by laws and that if these laws could be discovered then our control over our destinies would be increased immeasurably. If this did turn out to be the case then firms and designers would be able to plan for the future far more effectively. It would also enable design historians to predict future design trends! Charles Jencks, the architectural historian, once devised a time-chart of modern architecture from the 1920s onwards which divided architecture into six major traditions or species. Using his analysis of the past as a basis, Jencks predicted the future of architecture up to the year 2000. The flaw in such models is that humans can decide to contradict whatever predictions have been made, thereby invalidating them.

Historicism

Readers of books on design and historiography are highly likely to encounter the word historicism, and therefore a discussion of its various meanings may be useful: the word tends to be used differently in different discourses, that is, in art and design history, philosophy and history.

1. An eclectic tendency within the arts, especially architecture, to revive past styles instead of developing new ones appropriate to the age in which the artist lives. The term is used in this sense by Pevsner. Artistic historicism, in his view, is retrogressive: 'All reviving of styles of the past is a sign of weakness, because in revivals independent thinking and feeling matters less than the choice of patterns ... Historicism is the belief in the power of

history to such a degree as to choke original action and replace it by action which is inspired by period precedent.'[16] Architectural historicism in the twentieth century is thus criticized by Pevsner because it marks a retreat from the ideals of modernism. Hans Evers, a German art historian, has taken issue with Pevsner's argument on the grounds that it depends upon a unilinear, progressive conception of history. Evers claims that stylistic eclecticism/pluralism is the more 'normal' state of affairs than that in which a monolithic modern style dominates. In the past, he argues, there has always been a plurality of styles co-existing at any given time and there have always been stylistic revivals.[17]

Similarly, the architectural historian Charles Jencks has criticized Pevsner's *Pioneers of the Modern Movement* (1936) because it outlines a single-strand theory of architectural development from William Morris to Gropius (ignoring on the way futurist and expressionistic movements) and then presents it as *the* style of the twentieth century. Jencks even characterizes Pevsner's approach as 'historicist' (in the sense of definition four). This critique occurs in the Introduction to *Modern Movements in Architecture* (1973), a book in which Jencks presents modern architecture as a plurality of traditions.

2. A theory which asserts the priority of historical development. The view that everything changes with time, that there are no absolute, static or eternal entities. It follows from this view that the standards of one age are not transferable to any other and that therefore each epoch has to be studied in terms of its own values and not those of the historian. This conception of history produces a sequence of time boxes – 'epochs' – each of which is self-contained and insulated from all the others.

3. 'The recognition that each of us sees past events from a point of view determined or at least conditioned by our own individual changing situation in history.'[18] This definition, supplied by Arnaldo Momigliano, is really a logical consequence of (2) above. In its most extreme form – Croce's remark that 'all history is contemporary history' – it can lead to what is called 'presentism'.

If all history is written from the vantage point of the present of the historian, then there is a danger of projecting back attitudes and ideas that were unknown to the past, for example, characterizing the Gothic style as 'expressionist' as a result of an awareness of modern German expressionism.

This danger can be avoided by identifying the ideas and attitudes current during the age in question and by highlighting any differences between then and now by comparing them to today's norms of behaviour. Of course, it would be absurd for the historian to refuse to use modern methods of analysis, such as psychoanalysis, just because they were unknown in the past. Full justice should be done to a past culture, it must be understood in its own terms, but even so it cannot be judged by its own standards alone for, as Marx pointed out, one does not judge a person according to their own evaluation. Carried to its logical extreme, the view that an ideology should be judged only by its own standards would lead to an approval of Nazism, for instance.

If every age rewrites history according to its own values, does this produce total relativism? Is it possible to achieve an objective, truthful account of the past? These questions raise complex philosophical issues which it is impossible to discuss at length here. However, it is worth pointing out that there are two safeguards against complete relativism: not all accounts of the past are equally plausible - it is possible to discriminate between them; and secondly, the acquisition of historical knowledge is a cumulative process in both a quantitative and qualitative sense, therefore later generations can build upon the researches of their predecessors and gain insight from previous debates about the merits of contending interpretations.

4. 'The view that the story of mankind has a plot, and that if we can succeed in unravelling this plot, we shall hold the key to the future.'[19] This is Karl Popper's definition of historicism. He has attacked Hegelianism and Marxism - both of which he regards as historicist philosophies - on the grounds that a study of the past cannot be used to predict the future because history never repeats itself. Instead of invoking a mythical 'spirit of the age',

Popper argues, historians should look to the 'logic of situations' to explain events. Gombrich, Popper's follower in the realm of art history, has used situational logic in various books of his. What it seems to involve is reconstructing the context in which the artists found themselves and explaining artistic innovation in terms of a response to that state of affairs or to a problem inherent in it.

One can agree with Popper that the future is never exactly the same as the past without concluding that it is not worthwhile trying to anticipate and control events. In fact, modern businesses and industries regularly plan new projects and expansions on the basis of forecasts and projections drawn from an extrapolation of current tendencies. The future can be determined, in part, by human action: the designs and plans of architects and designers are evidence of this – they are often realized.

Notes and References

1. Historiography is a subject with a vast literature: virtually every major historian has at one time or another written a book or article reflecting upon the problems of history-writing. Two introductory texts are E. H. Carr's *What Is History?* (London: Macmillan, 1961) and A. Marwick's *The Nature of History* (London: Macmillan, 1970). A more complex text is Hayden White's *Meta-History* (Baltimore: Johns Hopkins University Press, 1973). An art history reader with a useful introduction is *Modern Perspectives in Western Art History* edited by W. Kleinbauer (New York: Holt, Rinehart, Winston, 1971) and a history of architectural history is supplied by D. Watkin's *The Rise of Architectural History* (London: Architectural Press, 1980). A special issue of *Architectural Design* on 'Methodology of architectural history' (London: Academy Editions, 1981) is also relevant.
2. M. J. Dhont quoted in A. Schaff, *History and Truth* (Oxford: Pergamon Press, 1976).
3. White, *Metahistory* p. 7.
4. W. Benjamin, 'Theses on the philosophy of history', *Illuminations* (London: Cape, 1970) p. 257.
5. W. Benjamin, 'A Berlin chronicle', *Reflections* (New York: Harcourt, Brace, Jovanovich, 1978) p. 26.
6. D. Hebdige, 'Digging for Britain', *The British Edge* (Boston (USA): ICA, 1987) pp. 35-69.
7. F. de Saussure, *Course in General Linguistics* (London: Fontana/ Collins, rev. edn 1974) p. 91.

8. P. Burke, *Sociology and History* (London: Allen and Unwin, 1980) p. 13.

9. R. Williams, 'Determination', *Marxism and Literature* (Oxford University Press, 1977) p. 83.

10. K. Popper, *Conjectures and Refutations* (London: Routledge & Kegan Paul, 4th edn 1972) p. 338.

11. R. Barthes, *The Fashion System* (London: Cape, 1985) p. 295.

12. Barthes, *The Fashion System* p. 296.

13. J. Richardson and A. Kroeber, 'Three centuries of women's dress fashions: a quantitative analysis', *Anthropological Records* 5 (2) 1940 pp. 111-53.

14. D. Morris, *Manwatching: a Field Guide to Human Behaviour* (London: Cape, 1977) p. 221.

15. On F. Braudel see S. Clark, 'The French new history', *The Listener* 24 May 1984 pp. 14-15.

16. N. Pevsner, 'The return of historicism', *Studies in Art, Architecture and Design* vol 2 (London: Thames & Hudson, 1968) pp. 242-59.

17. H. Evers cited in A. Neumeyer, 'Art history without value judgements', *Art Journal* 29 (4) Summer 1970 pp. 414-21.

18. A. Momigliano, *Essays in Ancient and Modern Historiography* (Oxford: Blackwell, 1977) p. 296.

19. K. Popper, *The Poverty of Historicism* (London: Routledge & Kegan Paul, 2nd edn 1960); E. H. Gombrich, 'The logic of vanity fair' in P. Schilpp (ed), *The Philosophy of Karl Popper* (La Salle, Illinois; Open Court, 1974) pp. 925-57.

Varieties of Design History

Having summarized the general problems of history-writing, it is now possible to look at the various ways in which design historians have approached their task. As explained earlier, histories of design vary not only because they treat different facets of the subject but also because different scholars adopt different methods and approaches. Readers will find it helpful in understanding and evaluating such texts if they can characterize and name the approach in question. Some writers give this information in the introductions to their books, others do not. Where no explicit methodological discussion occurs, it is worth scanning the index: if Marx, Engels and Gramsci are frequently cited then the chances are the book employs a Marxist approach (alternatively, it could be anti-Marxist). If the index proves unhelpful, then the text will need to be closely scrutinized and read symptomatically.

Texts can be categorized in several ways:

1. According to level and audience. Every text presumes an ideal reader or group of readers. There are specialist, academic books on design and there are also popular, journalistic ones.
2. According to the political perspective informing the text. For example, liberal, anarchist, feminist, socialist.
3. According to the underlying philosophical assumptions, for example, idealist, materialist, realist, Hegelian.
4. According to the principal academic or scientific mode of analysis employed, for example, structuralist, semiotic, functionalist, stylistic, comparative, typological, deconstructive.
5. According to the kind or school of history-writing employed, for example, humanist, social, cultural, history of ideas, Braudelian.
6. According to time or place, for example, histories of twentieth-century design, the design of particular nations or larger geographical units such as Europe.

7. According to the extrinsic discipline employed, for example,
 anthropology, sociology, economics, archaeology, psychology.
8. According to a materials/techniques emphasis.

Although these approaches have been listed separately, in any
particular text one will generally expect to find a mix of el-
ements. If a writer combines ideas and methods promiscuously,
then one may be compelled to characterize the text as 'eclectic'.

A few approaches will now be considered in more detail to
see what they involve.

The Materials/Techniques Approach

Traditionally, one of the popular ways in which museum cu-
rators and design historians arranged their objects of study was
on the basis of physical materials and their associated tech-
niques and processes. Although a wide variety of artefacts can
be constructed from a natural material such as wood, scholars
frequently grouped them together because of their common
substance and because they were made in similar ways with the
aid of particular kinds of tools and machines. Thus it was usual
to collocate books and printing, silverware and silversmithing,
furniture and woodwork (it should be noted that furniture can
be made of fabrics and leather besides wood, and also from
cane, moulded plastic and tubular steel, so the equation 'furni-
ture equals wood' does not, in reality, always apply), and so on.

If we consider the plan initially adopted by curators at the
Victoria and Albert Museum to present their collections in the
new building opened in 1909, the predominantly materials/
techniques basis is evident: (1) Architecture and sculpture;
(2) Metalwork; (3) Woodwork, furniture and leather; (4) Tex-
tiles; (5) Ceramics, enamels and glass; (6) Paintings; (7) Engraving,
illustration and design. Within these sections the aim was 'a logi-
cal scheme illustrating the technical and artistic development of
the particular industry represented'.[1] (So, historical or typo-
logical arrangements could exist within main sections.) It should
be remembered that the museum's collections were not primarily
intended for the edification of the general public. Their presumed

BROOKLANDS COLLEGE LIBRARY
WEYBRIDGE. SURREY KT13 8TT

constituency was narrower: craftsmen, manufacturers, designers and students. These groups were supposed to be educated and stimulated by what they saw in order to bring about an improvement in the quality and standard of British crafts, decorative arts and manufactures. This is why a materials/techniques arrangement was favoured and why the collections were limited to examples of the highest quality.

A book organized exclusively in terms of materials is *The Pattern of English Building* (1972), by Alec Clifton-Taylor. Its chapter headings include: stone, granite, slate, marble, flint, brick, tiles, wood, thatch, plaster, metals and glass. The author's aim is to demonstrate the close link between the geology of the country, the various materials this provides, and the distinctive pattern of traditional buildings that resulted from the use of them. Although the materials from which a building's shell are constructed contribute a great deal to the character of its external appearance, exactly what part they play in the structure's form and design is much more difficult to ascertain. After all, bricks can be used to make a thousand differently shaped structures. Other factors, it would appear, determine form and design. Clifton-Taylor certainly recognizes the existence of other factors but, as the following quotation makes clear, he still assigns priority to materials:

> In the past the very uneven distribution of wealth between one district and another certainly had an important influence; but neither this nor other factors, such as the exigencies of climate, or changing social requirements, or the strength of tradition, or the swinging pendulum of fashion, affected the character of our local building activities nearly so radically as the nature of the materials which were available.[2]

Our second example of a materials-based text deals with a substance generally regarded as quintessentially modern – plastic – even though, in fact, it has existed in natural forms for centuries. Sylvia Katz's book *Plastics: Designs and Materials* (1978) systematically examines over 60 kinds of plastic, both natural and synthetic, and the extraordinary variety of products they

have made possible. It also includes a chapter on the chemistry of plastics and an appendix on moulding processes. As Katz explains, plastic has a poor public image because it was originally intended as a cheaper substitute for other materials. She sees herself as a champion of plastic and endows it with democratic potential: 'a universal material available to everyone'. Furthermore, she says 'the chemist, processor and designer can fashion an infinite combination of chemicals' and the mouldability of plastics means that it can take virtually any form. One advantage of the materials approach is that it enables the writer to transcend conventional divisions, thereby broadening the scope of the text. Katz, for instance, includes examples of medical aids, transportation, engineering, architecture (air structures) and works of art, besides furniture and consumer goods.

On the question of the design/material relationship, the book illustrates examples of plastic radio cabinets in a neo-baroque style. This suggests that the very versatility of plastic means that any style can be imprinted upon it, that there is no necessary connection between material and form. Katz argues, however, that 'streamlining in plastics is an inherent characteristic of the material. Plastic objects are curved because polymers need to flow within the moulds and corners are difficult to produce.'[3] She also says that step-form objects in plastic were popular not only because the art deco style was fashionable at the time but also because the step-form facilitated the removal of the object from the mould. It seems clear from these examples that the physical properties of materials and the nature of the processes involved in manufacture favour certain forms and styles and not others, even if there is nothing absolute about the determination.

Descriptions of materials and processes can easily result in a highly technical, quasi-scientific textbook. It is difficult, therefore, to combine the materials approach with a sociohistorical study arranged chronologically. This is, however, what Katz attempts in her more recent publication, *Classic Plastics: from Bakelite to High-Tech* (1984).

The materials/techniques approach serves less well for complex artefacts assembled from parts made from many different

materials. In these cases, museum collections and texts tend to be organized according to social function and type; for example, a museum of transport vehicles; a book about bungalows.

There is little doubt that technological progress, in particular the invention of new materials such as synthetic plastics, concrete and chipboard, stimulates designers to reinterpret old products and to devise original ones. A highly standardized and uniform new material may permit the solution of long-standing mass production problems, thus enabling an ancient craft to be industrialized. Since new materials with special properties can solve design problems the search for them is, in fact, often deliberate, especially in wartime when certain familiar materials suddenly become unavailable or are in short supply. Evidently, the relation between design and materials is reciprocal. When making use of materials, however, designers always have the choice of foregrounding or denying their natural characteristics.

Histories of design emphasizing materials and techniques are closely related to histories of science, technology and invention. They will, in fact, be heavily dependent upon the latter for much of their information unless, of course, it is derived directly from the laboratory and industry.

The Comparative Method

Making comparisons between products, designers, styles and so forth is one of the routine activities of design historians and critics and yet the comparative method itself receives almost no critical attention. The aim of comparing and contrasting items is to reveal similarities and differences, so it is of little value when two items are virtually identical or utterly different. In other words, the method works best when two items have some characteristics in common but vary in other respects; for example, a telephone dated 1920 and a telephone dated 1980, or an American spacecraft and a Soviet sputnik.

The comparative method is ancient – it can be traced back to Aristotle at least. It also seems to have had a special appeal to nineteenth-century scholars and scientists. In art history the method was popularized by Heinrich Wölfflin who introduced

two projectors into his lectures in order to highlight stylistic
differences and similarities between two works of art. Archi-
tectural history supplies an earlier example: Augustus Pugin
used a two-image juxtaposition to great effect in his book *Con-
trasts* (1836; second edition 1841). Pugin wanted to celebrate
the virtues of Gothic architecture and at the same time denigrate
what he regarded as the barbarity of the architecture of his own
day. He achieved this pictorially by juxtaposing a series of pairs
of images; for example, he placed a view of a noble and har-
monious Gothic townscape next to a view of the same city
several centuries later ruined by industrialization. Pugin had no
hesitation in embroidering and exaggerating history and reality
in order to maximize the contrast between the glorious past and
the odious present.

Another Victorian who favoured the comparative method
was the architect and designer Owen Jones. In 1856 he published
his famous book *The Grammar of Ornament*, a sumptuous vol-
ume full of colour plates featuring some 1,000 examples of
pattern and decoration ancient and modern from around the
world. To our eyes it might seem that Jones' purpose was to
provide a sourcebook for stylistic borrowings, historicism and
eclecticism. In fact, his comparisons were intended to reveal
certain 'general principles in the arrangement of form and colour'
which he believed were common to all good examples. The Vic-
torian designer was supposed, therefore, to learn and apply these
design principles, and not merely to copy the examples repro-
duced. Jones' ultimate aim was the establishment of a new style-
of-the-age based upon the 'grammar' he had identified, which in
turn, he believed, derived from the laws of nature. At first sight,
his compendium appeared to demonstrate the bewildering
variety of design throughout the world but what Jones wanted
the reader to realize through the process of making comparisons
was not the variety of the designs but their underlying unity:
'see how various the forms, and how unvarying the principles'.

During the mid-nineteenth century art history was influenced
by the comparative method employed in other disciplines. For
instance, Gottfried Semper's writings on style took their cue
from the comparative philology of Franz Bopp:

Just as in the most recent researches into linguistics the aim has been to uncover the common component of different linguistic forms, to follow the transformation of words through the passage of centuries, taking them back to one or more starting points where they meet in a common *Ur*-form ... a similar enterprise is justified in the case of the field of artistic enquiry.[4]

Making comparisons thus represented a first stage which was then followed by historical reconstruction. As Margaret Iversen explains: 'Semper believed that one could authoritatively identify motifs and understand their transformations by tracing motifs back to their original forms and by recognizing the original purposes, materials and techniques which fashioned them.'[5]

Ferdinand de Saussure, the founder of modern linguistics, has commented on the limitations of the comparative method: 'In [the comparative philologists'] investigations, they never asked themselves the meaning of their comparisons or the significance of the relations they discovered. Their method was exclusively comparative, not historical.'[6] He adds: 'Of course, comparison is required for any historical reconstruction, but by itself it cannot be conclusive.' And later still: 'The sole means of reconstructing is by comparing, and the only aim of comparison is a reconstruction.'[7]

Perhaps the best-known instance of the comparative method within the domain of architectural history is Banister Fletcher's *A History of Architecture*, a standard reference work which first appeared in 1896; its nineteenth edition was published in 1987. The book was based upon Professor Fletcher's series of evening lectures given to trainee architects at King's College, London. His son – Banister Flight Fletcher – took on the project and edited the first 16 editions of the book. As the goal of comprehensiveness was pursued, each successive edition was expanded in size (it is now 1,621 pages long) but as late as 1959 there was nothing on the architecture of Africa. One reason for this neglect was that whereas Western styles of architecture were deemed 'historical' – that is, formed a chronological sequence – non-Western ones were regarded as 'non-historical – that is, primitive, unchanging, not belonging to 'real' history.

The original aim of the book can be gleaned from the full title of the first edition: *A History of Architecture for the Student, Craftsman and Amateur, Being a Comparative View of the Historical Styles from the Earliest Period.* The author explains in his preface that his objective is to display 'the characteristic features of the architecture of each country by comparing buildings of each period ... thus the character of Gothic is emphasized by comparison with Classic and Renaissance architecture'. This he does by systematically comparing plans, walls, openings, roofs, columns, mouldings and ornament. Fletcher died in 1953. If he were alive today he would, no doubt, be disappointed to learn that his comparative method is no longer regarded as useful: in the eighteenth edition the comparative sections were excised on the grounds that they simply repeated information found elsewhere in the text. Another reason was the assumption – drawn from modernism – that the practice of architecture was no longer based upon historical precedents.

Whereas in Fletcher's case comparisons were a means of learning about styles and differentiating between them, in the case of the *Which* reports published by the Consumers' Association comparisons between products designed for similar purposes are an aid to purchasing. Products are compared according to their performance, convenience, appearance and price. *Which* reports are not solely the result of intelligent observation and analysis, but also the consequence of operating and testing products. To assist readers in making their choice, the findings of the *Which* researchers are generally summed up graphically in terms of a table which ensures a systematic and clear presentation. This suggests that design historians too may find it helpful in making comparisons to employ the kind of visual aids/ diagrams developed by logicians.

A collection of articles about urban planning making use of the comparative approach is found in *City, Economy and Society: a Comparative Reader* (1981) edited by Allan Cochrane and others. Three relatively similar urban areas – Vancouver (Canada), Birmingham (Britain) and Cracow (Poland) – were selected in order to illustrate the interplay between market and state intervention in different social settings. The free market economy

was typified by the Canadian example, the mixed economy by the British, and the planned economy by the Polish. Once a comparison had revealed the similarities and differences between the three areas, the editors' intention was to identify 'causal relationships, or at least similar chains of historical events' underpinning any shared characteristics. Their belief was that the comparative method enabled 'limited generalizations' to be made about different times and places.

There are a number of popular illustrated books about the design of clothing, body decoration and hairstyles in different cultures which, although they may not proclaim the fact, depend upon the reader making comparisons. The value of such cross-cultural comparisons is, of course, that by contrast they make strange the customs and norms of our own society. Another, unsettling, consequence of exposure to a spectrum of different examples from many cultures is the relativization of the viewer's own culture.

When images of punks with painted faces and chains attached to their lips and ears are juxtaposed against photographs of tribal people similarly decorated, as they are in Val Hennessy's photobook *In the Gutter* (1978), then the conclusions drawn by the viewer vary according to whether similarities or differences are attended to. If the former, the conclusion may be: 'The punk's appearance emulates the "primitive's", hence the punk wishes to be seen as a "primitive" in modern Western society'; if the latter, the conclusion may be: 'The punk's decoration is actually different from the "primitive's", which indicates that their cultural and historical situations are alien despite superficial resemblances.' In comparing, it would seem that the observer always has the option of stressing what is common or what is unique about the examples being examined.[8]

Finally, some problems associated with the comparative method ought to be mentioned. These can best be illustrated by means of an example. Suppose a scholar is confronted by two photographs of water jugs which are similar in their forms and decoration. The items are presented without any social and historical context so additional information would be needed to settle the questions: are the similarities due to the fact that both

pots are from the same culture and from the same time and place? If they come from two different cultures are the similarities due to the influence of one culture upon another (cultural diffusion) or are they due to similar physical and social conditions? In the photographs the pots may appear to be the same size whereas in reality one could be very small and the other very large. A significant difference in size could undermine the validity of the comparison: is like really being compared to like? Another fact the photographs fail to provide is any indication of quantity: if thousands of pots were produced in one culture and only a few in the other, generalizations based upon the two artefacts could be misleading. It is clear from this that the comparative method has to be employed judiciously.

Content Analysis

The technique of content analysis is wholly dependent upon comparisons. It is commonly employed in the social sciences and the humanities for analysing the manifest or latent content of messages, texts or images.[9] Literature and the mass media have been exposed to particularly close scrutiny by content analysts. The technique is essentially quantitative in character, in that it involves counting. Every time a writer qualifies a statement with the words 'many', 'most', 'few', 'the majority', 'often', 'frequently', an estimate of quantity or frequency is taking place. Normally this estimate is intuitive or semi-conscious, but in content analysis it is explicit and systematic. To cite a simple example: one could measure with a ruler the column inches a specific story is given in a set of daily newspapers. This would supply a crude indication of the story's importance in the eyes of the different editors and in relation to other news stories if they too were measured. A second example: if an old play was discovered which scholars suspected was by Shakespeare, one way of testing the hypothesis would be to count the frequency with which certain rare words or grammatical expressions occurred in all the known plays by Shakespeare and then to compare the results with a similar count applied to the play of uncertain authorship. If the counts agreed, then this evidence would support the hypothesis that the play was indeed by Shakespeare.

As a method, content analysis claims to be objective and repeatable - in all cases several people undertaking the same procedures independently should achieve the same results. Before content analysis can take place, a specific body of material has to be delimited. Its size and completeness is important. If the total annual output of new book titles in Britain is 30,000, then any generalization about new trends in bookjacket design based upon, say, 100 titles would be suspect because the sample is too small in relation to the total. Ideally, all 30,000 titles should be examined. Where huge quantities make an analysis of the whole corpus impracticable, random sampling procedures are employed to eliminate subjective bias in the selection of items for testing.

Once a body of material has been identified it has to be coded, that is, researchers armed with a set of categories examine the material to see if the categories apply or not. Analysis presupposes that a theoretical question has been addressed to the material. For instance, in relation to pictorial advertisements, questions such as 'How often does an image of the family appear? In these images is the man or the woman the dominant figure?' might be put. Coding in this case would involve (1) identifying and counting the images with families; and (2) identifying and counting the frequency in (1) of (a) male dominance, and (b) female dominance. Ideally, different researchers using the same criteria should code all items in an identical manner, but one can well imagine divergences of opinion arising concerning what constitutes dominance in a particular image.

When coding is complete the researchers are left with a mass of data which can be arranged and manipulated - by computer if necessary - in various ways. It is from this material that inferences, interpretations and generalizations are made. The kind of conclusions that are reached may be of the type: '75 per cent of all TV adverts using females were for products in the kitchen or bathroom'; 'Twice as many women as men in TV adverts were shown with children.' From such results it would then be possible to make certain generalizations about the status of women in society as perceived by advertisers. Although the generalizations might not represent new information, they would provide objective evidence in support of existing impressions.

As a method, content analysis has been criticized on various grounds. For example, it has been pointed out that high frequency is not always a sign of significance: an item which occurs only once can be of more importance in certain circumstances. Also, measures of frequency give no indication of intensity or quality: the dominance of a figure in an advert could be slight or extreme. To measure such qualitative differences between items, a separate scale of values would have to be predefined for coding. Some writers are highly sceptical of the idea that culture can be measured. Theodor Adorno, for instance, once responded to such a request: 'I reflected that culture might be precisely that condition that excludes a mentality capable of measuring it.'[10] Even so, Adorno was given to qualitative judgements – a measurement of sorts.

It could also be argued that the meaning of, say, a text cannot be fully comprehended without taking into account the actual context and readership. An analysis of 'content' in the abstract may, therefore, yield results which are in practice invalid.

The main value of content analysis – which as far as I am aware has not been applied to any great extent so far by design historians – is that it is a way of increasing the precision and objectivity of the historian's observations. It can also, on occasion, generate new and unexpected insights.

The Typological Approach

Earlier it was argued that when design historians focused their attention upon designed objects, it was groups and series of objects which interested them rather than single items. Works of art are generally unique artefacts, hence it is legitimate for an art historian to analyse an individual work. Designed goods, by contrast, are generally manufactured in batches, with the result that there are many sets of identical objects and series of objects with minor variations. (Modern automobile manufacture increasingly consists of a basic make which can be purchased with different colours and finishes and with various kinds of accessories.) Given this, it is more sensible and economic for design historians to base their analyses and generalizations upon groups

and series of products. One way of grouping objects is according to type.

Edward Tiryakian has defined a type as follows: 'A type as its etymology suggests (from the Greek *typos*, an impression, a cast, a model) has recurrent, general distinctive features which are not the properties of the individual as such.'[11] Typological classification, he adds, is a subdivision of taxonomy closely related to morphology, the study of forms. When we consider the totality of artefacts they appear to fall 'naturally' into types; they are 'inductively arrived at rather than formally deduced *a priori*'.

For example, all washing machines share a common function. Today, most of them are also similar in form and appearance. The connection between a single machine and the whole class is a token/type relationship. If all the makes of washing machine now being manufactured were to be grouped together and compared, then certain variations of form, colour, quality, mechanism and price, due to differences within product ranges and differences between manufacturing companies, would become obvious. These differences would then need explaining. This would be an exercise in *synchronic* analysis. A *diachronic* analysis of the washing machine would consider the evolution of the type from its invention and early, primitive forms to its current sophisticated state.

Sorting objects into types can be a complex operation because major types always seem to include a host of subtypes (a genus/species situation). For example, the furniture-type 'chair' encompasses thrones, Windsor chairs, armchairs, typists' chairs, dining chairs, deckchairs, stacking chairs and so forth, which vary in their materials, forms and uses. Objects such as park benches and bar stools clearly share the same overall function as chairs – seating – but somehow do not seem to belong to the type 'chair'.

As societies have developed and human culture has become more specialized and differentiated, the number and variety of types of artefact has increased exponentially. So, however onerous the task of classification, it has to be undertaken if the subject matter of design history is to remain manageable.

Some scientists would argue that, ideally, a typology ought to be exhaustive, that is, it should identify all the types within a particular field of inquiry, but identifying all the types of designed goods and buildings in modern society would be an enormous task. If it could be achieved, the result would be a complete classification of society's material culture according to type at a specific moment in time. Such a record would provide present and future scholars with a comprehensive picture of our society's technical and cultural development.

In his illuminating study of the application of the biological analogy to architecture and the applied arts, Philip Steadman discusses the type/token relation and also how types evolve.

> The type is what is transmitted in copying. It is the set of 'genetic instructions' which are somehow passed from one generation of craftsmen to another ... artefacts themselves in some sense serve to carry *information* about their own functioning and manufacture through time ... such information passes through the heads of craftsmen ... there exists in the mind of the craftsman in some form the type, or image, or model for a species of artefact, which guides him when he comes to make a new copy ... it is not individual artefacts which evolve ... It is abstract *designs*, of which particular artefacts are concrete realizations. The distinction corresponds to that made in biology ... between the *genotype*, which is the 'description' of the species transmitted through biological heredity, and the *phenotype*, which is the physical embodiment of what is described in the individual organic body.[12]

In early twentieth-century German design theory, the concept of type-forms was extremely influential. Muthesius and Gropius, for instance, regarded types as supra-individualistic because they were the result of the work of many designers over long periods of time. It was argued that after an initial period of technological development and experiment in which various forms were tried, a standard type-form would emerge (as a result

of a process of selection akin to that taking place in natural evolution) and that once this had been perfected, no further development of the type would be necessary or desirable.

One vexed question concerning types is their relation to styles. Charlotte and Tim Benton remark about the British architecture of the 1930s: 'The sheer range of available styles ... makes it difficult to generalise except by building type, patronage group and functional programme. Many of the books about architecture during the decade resorted to a typological approach. A correlation between building type and style is usually possible. Different styles were used, more or less automatically, to express different social functions at various levels of the social hierarchy.'[13] They claim, for instance, that 'it was fairly natural that progressive buildings expressive of new programmes (in health, welfare or education) should adopt a progressive image', that is, the modern style.

Nikolaus Pevsner's *A History of Building Types* (1976) discusses 20 different kinds of building including government offices, national monuments, theatres, libraries, museums, hospitals, hotels, railway stations, shops and factories. It is evident from this list that social function was the basis for Pevsner's classification. He arranges his types in a sequence running from the most monumental, most ideal, to the least monumental, most utilitarian. A contemporary survey of buildings according to type would produce such piquant juxtapositions as ancient cathedrals and modern airports. (A typology encompassing the whole of recorded history would include building-types which no longer exist.) Comparisons between cathedrals and airports are unlikely to be fruitful, and one can also envisage criticism on the grounds that typologies are a-historical, though of course historians can, if they wish, trace the temporal development of each type separately (in parallel as it were). Many architectural histories confine themselves to the study of a single type of structure, for example, bungalows, castles, cottages, country houses, brothels, skyscrapers, etc., and there are design histories which confine themselves to a single type of artefact, for example, the sewing machine, the Windsor chair, the stiletto heel shoe.

Pevsner's book has been criticized by Anthony D. King as follows:

> While giving many interesting insights into the social function of the buildings discussed and including a wealth of valuable data, [it] relies primarily for explanation on the contribution of individual architects and prevailing styles. The selection of buildings is principally from the work of known architects, and there is no general explanation of why the form of building types changes beyond an implicit evolutionary model; there is no explanation of why buildings serving the same function have different forms in different societies. To some extent, this issue is avoided by limiting the book's compass to European and American society (i.e. parts of the world dominated by Western tradition or civilization). The questions of change and cultural variation are avoided.[14]

King is the editor of another text focusing upon building-types entitled *Buildings and Society* (1980). It contains essays on insane asylums, hospitals, prisons, temples, apartments, vacation houses, restaurants and offices. This somewhat curious set of examples was the consequence of the contributors' desire to explore the relation between built/spatial forms and the various social and cultural forms or institutions which gave rise to them: crime and the law gave rise to prisons, the Hindu religion gave rise to temples, the institution of the family to houses, and so forth. In order to highlight temporal and cultural similarities and differences, all the types analysed were taken from different periods and places. To preclude purely technological and stylistic accounts, an interdisciplinary approach was considered vital, so contributors were chosen who had knowledge of sociology, anthropology and urban planning as well as the history of architecture.

A valuable point King makes in his introduction concerns the first appearance of a new building-type. This is important, he maintains, because it marks a significant shift in the way a society organizes its needs. King's premiss is that the building/society relation can be read in both directions: we can learn about a

society by studying its buildings, and about buildings by studying the society in which they occur.

No account of the typological approach to the history of design would be complete without a consideration of Siegfried Giedion's famous text *Mechanization Takes Command: a Contribution to Anonymous History (MTC)* (1948). Giedion (1888–1968), a critic, historian, lecturer, journalist and social anthropologist, was born in Switzerland and after his education in Europe he worked in the United States. He had degrees in mechanical engineering and art history, hence his interest in machines, engineering and factory organization as well as art and design. Giedion was a friend of the architects Gropius and Le Corbusier and a secretary of the Congrès Internationaux d'Architecture Moderne (CIAM). He was an enthusiastic supporter of the modern movement and his ideas on space-time in architecture were influenced by cubism.

In the introduction to his book – *MTC* – Giedion justifies his approach and discusses the question of method. His aim, he says, is to trace 'our mode of life as affected by mechanization – its impact on our dwellings, our food, our furniture . . . We shall deal with humble things, things not usually granted earnest consideration, or at least not valued for their historical import . . . The slow shaping of daily life is of equal importance to the explosions of history . . .' Here Giedion deliberately eschews the 'great events' type of history and the 'classic designed object' type of history. The subtitle of *MTC* also signals a rejection of the 'great designers' kind too. Significantly, Giedion was a student of Wölfflin, the advocate of 'an art history without names'. Of course, Giedion does mention names but biography is not his focus and the people he cites are as likely to be inventors, entrepreneurs, painters, scientists and philosophers as designers and architects.

MTC is a monumental text (743 pages) covering long periods of time and an array of topics. The main theme is the impact of mechanization upon factory production, agriculture and the home. Surprisingly, the mechanization of war is not addressed. Subsidiary subjects include locks, scientific management, assembly lines, tractors, slaughterhouses, meat and bread, furniture, posture, nineteenth-century taste, servants, cleaning,

refrigeration, the bath, bathing. Evidently, *MTC* is as much a history of industry, technology and social customs as it is a history of the design process.

Giedion's concept of type was much broader than certain kinds of physical artefact. For example, he traces the history of bathing from ancient times to the present in relation to two basic types of bath: 'the bath as an ablution and the bath as total regeneration'. In other words, 'the bath' refers as much to a kind of social behaviour or custom as to a material thing. Giedion's point is that the character of the artefact is linked to the character of the social behaviour of its users, and that it is the relation between the two which should concern the historian. *MTC* therefore includes a good deal of information about humanity's manners and habits – which vary from culture to culture and from age to age – and also their changing conceptions of ideas like 'comfort'. When Giedion does discuss particular products he generally situates them within larger systems: the washbasin as one element in the layout and mechanical services of a bathroom, for instance.

Giedion's reasons for adopting the typological approach were as follows:

A treatment of problems suited to our day will constantly bear interrelations in mind. This leads to a typological approach. The history of styles follows its theme along a horizontal direction; the history of types along a vertical one. [Horizontal equals diachronic, vertical equals synchronic?] Both are necessary if things are to be seen in historical space.

We are interested in following the growth of phenomena, or if one will, in reading their line of fate, over wide spans of time. Vertical sections make it possible to trace the organic changes of a type. How far a type need be followed back into its history varies with the case ... some of the developments will call for far-reaching retrospect, others only for rapid backward glances. What is essential is the panoramic and simultaneous view. This may lead to discontinuous treatment ... Conceiving of history as *constellations* ...

His use of the word 'constellation' and elsewhere his reference to 'fragments', suggests the influence of Walter Benjamin's historiography, even though Benjamin's name does not appear in the index.

MTC has two claims to fame, first as a founding text of design history which went some way towards achieving a social history of design, and secondly as an influence upon discussions of the Independent Group at the ICA in London during the mid-1950s.[15]

Penny Sparke's concise text *Electrical Appliances* (1987) is a recent example of a typological history very much in the tradition of Giedion's *MTC*. Sparke's subject matter is not a single kind of product but a range of British and American products distinguished by (a) the nature of their energy source and (b) their role as domestic utensils, that is electric refrigerators, ovens, kettles, irons, fires, radiators, vacuum cleaners, washing machines, food mixers, dishwashers, frying pans, toasters and coffee/tea makers. As one would expect, Sparke devotes considerable attention to designers, their appliances and to the evolution of individual products over time, but she also broadens the context by considering technological advances in the power supply and manufacturing industries. Furthermore, since the existence and character of appliances in the home cannot be understood without reference to social issues and historical changes, she also discusses housework, the question of servants, the status of women and feminist attitudes towards labour-saving machines.

So far the examples of types cited have tended to be buildings or artefacts. It should be remembered that human beings too can be categorized according to social type. The 'yuppie' is a contemporary example. Peter York, the design and style journalist and marketing consultant, is notorious for his perceptive and witty dissections of English social types such as the Sloane Ranger and the Mayfair Mercenary.[16]

Various general criticisms have been levelled against this approach. For example, Tiryakian has argued that it lacks the flexibility to deal with individual items on their own merits; he also observes: 'sophisticated users of typologies have fully

realized that quantitative differences between individuals as-
signed to the same category may be ... as significant as quali-
tative differences between the categories themselves. In other
words, differences in degree are as essential to a good typology
as differences in kind.' Typological classification, he continues,
is rarely contextual and tends to exclude temporal and spatial
factors. Furthermore, a typology may have a sterile effect by
'freezing' artefacts into a set of fixed categories, hence his con-
clusion: 'the upholding of typologies and a typological classifi-
cation is a conservative position.'

In spite of this, it is unlikely that design historians will be
able to dispense with the notion of type. Providing scholars take
note of the dangers and ensure that the social context and his-
torical development of types are explained, there seems no
reason why they should not continue to find the approach fruit-
ful.

National Histories of Design

Designed goods are often promoted by reference to their nation
of origin and some histories of design are written in terms of
national achievements or characteristics. The relation of design to
the nation and nationalism therefore needs to be considered. To
some degree this question has been addressed in the discourse of
design, as in the 1985 exhibition at the Boilerhouse Project, Vic-
toria and Albert Museum on the theme of national characteristics
in design, the catalogue text for which was written by Jonathan
Glancey.

National histories are, of course, commonplace in the history
of art, as are discussions of the type 'the Englishness of English
art'. The latter was, indeed, the title of a series of Reith Lectures
which Nikolaus Pevsner gave in 1955.[17] He described the lec-
tures as a contribution to 'the geography of art', arguing that
artists are determined by their country/nationality as well as by
the spirit of the age in which they live and by their individual
temperaments. English artists, he claimed, were notable for their
empiricism (they are observant, interested in particulars), toler-
ance, detachment and rationality (the ability to select and use

styles according to purpose, a pragmatic political attitude 'judging each case on its merits'), a liking for tall perpendiculars and long horizontals but also, at times, a love of flowing or flame-like lines, and a concern with nature (landscape painting and gardening) which, Pevsner says, was due to 'a climate which favours an outdoor life'! Modern historians will find Pevsner's mode of analysis too simplistic: a heterogeneous artistic heritage, a complex history of hundreds of years is reduced to a few stylistic and formal characteristics which are then 'explained' in terms of a set of presumed essential factors of the national culture and the physical environment. At the same time it is intriguing to see how in the case of tolerance Pevsner makes connections between artistic qualities and political attitudes or traditions.

For materialist historians the concept of nation is extremely problematical. Nations and countries (these two ideas are not identical in all cases) are not fixed by nature – they come into being and disappear; their boundaries and names change over time. As Raymond Williams points out in his discussion of the word 'nationalist', the concept of nation originated in an association of racial grouping and political formation: claims to be a nation in the racial sense usually predated the formation of a nation-state in the modern political sense.[18] Most countries have a mixture of races, regions, languages and cultures, so the idea that a nation's essence is the culture of one homogeneous race of people who occupy a specific area of land is untenable. Evidently, the concept of nation is a historical, ideological and political construct, a construct moreover which is subject to constant revision and which is the site of continual struggle between different factions within the nation-state.

Two texts are helpful in understanding nationalism: Benedict Anderson's *Imagined Communities* (1983) and Ernest Gellner's *Nations and Nationalism* (1983). Anderson identifies three paradoxes: the objective modernity of nations according to the historians versus the subjective antiquity according to nationalists; the formal universality of nationality as a social-cultural concept versus the particularity of its concrete manifestations; the political power of nationalisms versus their philsophical poverty and incoherence. A nation, according to Anderson, can only be

defined as an imagined community in the sense that it is what the members of a group think or believe unifies them.

Gellner argues that nationalism, although apparently based upon ethnicity, was an ideological concept which emerged at precisely the time folk, peasant and tribal cultures were being subordinated to larger political units: the age of nationalism coincided with industrialization and the destruction or incorporation of agrarian societies. Generally, the advocates of national identity were town- and city-based intellectuals who imposed their views on the population at large. In the twentieth century, many nation-states have been created as a result of political decisions taken by imperial powers shedding their empires or by the victors of major wars.

Attitudes towards nationalism vary considerably. Patriots are fervent believers in their own nations whereas internationalists despise nationalism as a primitive, reactionary form of consciousness which is the source of much human strife and war. Even some patriots are unhappy when the idea of the good of the whole nation prompts socialist governments to *nationalize* privately-owned industries.

In spite of the mythical nature of the concept of nation, it does have material consequences: people are willing to fight and die to create or preserve their nation; laws control who can and cannot belong to a nation. Furthermore, despite the inexorable growth in travel, population movement and international communication systems, there are still real, material differences between the products of different countries. How then are we to account for these differences if the concept of nation will not serve?

The land, geology, climates and material resources of countries vary. Certain features of Swedish design have been explained in terms of the country's harsh climate but, presumably, this factor also applies to Norway, Finland, Canada and the North of the Soviet Union. Also, goods designed for export need not be determined by the climate of the originating country. Where buildings are constructed from local materials which are specific to that area, then distinctive kinds of vernacular architecture can result. These real, material differences are, however, more

likely to be regional than national. Differences between regions and countries were greater in the past. The persistence today of traditions of craftsmanship, training, styles and so forth can also generate real differences between one nation and another. Yet it could be argued that in most cases these differences are likely to be minor compared to what manufactured products the world over have in common. Let us now consider the question of internationalism before returning to the issue of national identity.

Early modern architects and designers sought to transcend nationalism. Their aim was to solve design problems in a rational manner using new materials and technologies. Such solutions, they thought, would be universally valid, hence the origin of the label 'international style'. Today, few firms can exist by selling just to home markets. And since goods have to be marketed internationally, even globally, this has led to the emergence of huge multinational companies whose goods are made in several countries and whose loyalty is not to any one nation.[19] Products such as cars are often designed in one country, manufactured in another and assembled in a third. It has become commonplace to refer to the national content of products in terms of percentages – '70 per cent British' – but what percentage has to be in digenous before it can be considered as belonging to that nation?

Internationalism in trade and manufacture has created an increasing homogeneity and standardization of design: the same jeans and TV programmes are to be seen virtually the world over; the consumer goods of one country look much the same as those of another. The national airline of one country may purchase its aeroplanes from another: national identity is communicated solely by the livery of the aircraft and the uniforms of the crew. In this situation minor differences of style and material can take on an increased significance and value. And, as firms become conscious of the homogenizing trend, they seek to resurrect the idea of national identity through design and advertising in order to give their products a distinctive character however spurious it is in reality. The ideological construct of nation is thus streamlined and mobilized for use as a marketing strategy. How the myth of national identity is sold in this way is most vividly seen in the tourist industry, as Donald Horne explains:

Nationality can be one of the principal colourings of the tourist vision. Turning ancient objects into 'monuments' began largely to occur while the nation-states were forming and concepts of nationality were being created. Whether recognizing it or not, as tourist-pilgrims we pay our respects to nationality; most obviously, in tourism's most stereotyped cultural forms – the souvenir, the national dish, the national drink, the picturesque quarter, the quaint folk ceremony, the phrase book, national dress.[20]

He also points out that even relatively universal forms can seem national: 'in England, architectural styles from romanesque to regency were derived from other cultures, yet they can be presented as distinctively English.'

Another element contributing to the internationalism of design, the endless diffusion of styles and ideas, is the fact that designers travel and work in different countries. Many British-born designers, trained in Britain's art and design colleges, find employment in Italy where, presumably, they contribute to the Italianness of Italian design! Designers do not even have to travel to be aware of design trends elsewhere: the importation and exhibition of foreign goods, and the existence of heavily illustrated magazines enable them to keep abreast of whatever is happening in Milan, New York and Tokyo. A fashion designer resident in London can, therefore, easily make use of traditional Japanese dress or produce an eclectic mix based on styles 'borrowed' from several foreign nations. To re-export such clothes as 'British' would surely be a form of self-deception.

As the world increasingly becomes a global village, the prospect of a unified world culture draws nearer. Such a development would yield important advantages but there are many who would regret the loss of cultural and linguistic diversity. One factor militating against the globalization of design is the present possibility of a shift from large-scale mass production to small-scale batch production. In this way goods can be tailor-made for specific groups of consumers. Markets, it is argued, are no longer mass markets, they are plural and fragmented, hence the need

for 'niche' design and marketing to reflect and reinforce these differences. Advertising executives are also now calling for more 'character' in design, for greater variety and individualism. Diversity is thus likely to be artificially maintained by manufacturers in order to sell goods.

In the Boilerhouse exhibition, products from Britain, France, America, the Soviet Union, Italy, Sweden and Germany chosen to exemplify the various national identities were compared and contrasted. (This list reveals an exclusive concern with the advanced nations; Third World countries were not considered.) Glancey's catalogue text argued that national design differences do exist and that they are an aid to selling goods. He also acknowledged that modern products are highly standardized but noted that this was more marked in how they worked than in how they looked. Even so, he maintained: 'there are certain ways of engineering that remain peculiarly American, French or German. These reflect important cultural, economic and geographical differences.'[2] One interesting way of explaining national identity he employed was to point to the worldview of the dominant group in a particular society. For instance, he argued that West Germany is a 'thoroughly bourgeois country with thoroughly middle-class ideals – hard work, industry, hygiene and seriousness of intent', which accounted for the extremes to which the functional aesthetic is taken there.

Another scholar with an interest in German design is John Heskett. He is the author of a book on design in Germany and was a consultant to a public relations exhibition of West German industrial design subtitled 'Images of Quality' shown at the Science Museum, London, in 1987. Heskett argues that the products of West German industry and commerce 'can be considered as an expression of contemporary German culture'.[22] The show consisted of a few items by a few prestigious companies – Mercedes, Braun, Siemens, Bosch, Krups, etc. The common denominator, according to Heskett, was 'a sense of value embodied in the concept of quality'. West German design does have the image of fine quality/advanced engineering, but is this true of all its manufactured goods? A wider selection of items including tourist

kitsch might well have revealed a different story. And is quality not achieved by other countries? If so, it cannot be claimed to be exclusively West German.

What is Glancey's opinion of West German design? He too acknowledges that 'the image of efficiency is all important'. Its products have a reputation for solid engineering and reliability. He notes a preference for black and white as against colours and uses terms like 'cold', 'stern', 'clinical' and 'rational' to characterize the Germanness of West German design. However, he also points to negative aspects of its design ethos: 'heaviness', 'massive dullness', 'a lack of design flair'. Efficiency too, he says, is sometimes an illusion created by the design. A historical view of the German people suggests a different picture: their fondness for romanticism, kitsch, vulgarity and fascist ideologies. Are we to conclude that a fundamental change of character has taken place or is the present hygienic and rational image simply the sign of massive repression in their collective psyche? And to what extent can the contribution to the German economy of the Turkish 'guest' workers be considered 'expressions of German culture'? All these questions indicate the complexity of the issue of national identity in relation to design.

In her 1983 book *Consultant Design* Penny Sparke observes:

> While Germany sells design in the name of science, Italy in the name of art, Scandinavia in the name of craft and the USA in the name of business, all these nations' images of design were necessary strategies in the highly competitive world market of the immediate post-war years.[23]

Such shorthand accounts of national identities which reduce them to a single characteristic are surely untenable: nations are too complex and diverse to be encapsulated in this way; they possess manifold characteristics, many of which are shared by other nations. What could distinguish nations is not any one characteristic but a particular configuration of characteristics which achieves dominance at a certain time. This then becomes naturalized and stereotypes emerge – the British as a nation of

shopkeepers, for example – which can persist long after the actual composition of a nation has changed.

Anthropology and Design History

As an example of the relevance of an *extrinsic* discipline to the study of the history of design, anthropology will now be considered. Anthropology was one of the human sciences founded by European intellectuals in the mid-nineteenth century (*anthropos* – a word element meaning 'man'). It now has two main branches: physical and cultural (or social) anthropology; the latter is the most relevant to the design historian. Anthropologists study the origins, development and varieties of human societies and cultures. They are fond of comparing and contrasting different societies – especially tribal and modern industrial ones – in order to highlight the diversity and relativity of human experience. They are interested in all human customs, rituals, social structures and systems of interaction and exchange, myths, languages, modes of production and consumption, technologies and material artefacts. Their concept of material culture – the shelters, weapons, tools, craft objects, ornaments, body decor and so on that humans make – is of particular and obvious interest to design historians because the category includes designed goods.[24]

A particular objective of anthropologists is to understand the rules or laws governing social life, for example the rules concerning kinship and marriage. Complex theories based upon the analysis of language have been evolved for this purpose: structuralism is one example. (For the relevance of this topic to design history see 'Structuralist and Semiotic Approaches'.)

Anthropology originated in the context of European colonialism. Early scholars studied foreign native cultures which were markedly different from their own. These cultures tended to be perceived as primitive, backward, fossilised, inferior, abnormal and non-historical or static. Otherness also had an exotic appeal. Modern anthropologists are now aware of the dangers of paternalism and Eurocentrism and they seek to understand and

respect cultural otherness and to conduct research with their subjects in a relationship of equality not dominance. They also now realize that the presence of an outsider has an impact upon the people being studied and that this has to be taken into account when drawing conclusions about the normal functioning of the society. There are, perhaps, lessons here from which design historians could benefit. They too need to show a tolerance and respect for the design tastes of others which the historians themselves may not share. They too need to consider the impact of their presence when conducting interviews and observations.[25]

Since design in the modern sense is a feature of advanced industrial/consumer societies, the validity of anthropological findings based upon the study of undeveloped, small-scale tribal cultures can be questioned. Nevertheless, as certain tribal practices such as tattooing, body painting and adornment also occur in advanced cultures, it is to be expected that writers on fashion like Ted Polhemus and Lynn Proctor will draw upon the work of anthropologists and juxtapose illustrations of tribal and urban subcultural examples.[26] However, the emphasis of some anthropologists on functionalism - whereby the elements of a system can only be explained in terms of the functions they perform in relation to the whole - implies that the roles played by, say, face painting/cosmetics are likely to be different in a tribal society than in a modern, urban one.

To qualify the above: some anthropologists have studied advanced societies. Richardson's and Kroeber's analysis of fashion changes in the dress of European women, discussed earlier, is an example. Another is Pierre Bourdieu's survey of tastes in modern France (of which more later). Bourdieu has been described as a social anthropologist and as a sociologist. This is a sign that when anthropologists look at contemporary society their discipline seems to become indistinguishable from sociology.

What should be of value to design historians are the research methods employed by anthropologists, particularly fieldwork. Where methods of observation, interviewing and photographic documentation are applied to a modern, urban situation - as in the case of Daniel Miller, an anthropologist from University College (London), who has been studying the variety of ways

London tower block residents have altered and adapted their originally identical kitchens over a number of years – anthropology and design history (and indeed sociology) appear to converge.[27]

Although anthropology has close connections with archaeology and is concerned with the origins and development of human cultures, many of its analyses have been synchronic rather than diachronic. Since it is *history* which interests design historians most, this is a drawback as far as they are concerned. Anthropologists, it has been argued, employ a concept called the 'ethnographic present':

> a special tense that aims to concentrate past, present, and future into a continuous present ... [it] has more merit than a reconstructed and misconstructed time dimension. It synthesises into one temporal point the events of many periods, the value of the synthesis lying in the strength of the analysis of the perceived present. Whatever is important about the past is assumed to be making itself known and felt here and now. Current ideas about the future likewise draw present judgements down certain paths and block off others. It assumes a two-way perspective in which the individual treats his past selectively as a source of validating myths and the future as a locus of dreams ... the ethnographic present assumes an unchanging economic system.[28]

Design historians may well feel that this conception is not appropriate for their needs.

As social beings, humans enter into relations with one another. One form this reciprocity takes is the exchange and circulation of goods. Goods can be bartered or exchanged as gifts and/or for money. Almost anything can become a gift but in contemporary society certain products are specifically designed and manufactured to serve this purpose. Any light which can be thrown upon this behaviour will be of value to design historians, hence the relevance of such works as *L'essai sur le don* (1924), a study of gift-giving in 'primitive' societies by the French anthropologist Marcel Mauss.

A more recent text addressing a similar theme is *The World of Goods: Towards an Anthropology of Consumption* (1979) by Mary Douglas and Baron Isherwood. This book is itself an inter-disciplinary project: Douglas is an anthropologist and Isherwood an economist. They set out to answer the basic questions 'Why do people want goods?', 'Why do they acquire the goods they do?' by comparing the findings of economics and anthropology. Studies of peoples outside the industrial system, the authors con-tend, suggest that goods are desired and selected not merely for their particular use-values but as markers within larger communi-cation systems and as a way of imposing identity and sense on the environment: 'Goods assembled together in ownership make physical, visible statements about the hierarchy of values to which their chooser subscribes.'[29] It is this which explains why certain goods are preferred to others. While this text does not deal di-rectly with the factor of design in the selection process, any light which can be thrown on the behaviour of consumers and the question of taste is clearly of importance to design historians.

As a discipline, anthropology has existed far longer than design history. Its reflections on theory and method are thus much more extensive and sophisticated. Anthropological literature addresses such topics as evolution, diffusion, typology, func-tionalism, the comparative method, periodization, causality and determination, social structures and material culture. (An over-view is provided by Marvin Harris's *The Rise of Anthropological Theory* (1968).) An examination of this literature could save design historians troubled by theoretical questions a great deal of time and effort.

The Social History Approach

Social history is one of the key schools of contemporary history-writing. (There is even a Social History Society and a journal with the title *Social History*.) Reflections upon its character and origins can be found in Eric Hobsbawm's article 'From social history to the history of society' (1971) and in the seven re-sponses to the question 'What is social history?' published in *History Today* (1985).

According to Hobsbawm, the term 'social history' was in the past used in three, sometimes overlapping senses: (1) the history of the poor or lower classes (this encompasses histories of the 'people', the peasantry and the labour movement plus 'subordinate' groups like children and women); (2) the history of the manners and customs of everyday life; (3) the history of society with a strong emphasis on the economy (socioeconomic histories).

None of these versions of social history, Hobsbawm claims, produced a specialized academic field until the late 1950s. In this respect, therefore, it is a fairly recent development. Raphael Samuel ascribes the current popularity and character of the 'new' social history to the cultural revolution which took place in the 1960s.[30]

Since the total object of study of social historians is the history of societies (societal history), their subject matter is potentially infinite – it includes everything that exists and happens within society. Nevertheless, according to Hobsbawm, scholars have tended so far to focus upon certain themes: demography and kinship; urbanism; classes and social groups; mentalities (that is, forms of collective consciousness); large-scale transformations such as modernization and industrialization; social movements and social protest.

It could be argued that the word 'social' in social history is redundant since all history-writing must inevitably address itself to human societies or aspects of them. This has prompted several historians to argue that social history is not an autonomous field of study but a methodological or interpretative approach which became necessary as a counter to other ways of writing history which used to dominate the discipline.[31] Social histories date from the late nineteenth century: J. R. Green's *Short History of the English People* appeared in 1874. Before this time historians favoured a 'great events, great men' type of history; what have been called 'drum and trumpet' histories. Social history emerged in contrast and opposition to this prevailing mode. Instead of focusing upon the actions of governments and ruling elites, it concerned itself with the experience of the mass of ordinary people, with the mundane happenings of everyday life,

and with material and popular culture as against constitutional and administrative issues. Hence G. Trevelyan's famous definition of social history, in his 1944 text *English Social History*, as 'the history of the people with the politics left out'. (Presumably, a truly adequate social history would have to cope with both the rulers and the ruled, with both rare and expensive goods and cheap, mass produced ones, otherwise a one-sided account of the past would result.)

The presence of the word 'social' indicates a stress upon social relations and the assumption that individuals are, necessarily, social beings. Individuals tend not to be studied as such except in so far as they belong to social groups such as classes, castes, occupations, the family and so forth. Attention also shifts from the will and personalities of individual actors to impersonal forces like the economic. In recent years, social history has come to be regarded as the appropriate way of writing histories of art and design; it can no longer claim an 'alternative' status.

Politically, most social historians are on the left. This explains their interest in, and identification with, subordinate classes and groups. Edward Thompson's well-known book, *The Making of the English Working Class*, is a prime example. Nevertheless, there is nothing inexorable about the link between the left and social history. Right-wing historians can and do study the customs and habits of social groups. Nor is the subject matter of social history limited to the lower classes: there are social histories of the aristocracy and the bourgeoisie. Similarly, in architectural history examples of social histories of palaces and country houses exist alongside those dealing with cottages and working-class housing.

Given that social histories can be written from various political perspectives, it is perhaps helpful to distinguish between *social* histories, *socialist* histories and *Marxist* histories. In the latter, emphasis would be given to the struggle between the classes and the conflict between the forces and relations of production as causes of change. The historian would identify with the struggles of the exploited against their oppressors.

What a Marxist account of design might look like is indicated by Frederick Engels' chapter on 'The great towns' in his book *The Condition of the Working Class in England* (1845), especially

his analysis of the way the main streets of Manchester were organized for the benefit of the bourgeoisie in such a way as systematically to conceal from their gaze the areas of dismal working-class dwellings behind them.

Hard and fast distinctions are, however, difficult to maintain because many socialist and Marxist historians have employed the term 'social history'. In a recent attack on the post-1960 vogue for the social history of art, Nicos Hadjinicolaou has argued that this mode of history-writing is being used as an 'alibi' for a 'more principled commitment' to historical materialism.[32] '

The social history approach has been entrenched within the discipline of art history for a number of decades. It is associated with the work of such scholars as Arnold Hauser, Frederick Antal, Francis Klingender and T. J. Clark. Design historians have tended to take their cue from these writers rather than from other social historians.

Art and design historians are, of course, only concerned with parts of the total social process: they have to establish the relative autonomy of art and design within society as a whole. But this part/whole relationship immediately gives rise to the 'foreground/ background' problem: how does 'foreground' (art, design) relate to 'background' (social context)? Clark has commented on this issue in his book about Courbet, *Image of the People* (1973):

> What I want to explain are the connecting links between artistic form, the available systems of visual representation, the current theories of art, other ideologies, social classes, and more general historical structures and processes . . . If the social history of art has a specific field of study, it is . . . the processes of conversion and relation . . . I want to discover what concrete transactions are hidden behind the mechanical image of 'reflection', to know *how* 'background' becomes 'foreground'; instead of analogy between form and content, to discover the network of real, complex relations between the two. The mediations are themselves historically formed and historically altered; in the case of each artist, each work of art, they are historically specific.[33]

With this programme in mind, let us consider some examples of social histories of design to see what they entail.

John Gloag is the author of several books on British design which can serve as early, somewhat crude examples of the social history approach. His 1961 book, *Victorian Comfort: A Social History of Design from 1830-1900*, for instance, is a broad account of products and services which ministered to the desire of the Victorian middle classes for comfort both physical and moral. Over-ambitiously, the text considers corsets, chairs, interior design, fireplaces, memorials and monuments, plus various forms of transport, entertainment, sports, pastimes and festivities. Habits, manners and tastes are discussed as much as design itself. There is nothing about the world of work and much of the content can be described as anecdotal. This type of social history seems to have been aimed at the general reader and, although highly factual, had no pretensions to scientific rigour.

A more recent and sophisticated attempt at a social history of design is Adrian Forty's *Objects of Desire* (1986), subtitled 'design and society'. This text concerns the period 1750 to 1980 but there is no linear, chronological account, nor is the subject matter consistent throughout. Forty limits himself to a small number of topics and themes in order to treat them in depth: for instance, design and mechanization; differentiation in design; the home; the office; electricity; and corporate identity. He pays little attention to individual designers and instead sets out 'to show the ways in which design turns ideas about the world and social relations into the form of physical objects. Only by exploring this process and by shifting our attention away from the person of the designer can we properly comprehend what design is ...'[34]

Discussing the re-design of a Lucky Strike cigarette packet – which involved a change of colour from green to white – Forty explains its success in terms of an ideology of hygiene, purity and cleanliness so pervasive within American culture that it was seen as symbolizing Americanness by immigrant groups aspiring to a national identity. Design, in Forty's view, casts 'ideas about who we are and how we should behave into permanent and tangible form'. It is, in other words, an objective, material realization

of ideology and desire. This suggests that the analysis of designed objects can give direct access to the ideas and emotions of a social group; it perhaps overlooks the processes of mediation T. J. Clark discussed.

In addition to design historians who have adopted the social history approach, there are social historians who have tackled design-related subjects. John Burnett, for instance, is a professor of social history at Brunel University and the author of *A Social History of Housing, 1815-1985* (1986). His book is conceived as an alternative to those histories of architecture which only concern the styles of 'important' houses. Its aim, he declares: 'Is to describe the types of accommodation, both existing and new, which were available to the majority of people in the period 1815 to the present day (in England), to measure and evaluate changes in housing quality over time and seek an explanation of the determinants of built form'. Among the chapters are: 'Middle-class housing', 'Housing the labourer', 'Housing the suburbans', 'Council housing' and 'Speculative housing'. These reveal Burnett's interest in the relation between design and class, occupation and the public and private sectors. He claims his book is not an economic history of housing nor of the social policy of housing. In the case of middle-class estates he seeks to explain their design in terms of social factors such as demographic and family structure changes, an increasing shortage of servants and so on. From the point of view of the design historian, the main danger of this approach is that the bulk of the content will concern social context and determinants, while house design itself plays a minor role.

Another text on housing is relevant here even though its author, Mark Swenarton, does not make use of the term 'social history'. *Homes Fit for Heroes* (1981) is a detailed exploration of the relationship between politics, ideology and the design of state housing in Britain in the aftermath of the First World War. In his introduction, Swenarton claims that 'historians and sociologists deal with politics and society but leave out design' while 'design historians look at design and ignore everything else – or at best relegate it to what is called "the social background" which, by its name, implies that design and society are not involved

in a single process but are separate and distinct.' He continues:
'In this book a very different view is taken. Design is treated not
as a question divorced from politics and housing policy but ...
as a central part of politics and policy.'[35]

Swenarton's book was, in part, written as a corrective to cer-
tain materialist histories of urbanism which gave priority to
economic factors, in particular the 'collective consumption'
theory of Manuel Castells. In his conclusion he writes: 'The evi-
dence of "homes fit for heroes" shows that the attempt to lo-
cate the determinants of housing policy solely at the material
level does not work.' Later he says: 'The ideological aspects of
design have been largely ignored by historians of architecture
and design ... One of the reasons for this is that for designers at
the drawing board, the suggestion that design is an ideological
process is largely incomprehensible since it seems unconnected
with their own daily experience.'[36]

In sum, Swenarton's thesis is that the design of the houses for
the returning soldiers of the British army in a period when pol-
itical revolutions were taking place elsewhere 'was to prove to
the people that revolution was unnecessary ... it was through
the design of buildings that the state hoped to instil into the
population ideas favourable to the continuing existence of the
status quo.' He adds:

> The conventional phrase 'the social function of design' involves
> a good deal more than is usually allowed. For the inference
> from 'homes fit for heroes ' is, first, that design is not, as it
> is usually presented, a self-contained affair that those inter-
> ested in 'society' can leave to the design specialists; and
> secondly, that the processes of ideology are not confined to
> those channels dealing explicitly with ideas (education, the
> press, television, etc.), which have usually been identified as
> the 'ideological apparatus' of society. On the contrary: it
> seems that design – the silent testimony of inarticulate ob-
> jects – is one of the ways in which 'suitable' ideas are propa-
> gated and reinforced.[37]

Swenarton's emphasis on the role of ideology and politics in

relation to design reflects significant developments in left-wing thinking during the 1970s, in its attempt to produce a more complex account of social processes than the vulgar materialist ones ascribing everything to economic factors.

Buildings and Society (1980), a collection of essays edited by Anthony King, a lecturer in sociology and environmental studies, has already been cited in the section on typologies. It is also relevant here because its theme is 'the social development of the built environment'. (The word 'building' in the book's title was preferred to 'architecture' because the authors did not want to confine themselves to 'high style' structures.) The editor contends that buildings cannot be regarded simply as physical entities because they, and indeed the entire built environment, 'are essentially social and cultural products. Buildings result from social needs ... Their size, appearance, location and form are governed not simply by physical factors (climate, materials or topography) but by a society's ideas, its forms of economic and social organization, its distribution of resources and authority, its activities, and the beliefs and values which prevail at any one period of time.'

He also argues that there is a reciprocal relationship between society and buildings: 'As changes in society occur, so does change in its built environment ... Society produces its buildings, and the buildings, although not producing society, help to maintain many of its social forms.'[38] The two-way process means that buildings can be used to study society and vice versa.

Through a series of case studies the book seeks to explore the relationship between built form and social factors. Emphasis on the actual design of buildings is what distinguishes this approach, King claims, from urban sociology, a sub-discipline concerned with the political economy of cities and regions. It is worth pointing out that although there is a close connection between social history and sociology, their aims are still different: sociologists are not normally concerned with history and what they hope to achieve above all is an understanding of the 'laws' governing social life.

To summarize just one case study from the book: King's account of the growth in popularity of the vacation house in

England from the late nineteenth century onwards. Four main factors are cited:

1. Advances in industrial capitalism produced a larger economic surplus which enabled more people to buy or rent a second house.
2. Increasing differentiation of space and building as society became more complex and specialized. A greater variety of types of buildings developed and some seaside towns became specialist holiday centres.
3. Changes in the social organization of time due to industrialization and progress in transportation. Working hours were reduced and became more standardized. Paid, longer holidays and more leisure time enabled the use of vacation houses. The 'weekend' became a social institution. Railways, bicycles and then cars meant that people could reach their second home more easily.
4. The wider diffusion of the cultural and ideological values of the elite. Aristocrats normally possessed town and country residences. This ideal spread to the middle classes and then to the working class.

King goes on to explain that bungalows fulfilled a need for solitude (an escape from urban crowds) or served as a place to renew the family. The pressures of city life generated a desire for a simpler, more rural life and this influenced the design of vacation houses. For example, picture windows and verandas brought inside and outside closer together.

The popular formulation 'design *and* society' is unsatisfactory because it implies design is separate from society; diagramatically, it produces two vertical columns with a list of design events in one and more general historical events in the other; what connects the two remains unexplained. 'Design *within* society' is much better but still gives rise to a foreground/background or internal/external dialectic. (Clark's programme was intended to make the study of mediations between foreground and background more rigorous.) The challenge to design historians is to demonstrate how the design process is embedded within

particular social relations which it helps to reproduce or to alter. One theorist - Michael Thompson - has objected to the symmetry of statements like 'society shapes design and design shapes society' on the grounds that they assume 'not just some recognizable persistence but eternal repetition'. He adds: 'But our buildings were not always as they are now, nor were we always as we are now, and in using such a formula we impose a static understanding upon a changing reality.'[39] So whatever model is adopted it ought to be a dynamic one capable of accounting for both cyclical change and more radical, fundamental change.

As we have seen, some writers distinguish social factors from economic, political and ideological ones. Any social history of design which excludes the last three would surely be inadequate. Ideally, all relevant factors impinging upon the design process should be considered and evaluated.

Structuralist and Semiotic Approaches to Design

Structuralism and semiotics are frequently discussed together. They have much in common - linguistics, for example - without being identical. (Structuralism is concerned with structures, semiotics with signs.)

Structuralism

Modern structuralism is closely associated with the discipline of anthropology, in particular the work of Claude Lévi-Strauss, who in turn is heavily indebted to the Prague School of Structural Linguistics and the work of Saussure. Structural anthropologists demonstrate their debt to linguistics by treating human culture, myth and behaviour as if they were 'articulated like a language' and by employing terms derived from linguistics such as *langue* and *parole*. During the 1960s, structuralism was one of the most fashionable and influential schools of thought emanating from Paris. Its impact on British scholars was most marked, therefore, in the 1970s.

As its name indicates, structuralism is interested above all in structures, especially unconscious ones. People obey the social

rules of kinship without being taught them in any systematic way; similarly, people speak languages based on systems of grammatical rules without consciously understanding them. It is these deep, hidden structures which the analyst seeks to identify. A structure is a whole or totality consisting of various parts or elements which are systematically related to one another and to the whole. In other words, a structure is not a mere aggregate or composite. Furthermore, structures are dynamic: they are capable of change or, rather, transformation. Structures are governed by sets of intrinsic laws which enable transformations to take place, hence they are capable of *structuring*.

In linguistics it is assumed that language has a surface structure and a deep structure and that the first differs in appearance from the second. It is also assumed that what governs the translation of deep structures into surface structures are certain rules of transformation. Similar rules are considered by structuralists to govern the ability of myths to change their configurations: while the elements making up the variant forms of a myth may differ, their underlying pattern of relations remains the same; this is because they all share the same deep structure. A key aspect of structuralist thinking is that the relations between things are more important than the things in themselves.

It should be acknowledged that there are several varieties of structuralism and several definitions of 'structure'. Lévi-Strauss believes that structures are not directly observable, empirical phenomena but models devised by the analyst as a means of understanding reality. However, he maintains that the best models are 'true', hence a correspondence between model and reality is presumed. A favourite method of analysis in structuralism is the reduction of the complexity of social life to a series of binary oppositions such as nature/culture, raw/cooked. It is sometimes argued that such oppositions are the invariant universal forms of the human mind.

Apart from anthropology and philosophy, structuralism has been most influential in literary criticism. Some structural analyses, however, have also been undertaken in respect of painting, architecture and advertising. Structuralism's relevance to design can, perhaps, be glimpsed in Pierre Bourdieu's analysis of the

spatial orientation and interior layout of a Berber peasant dwelling in Algeria (first published in 1971).[40] Bourdieu begins by criticizing existing accounts on the grounds that mere descriptions and inventories of the contents of Berber houses fail to reveal their underlying meanings and significances. Only a structural analysis which considers the household in terms of the larger society with its religion, rituals, proverbs and conventions governing the respective roles of men and women, he claims, can fully explain the positioning of the house and the arrangement of its parts and contents. Bourdieu's analysis revolves around a series of binary oppositons: male/female, dry/wet, fire/water, day/night, outside/inside, etc., and he assumes that these are analogous or homologous to one another.

Although this kind of analysis is illuminating, the design historian can legitimately object that it is non-historical. Berber society is assumed to be eternal, untouched by the political, economic and social changes affecting Algeria. (The only changes which take place within it are the cyclical ones of religion and nature.) This is, in fact, the principal objection of design history to structuralism. Nevertheless, so long as the historian realizes that what a structural analysis supplies is a synchronic account, then the method can be of value in understanding patterns of human culture – such patterns can, of course, persist for very long periods of time.

In one of his essays, Lévi-Strauss discussed the problem of the relationship between structuralism and history.[41] His conclusion was that they are complementary, not opposed, activities. Whereas structuralists are concerned with the ability of systems to transform themselves while still retaining the same structure, historians are concerned with how such systems originate, reproduce themselves, change and decay.

Another application of structuralism to a design topic is Varda Leymore's book about magazine and television advertising, *Hidden Myth* (1975). The book's basic methodological assumption is that the appropriate unit of study is the product field, that is all the advertisements relating to a single product or service rather than those for one brand or those created by one agency. It is argued that since the products in a product field

are in competition with one another for the same market, their associated adverts constitute a distinct system. To understand any particular advert one needs to consider how it relates to and differs from all other rival adverts trying to sell the same or similar products. It follows that butter advertising cannot be understood independently from margarine advertising. In this instance Leymore's analysis results in a series of homologies: the relationship between butter and margarine is considered equivalent to the contrasts:

> dear : cheap
> concord : protest
> content : discontent
> care : negligence
> love : hate

and when these are reduced to a single contrast called 'the exhaustive common denominator' the result is

> peace : war

Leymore's general conclusion is that advertising plays the same role in modern society as myth does in tribal society, that is, a conservative role. Its overall social function is to resolve, symbolically, the fundamental issues and contradictions of human existence: life and death, happiness and misery, war and peace, and so on. This process, she claims, is unconscious: neither consumers nor advertisers are aware of it.

Again the design historian can protest that while a structural analysis may reveal how advertising works as a symbolic system, it neglects the unique characteristics of individual examples, it ignores advertising's historical development and has nothing to say about the actual material conditions of its production. Another valid criticism, made by David Francis in his article 'Advertising and structuralism: the myth of formality' (1986), is that the elucidation of formal structures of meaning takes place in an empirical vacuum.[42] Structuralists, in other words, simply assume that their analyses are the correct ones without

checking their findings via an empirical study designed to reveal exactly how people read and understand advertisements. Underlying many structuralist and semiotic studies is the rather patronizing assumption that only the theorist can penetrate the ideological smokescreen of advertising whereas 'ordinary people' are its gullible victims.

Other critics have made the points that structuralism is conconcerned with formal relations not content and that it is indifferent to qualitative differences between the items it analyses. For a period, structuralism was a radical intellectual force. Its claim that human behaviour is governed by unconscious structures undermined the traditional humanist faith in the will and genius of individual subjects but it was equally disturbing for left wing thinkers because the assumption that structures were innate dispositions of the human mind implied a fatalism which threatened their belief in the powers of human beings to transform themselves and society by means of revolution or political reforms.

Semiotics

Semiotics has been described as 'the general science of signs, the science that studies the life of signs in society'. Like structuralism, this science became extremely fashionable in France and Italy among cultural and mass communication theorists during the 1960s, though its origins can be traced back several centuries. An International Association of Semiotics was formed in 1969 and it publishes a journal entitled *Semiotica*. Various scholars are associated with the science: C. S. Peirce and F. de Saussure are regarded as its founding fathers and leading contributors include U. Eco, R. Barthes, C. W. Morris, R. Jakobson, A. J. Greimas, T. Todorov, J. Kristeva, V. Propp, T. Sebeok and L. Hjelmslev.

The word 'semiotic' derives from the Greek *semeion* meaning 'sign'. On the continent of Europe 'semiology' was preferred to 'semiotic' but international agreement has settled on the latter term. One obstacle which the novice will encounter in studying this science is the specialist vocabulary associated with it: words like 'signifier', 'signified', 'paradigmatic', 'syntagmatic', 'index',

'denotation', 'connotation' and so on. Every science generates a set of technical terms peculiar to it – they simply have to be learnt – but an added complication in the case of semiotics is that the terms/concepts devised by different theorists do not necessarily accord with one another. This problem obviously causes confusion and limits the coherence of the discipline.

A full account of semiotics will not be attempted here. There are several published texts which can serve as introductions,[43] but our focus is on the relevance of semiotics to design history.

Laypersons think of signs as commercial and informational displays such as road and shop signs, but the concept of sign in semiotics is much wider than this: according to Peirce, 'a sign is something which stands to somebody for something in some respect or capacity'. Signs can refer to real referents (things in material reality), or they can refer to other signs or to themselves (self-reference), and to conceptual entities, that is fictional, imaginary, possible phenomena. The latter capacity means that signs can be used to depict utopian visions but also to tell lies. (The truth or falsity of signs is a separate issue which we cannot enter into here.) Some signs resemble what they represent, others do not. Resemblance is not a requirement for signification; all that is needed is an agreement between two people that such and such a thing should stand for something else. Some signs function by means of exemplification, e.g. a sample of material sent with an order for a large quantity of that material.

Any process involving the communication or experience of meaning makes use of signs, and semiotic research therefore encompasses a vast range of topics from the circus to body language. Indeed, as the whole of human culture can be thought of as a system of signs, semiotics is a crucial science. Umberto Eco has argued that its main objective is to understand 'the logic of culture'.[44]

Human language is the sign system which has been the most studied in the twentieth century. As a result linguistics – as in structuralism – has tended to function as the model for all branches of semiotics and literature has been the artform which has attracted the most sustained semiotic analysis. As a result,

visual signs tend to be discussed via concepts derived from linguistics, rhetoric and poetics. To some degree this has proved problematic because visual signs clearly differ from verbal ones in certain key respects. (It is argued that linguistic signs are arbitrary, i.e. purely conventional, while pictorial ones are motivated, i.e. determined by an external reality.)

Aesthetic signs – works of art – pose special difficulties for the semiotician because it is by no means clear that they can be elucidated by a science based upon the analysis of ordinary language. The aesthetic sign, it is maintained, is language in a special condition of use. Architecture and design can also be included here because they too possess aesthetic qualities. Roman Jakobson once defined poetry as 'organized violence against ordinary speech', hence the understanding of the aesthetic does require knowledge of everyday codes, genres, stereotypes and so on which artists and designers reformulate, transform and transgress.

Let us now examine the inner mechanism of signs more closely. Saussure argued that a sign consists of two elements: the signifier and the signified. Like the two sides of a sheet of paper, they are different yet inseparable. A diagram commonly employed is as follows:

SIGN	
signifier	signified

The signifier is the physical means or media which enable communication to take place: ink on paper in the case of printing, pigment on canvas in the case of painting. The signified is the mental concept associated with particular signifiers; what is meant, in other words. For example, the signified of the signifier 'dog' in English and 'chien' in French is a certain type of domestic animal. (Another way of describing signifier and signified is to talk of the plane of expression and the plane of content.) In the case of 'dog' there is a referent – something in reality to which it refers – but, in fact, signifieds should be distinguished from referents because one can have signifieds without referents. The

signified of the word 'utopia' for example is an imaginary, ideal society, but as yet it has no real referent. Another reason why signifieds and referents are not identical is that it is the sign as a whole which has a referent not the signified detached from the sign:

$$\left.\begin{array}{c} \text{signifier} \\ \hline \text{signified} \end{array}\right\} \quad \text{SIGN} \longrightarrow \quad \text{REFERENT}$$

More complex types of signification involve staggered systems: systems in which one sign serves as the signifier for another sign which in turn forms the signifier for a third sign and so on. Staggered systems enabled Roland Barthes to decode levels of rhetoric and myth in various kinds of communication.

Peirce's terminology is different from Saussure's. He was much preoccupied with identifying and naming the various kinds of sign he encountered. Eventually his list numbered over 60. Most writers on Peirce confine themselves to just three key types of sign: *index*, *icon* and *symbol*. Indexical signs are those in which there is a direct physical relation between sign and meaning, e.g. a windsock gives the direction of the wind because the wind blows it in the direction it is moving; a pen line on a sheet of paper is a trace of the human act of drawing. Iconic signs involve resemblance - they look like what they represent, e.g. a passport photograph. Symbolic signs are purely conventional in character, e.g. the figure of a woman standing for the political concept of liberty; the dollar sign - $ - representing American money.

Although these three types of sign can be discussed separately, they can also be seen as levels in a staggered system. For instance, pen lines (indexical signs) can be drawn in such a way that eventually they form the image of a house (iconic sign). And if that image resembles a particular, famous house - the White House in Washington - then the sign has a real referent and the meaning it conveys will be more than a building because the White House conventionally stands for the President of the United States (symbolic sign). Analysts of visual media have tended to favour

Peirce's three categories of sign – especially index and icon – because of their ability to cope with imagery.

Charles W. Morris, an American theorist, once proposed to divide semiotics into three branches: *syntactics* – concerned with the formal relations between signs; *semantics* – concerned with the meanings of signs, the relations between signs and referents, signs and truth; and *pragmatics* – concerned with the relations between signs and those who produce them and those who receive and understand them. Barthes' *The Fashion System* in this scheme would have encompassed the first two branches but not the third. Historians, no doubt, will feel on surer ground with pragmatics precisely because they are interested in questions like: who in the 1950s found Paris fashion meaningful? Who actually bought and wore it? What did it mean to French society as a whole and to other, foreign cultures?

Pragmatics necessitates a widening of the field of view to include not only texts and messages but addressers and addressees (or senders and receivers, or encoders and decoders) and the particular context in which communication takes place. Roman Jakobson has pointed out that such acts also require a code or language shared, at least in part, by the two participants plus a physical channel or a contact (in the sense of a psychological connection) between the two. There are, therefore, six elements in the situation:

CONTEXT

ADDRESSER $\xrightarrow{\text{MESSAGE}}$ ADDRESSEE

CHANNEL OR CONTACT

CODE

Jakobson also argued that while all these elements may be involved in any message, in many one predominates. This led him to identify six kinds of language function, one for each element:

1. **Context**: the *referential* function (the message refers to context or reality).

2. Addresser: the *emotive* function (the message calls attention to speaker's mood or feelings).
3. Addressee: the *conative* or *imperative* function (the message, e.g. an order, refers mainly to the listener's response).
4. Contact or channel: the *phatic* function (the message, e.g. remarks about the weather, is simply a way of keeping contact).
5. Code: the *poetic* function (the message is self-focusing, it foregrounds the codes of language itself for aesthetic reasons).
6. Message: the *metalingual* function (the message is about itself or other messages).

Although designed goods, fashions and buildings are perhaps not messages in the same sense as speech acts and letters, they can and do communicate ideas. And advertisements are certainly a form of design which deliver messages. So, in so far as designed artefacts can be said to be acts of communication, then Jakobson's six functions will prove of value to design historians in understanding them more systematically.

One troublesome issue in relation to the science of semiotics is the objectivity of the analyst. Can semioticians view communications between senders and receivers from an external vantage point? In order to read signs at all, semioticians must in fact participate in the process of semiosis, and as a result absolute objectivity cannot be attained. When scholars discuss the meanings of an advertisement or a consumer durable, in most instances they are citing their own interpretations. The question arises: how many other people share their interpretations? More emphasis is needed on empirical research to discover how others – the majority of users – 'read' designed goods. Misinterpretation, whether accidental or deliberate, is also crucial because the failure rate of mass media messages and new products is known to be very high.

There are a considerable number of semiotic analyses of visual/ material culture, too many to summarize in detail. They include: C. Metz and P. Wollen on cinema, C. Jencks on architecture, R. Barthes on photography, advertising and fashion, V. Burgin on advertising and photography, J. Williamson and G. Bonsiepe on

advertising, J. Bertin on diagrams, J. Baudrillard and M. Bense on design, U. Eco on comics, architecture and television, D. Preziosi on the built environment, D. Hebdige on subcultures, P. Bogatyrev on costume and folk theatre. As is evident from this list, aspects of graphic design and media have received more attention from semioticians than industrial design.

Barthes' *The Fashion System* blends structuralism and semiotics. As our previous description indicated, the historical development of clothing was deliberately excluded by Barthes, so his study was entirely synchronic. The analysis, based upon material in two French fashion magazines of the late 1950s, resulted in a highly technical account of the various codes making up the signifying system of fashion. Anyone who turns to this book expecting to find out what 1950s Parisian fashion looked like is in for a disappointment. No clearer example could be found to illustrate the difference between a history of dress and a semiotic account of it.

A writer who has subjected Barthes' book to a searching critique is Jonathan Culler.[45] He detects serious methodological problems in Barthes' work: to understand the rules governing the 'fashionability' of a garment, he argues, one needs information about unfashionable garments which Barthes fails to supply because he restricts himself to what is exclusively fashionable. Furthermore, since Barthes claims to be interested in the general mechanisms of the fashion system he ought to have considered more than just one year's examples to discover if different combinations were in operation at other times, otherwise one might confuse the particularities of a single year with the general properties of the system. Culler's conclusion is that Barthes' results are indeterminate and unverifiable.

To demonstrate very briefly how architecture can be analysed semiotically, the example of a triumphal arch will be considered. The signifier in this case is stone in the form of an arch, while the signified is the human emotion or concept of triumph; the sign is thus an arch of triumph. Evidently, the 'referent' of such an architectural sign is its function. And this sign is only fully realized when the arch is used as part of the route of a triumphal procession. The form of the arch is ancient, traditional and

specific to certain cultures. Its shape derives, one presumes, from the habit of people lining a route to acclaim victors by raising their arms or holding branches over them. It could be said, therefore, to be residually iconic or representational in its form. The permanence of its materials, the monumentality and massiveness of its structure can also be seen as signifying features: the more permanent the arch the more enduring the triumph, the larger the arch, the greater the victory.

An arch is a simple structure with a single meaning. Much more complicated buildings and assemblages of buildings exist whose 'messages' pose a greater challenge to semiotics. If a plain cotton mill can be regarded as a work of prose, then an elaborate cathedral can be thought of as a work of poetry. Hence, the analysis of the most complex types of building prompts semioticians to mobilize the vocabularies of rhetoric and poetics. In the case of a structure which makes reference to an earlier building, one can speak of 'quotation' or 'paraphrase' or 'pastiche', and one can describe the first building as 'metalinguistic' because it 'speaks' about another one. Analysts who try to apply the linguistic analogy systematically seek to establish which of the constituents of architecture – space, materials, forms, proportions – might be equivalent to those of language – phonemes, words, phrases, sentences. No two architectural semioticians seem to agree, so the discussion about these issues is long-winded and arcane. For a range of articles see *Signs, Symbols and Architecture* (1980) edited by Geoffrey Broadbent and others, which includes an ambitious article by Charles Jencks on the nature of the architectural sign.[46]

To the cultural theorists of the 1960s, and certain artists and critics of the 1970s, the value of semiotics was that it provided a more sophisticated analytical methodology than had hitherto been available. Many of these individuals hold left-wing political views and semiotics initially appealed because it promised to expose the workings of dominant cultural forms such as advertising, thereby revealing their underlying ideologies. In *Mythologies* (French edn, 1957) Barthes set out to demythify. Later, he passed through a more scientific phase – *Elements of Semiology* (1964) – but he ended by calling for a 'semioclasm', that is, an

irreverent deconstruction of signs. Within a few years the radical, critical potential of semiotics had dissipated and the science had been incorporated into the academy. It is now a fairly orthodox mode of analysis used in a host of subject areas. Even that which it set out to criticize has absorbed it: advertisements in magazines like *The Face* include quotes from Barthes.

Ultimately, professional semioticians are interested in the general laws governing sign systems and codes; the study of particular examples is only a means to that end. Historians, however, are concerned with specific examples for their unique qualities. Semioticians and historians also differ in that the history of signs is normally irrelevant to the former who seek only to understand how sign systems work. Nevertheless, in spite of these different objectives, the science of semiotics can be of use to design historians as a tool for naming and analysing complex signs. At least this has been my experience in examining the various kinds of signs – pictorial and linguistic – making up H. C. Beck's famous 1930s diagram of the London Underground tube system.[47] However, to achieve a comprehensive understanding of the diagram, the semiotic analysis had to be supplemented by discussion of its origin, development through time (its various editions), function, and its relationship to the referent (the rail network and geography of London).

Semiotics is also relevant to design historians because some designers, keen to increase their mastery of communication processes, are incorporating the science into their design methods.[48] Designers, after all, rework existing signs and construct new ones. Their control or freedom in this respect is, however, a matter of debate because of the social nature of signification: without shared codes and bodies of knowledge communication between people would be impossible.

Notes and References

1. J. Physick, *The Victoria and Albert Museum: the History of its Building* (Oxford: Phaidon/Christies, 1982) p. 236.
2. A. Clifton-Taylor, *The Pattern of English Building* (London: Faber, new edn 1972) pp. 25–6.
3. S. Katz, *Plastics: Designs and Materials* (London: Studio Vista, 1978) p. 64.

4. G. Semper, *Der Stil* 2 vols (Frankfurt: 1860-3) p. 1.
5. M. Iverson, 'Style as structure: Alois Riegl's historiography', *Art History* 2 (1) March 1979 pp. 62-72.
6. F. de Saussure, *Course in General Linguistics* (London: Fontana/ Collins, 1974) pp. 3-4.
7. Saussure, ibid., p. 218.
8. For a discussion of the comparative method see E. Leach, 'The comparative method in anthropology', *International Encyclopedia of the Social Sciences* vol 1 (New York: Macmillan & Free Press, 1968) pp. 339-45.
9. There are a number of books about content analysis, for instance: O. Holsti, *Content Analysis for the Social Sciences and Humanities* (Reading, Mass: Addison-Wesley, 1969); K. Krippendorf, *Content Analysis: an Introduction to its Methodology* (Sage Publications, 1980). See also the discussion of the strengths and weaknesses of content analysis in *Mass Communication and Society, the Study of Culture 2, Unit six: Messages and Meanings* (Milton Keynes: Open University Press, 1977) pp. 30-3, 56-7.
10. Adorno quoted in M. Jay, *The Dialectical Imagination: a History of the Frankfurt School* (London: Heinemann, 1973) p. 222.
11. E. Tiryakian, 'Typologies', *International Encyclopedia of the Social Sciences* vol 16 (New York: Macmillan and Free Press, 1968) pp. 177-86. Perhaps the most detailed and sophisticated analysis of the problem of defining types is that supplied by David L. Clarke in his book *Analytical Archaeology* (London: Methuen, 2nd edn 1978), the chapter entitled 'Artefact and type'. The discussion presented there is too complex to summarize here and, unfortunately, the systems theory jargon used hinders understanding. However, it is worth pointing out that for Clarke the type is one level in a hierarchy of archaeological entities which his book examines, systematically, from the most elemental to the most elaborate. The levels are: attribute, artefact, type, assemblage, culture and culture group.
12. P. Steadman, *The Evolution of Designs* (Cambridge University Press, 1979) p. 81.
13. C. and T. Benton, 'Architecture: contrasts of a decade', in Arts Council/Victoria and Albert Museum, *Thirties: British Art and Design before the War* (London: Arts Council/Hayward Gallery, 1979) pp. 47-61.
14. A. King (ed), *Buildings and Society: Essays on the Social Development of the Built Environment* (London: Routledge & Kegan Paul, 1980) pp. 6-7.
15. See A. Massey, 'The Independent Group: toward a redefinition', *Burlington Magazine* CXXIX (1009) April 1987 pp. 232-42.
16. See P. York, *Style Wars* (London: Sidgwick & Jackson, 1980).

17. N. Pevsner, *The Englishness of English Art* (London: BBC, 1955).
18. R. Williams, *Keywords: a Vocabulary of Culture and Society* (London: Fontana/Croom Helm, 1976) pp. 178-80.
19. See T. Levitt, 'The globalization of markets', *Harvard Business Review* (3) May-June 1983 pp. 92-102.
20. D. Horne, *The Great Museum: the Re-presentation of History* (London: Pluto, 1984) p. 165.
21. J. Glancey, the Boilerhouse Project, *National Characteristics in Design* (London: Boilerhouse/Victoria & Albert Museum, 1985).
22. *German Design: Images of Quality* (London: Science Museum, 1987) broadsheet.
23. P. Sparke, *Consultant Design: the History and Practice of the Designer in Industry* (London: Pembridge Press, 1983) p. 48.
24. For a discussion of the concept of material culture see J. D. Prown, 'Mind in matter: an introduction to material culture theory and method', *Winterthur Portfolio* 17 1982 pp. 1-20.
25. E. Leach, 'Observers who are part of the system', *Times Higher Education Supplement* 29 November 1985 pp. 16-17.
26. T. Polhemus and L. Proctor, *Fashion and Anti Fashion* (London: Thames & Hudson, 1978).
27. A paper given at the Design History Society conference, London and Brighton, 1987.
28. M. Douglas and B. Isherwood, *The World of Goods: Towards an Anthropology of Consumption* (London: Allen Lane, 1979) p. 23.
29. Ibid., *World of Goods*, p. 5.
30. E. Hobsbawm, 'From social history to the history of society', *Daedalus* (100) Winter 1971 pp. 20-45; R. Samuel, 'What is social history?', *History Today* 33 March 1985 p. 35.
31. John Breuilly has argued that social history should not be regarded as a particular kind of history but 'a dimension which should be present in every kind of history' and Royden Harrison suggests 'it is less a terrain of historical enquiry than a means of conducting one'. *History Today* March 1985 p. 40, 43. The same point is made by N. Hadjinicolaou, 'The social history of art - an alibi?', *Ideas and Production* (5) 1986 pp. 4-16.
32. Hadjinicolaou, 'The social history of art - an alibi?'.
33. T. J. Clark, *Image of the People: Gustave Courbet and the 1848 Revolution* (London: Thames & Hudson, 1973) p. 12.
34. A. Forty, *Objects of Desire: Design and Society 1750-1980* (London: Thames & Hudson, 1986) p. 245.
35. M. Swenarton, *Homes Fit for Heroes: the Politics and Architecture of Early State Housing in Britain* (London: Heinemann, 1981) pp. 2-3.
36. Ibid., pp. 194-5.

37. Ibid., p. 196.
38. A. King (ed), *Building and Society: Essays on the Social Development of the Built Environment* (London: Routledge, 1980) p. 1.
39. M. Thompson, *Rubbish Theory* (Oxford University Press, 1979) pp. 217-18.
40. P. Bourdieu, 'The Berber house' in M. Douglas (ed), *Rules and Meanings: the Anthropology of Everyday Knowledge* (Harmondsworth: Penguin, 1973) pp. 98-110.
41. C. Lévi-Strauss, *Structural Anthropology* (New York: Basic Books, 1963).
42. D. Francis, 'Advertising and structuralism: the myth of formality', *International Journal of Advertising* 5 1986 pp. 197-214.
43. See: R. Barthes, *Elements of Semiology* (London: Cape, 1967); U. Eco, *A Theory of Semiotics* (Bloomington: Indiana University Press, 1976); T. Hawkes, *Structuralism and Semiotics* (London: Methuen, 1977).
44. U. Eco, 'Looking for a logic of culture', *Times Literary Supplement* (3, 735) 5 October 1973 pp. 1149-50.
45. J. Culler, *Structuralist Poetics* (London: Routledge & Kegan Paul, 1975) pp. 32-8.
46. G. Broadbent and others (eds), *Signs, Symbols and Architecture* (Chichester: Wiley, 1980). See also G. Dorfles, 'Structuralism and semiology in architecture' in C. Jencks and G. Baird (eds), *Meaning in Architecture* (London: Barrie & Rockcliff, 1969) pp. 38-49, and M. Scalvini, *L'architettura comme semiotica connotativa* (Milan: Bompiani, 1975).
47. J. A. Walker, 'The London Underground diagram', *Icographic* (14/15) 1979 pp. 1-3.
48. Graphics and information designers have taken a particular interest in semiotics. At the German school of design Hochschule für Gestaltung, Ulm, semiotic analyses of visual communications took place from 1957 to 1960. See: G. Bonsiepe, 'Persuasive communication', *Uppercase* (5) 1961 pp. 19-34; 'Verbal/visual rhetoric', *Ulm* (14/15/16) 1965 pp. 23-40; T. Maldonado, 'Communication and semiotics', *Ulm* (5) 1959 pp. 69-78; 'Notes on communication, glossary of semiotics', *Uppercase* (5) 1961 pp. 5-10, 44-62. See also the three articles on *Information Design Journal* 4 (3) 1986 on designing and semiotics.

Style, Styling and Lifestyle

As products are often characterized by design historians in terms of their style and certain scholars have written histories of design and architecture in the form of a sequence of styles, this is a term/concept which merits our close attention. Before we can discuss the relationship between style and design history, we must first consider the word's meaning and the role the concept has played in the discourse of art history.

Style and Art History

Style is one of the most important critical concepts deployed by art historians. Indeed at one time – during the foundation period of the discipline – it was regarded by some scholars as the principal object of study. It was the emphasis on styles in art, they thought, which distinguished art history from all other disciplines. In fact, the study of style is not exclusive to art historians: anthropologists, sociologists, archaeologists and subcultural theorists also take an interest in it.

Art historians considered style vital because they thought of it as the outward manifestation of the inner being of a person, social group or an age. If one can understand a style one gains, as it were, direct access to the whole value structure of a foreign culture, a bygone age or a social strata. For example, Nicos Hadjinicolaou describes style as 'a particular form of the overall ideology of a social class'.[1] Actually, he dislikes the word 'style' and proposes to substitute 'visual ideology', that is an ideology made visible. If one can understand the reasons for stylistic change through time, one has also acquired a key to the laws of cultural evolution.

Art historians reasoned that if style was inextricably bound up with a time, a place, a people, then it could be used as a diagnostic tool to date anonymous artefacts, to situate them geographically

and to assign them to specific cultures. For this method to work, a relationship of authenticity between style and society had to be assumed, that is, it was believed that later copies and fakes could always be distinguished from 'the real things' because the former could never exactly reproduce the social and material conditions that gave rise to the originals.

For various reasons, problems of attribution have not pre-occupied design historians as much as they have art historians; nevertheless they do occur in certain areas of design. In the field of English furniture, for example, the attribution of an eighteenth-century chair to a famous designer such as Thomas Chippendale can make a tremendous difference to its monetary value and collectability; furniture historians have therefore to cope with the difficulty of distinguishing genuine items from the thousands of spurious ones in existence.[2]

Defining Style

The word 'style' derives from the Latin *stilus*, meaning 'a writing implement', hence the idea of handwriting as the direct expression of individual character. This is surely the origin of the theory of expression which has been so influential in the history of aesthetics; it could also be called 'the signature theory'. The implication here is that one cannot help but reveal oneself in writing and thus handwriting can be used to detect the identity of the author: 'the style is the man'. However, the ability of criminals to forge handwriting throws doubt on this theory.

There is another view of style which can be called 'the rhetorical'. This is the idea that in any complex society various styles of writing and speaking exist and can be learnt or imitated. So style in this sense is very artificial; it is public and social not private and personal. It is also self-conscious not unconscious as in the case of the signature theory. Self-consciousness is particularly evident in the cases of stylization and styling (car styling, hair styling, and so on). Negative connotations are often associated with styling: it is thought of as a final, superficial transformation of an object, as something applied to an object's surface almost as an afterthought, as a kind of packaging.

In such cases an inauthentic relationship is implied between external appearances and inner truth, hence the accusation levelled against some British design in the 1980s: 'all style and no substance'.

Style, in the rhetorical sense, can be viewed as a resource, as a factor in artistic production, in that once a number of styles exist, artists can select which one they wish to use or rework. They can also decide to combine styles to create hybrids. These points become obvious when one considers the cases of stylistic revivals: neo-classicism, Victorian gothic, and so on. And when one considers stylistic borrowings from foreign cultures, for example chinoiserie.

Let us now try to specify the meaning of the term more precisely. Meyer Schapiro, a leading American art historian, has defined style as follows:

> By style is meant the constant form – and sometimes the constant elements, qualities and expression – in the art of an individual or a group – style is, above all, a system of forms ... the description of a style refers to three aspects of art: form elements or motives, form relationships, and qualities (including an all-over quality which we may call 'expression').[3]

This definition emphasizes form and overall expression but says nothing about content. It conforms to the common view that style is concerned with how – the manner or way – something is expressed rather than with what is expressed. Frederick Antal, on the other hand, has argued that every work of art is a specific correlation of form and content.[4] One reason why women's hair was such a popular motif with art nouveau artists was that it lent itself to the exploitation of a favourite form – undulating lines. Judith Genova has also argued that 'style is created by wedding form to content in such a way that the form expresses, that is, metaphorically exemplifies the content.'[5] In the case of a Van Gogh peasant painting, for example, the earth-like colours and plough-like brushmarks reinforce the figurative content of the picture.

The question arises: 'Can designed goods be said to have

content as well as form?' In the case of products with figurative imagery or decorative ornamentation on their surfaces and buildings constructed in the shapes of animals or foodstuffs, the answer is clearly 'yes'. Even in the case of more 'abstract' products such as cars, the style may be designed to 'metaphorically exemplify' such contents as speed or sex. The fact that styles have meanings, that they evoke connotations and associations, suggests that there is always content as well as form or that form itself is a signifying agent. If, for instance, one leaves aside the referent of the London Underground diagram, the saturated colours, sharp edges and geometric arrangement of the lines themselves communicate a set of values – order, clarity, harmony, economy, unity, rationality – which, arguably, are those typical of classicism.

Style is not a concept which can be sensibly applied to a single artefact: it is only valid in respect of artefacts considered as members of groups. To identify an object as belonging to a particular style necessarily implies the existence of other objects with which it has features in common. And the specific character of one style is most clearly seen when it is contrasted with others.

Normally, scholars define a style not by means of contrast but by a checklist of formal or perceptual characteristics. Since any one object may not exhibit all the characteristics of the style in question we can see that the style concept is a kind of *ideal-type* to which concrete examples approximate with varying degrees of precision.

It is sometimes said of a person that she or he 'has style'. This implies there are others who do not. Is it really possible for people not to have style? From the anthropological point of view, everyone has a style because no one can stand outside it. Though it is possible to say that some people have a flamboyant style and others a discreet style, that some are elegant and others inelegant. It is also possible to say that some individuals are extremely style-conscious, while others are careless of their appearance. Given that everyone is subject to style, then a whole society can be analysed in terms of the spectrum of styles from which it is composed.

Some commonly-used style names in the history of art are: animal style, geometric style, Hellenistic, romanesque, gothic, baroque, rococo, Louis XIV, mannerism, Queen Anne, neo-classical, Empire style, art nouveau, international modern. It is clear that different principles govern these names: sometimes they derive from a historical period, sometimes a political leader, sometimes subject matter and sometimes formal characteristics. A style-name such as 'gothic' suggests a unified, homogeneous entity but various subdivisions can occur. Since gothic was an international style, national variants have been identified and these in turn have been further subdivided. English gothic, for example, has been divided into Norman, early English, decorated and perpendicular.

Styles are generally regarded as having life-cycles – birth, youth/maturity/decline and death – and are therefore character-ized as 'early', 'middle' and 'late'. Such terms are not always simply descriptive – they can be laden with moral judgements: for example, calling a late style 'decadent'.

Looking back, it has seemed to some observers that there were long periods in history when whole cultures were sufficiently homogeneous as to exhibit a major unitary style, a *Zeitstil* or style of the age. Wölfflin, for instance, noted a unity between the form of gothic dress and gothic architecture: pointed shoes and pointed spires. Other writers went further and claimed to detect a common spirit of the age – *Zeitgeist* – underpinning all the different spheres of social life. One objection to this idea is that it assumes that the various spheres – religion, law, visual arts, philosophy – have all evolved in parallel at the same rate. This seems unlikely except in very small or highly monolithic cultures. We shall return to the issue of *Zeitstil* and *Zeitgeist* shortly.

Is there such a unitary style for our own age? Most would argue 'no' because what we witness is a plurality of styles, a cul-ture of fragments. Some scholars have argued that the great unitary styles of the past are no longer possible because of the ever-increasing complexity of modern society, the differentiation and desire for autonomy manifested by the separate arts. The British art critic Peter Fuller has also pointed to the lack of a

'shared symbolic order' which could serve as the basis for a common style. Our age is typified not only by stylistic diversity but also by stylistic eclecticism. From the vantage point of post-modernism it is clear that the international style of modern architecture and design was the last attempt to forge a universal style, though perhaps a case could also be made for the para-military styles of fascist Italy and Germany.

One person who regretted the absence of a common German style in the early twentieth century was the Prussian civil servant, historian and founder of the Deutscher Werkbund, Hermann Muthesius. In July 1914 at the seventh annual meeting of the Werkbund, he claimed that architects and designers were moving towards standardization and the adoption of common type-forms. It was only by such means, he thought, that German design could achieve 'that universality characteristic of ages of harmonious culture'. According to Gillian Naylor, what Muthesius sought was 'the transcendence rather than the suppression of individuality; the re-establishment of a universal language of form that could be related to German ideals and German culture'.[6] The artist-craftsmen of the Werkbund, it seems, disagreed vehemently with these propositions and responded by celebrating individual creativity.

On the one hand, style is thought of as the expression of an individual and, on the other, as the expression of a social group. How can the two be reconciled? One answer may be supplied by the analogy with language: all English speakers share a common language but there are individual variations - idolects - and regional variations - accents, dialects. In this way we can speak of individual and group variants of a common style.

Is it possible to regard a style as being unique to an individual? The answer must be 'no' because private styles are as impossible as private languages. For example, Picasso's most famous achievement was cubism, a style shared with Braque and Gris. It is only with great difficulty that some cubist paintings by Picasso and Braque can be told apart. Picasso changed his style continually and, furthermore, he often worked in more than one style simultaneously. If we assume that style is the expression of an artist's personality, then to account for these changes we would

have to postulate radical changes of personality. This is absurd. As Genova puts it: 'Artists may change their styles often in a lifetime without our having to assume severe personality changes.'[7] These conclusions undermine the certainty that styles can provide us with a direct way of understanding the psychology of an individual, a nation or social group.

Certainty is also undermined by the ability of people to adopt styles temporarily without deep commitment: fancy dress for a party; the weekend punk; and so forth. Indeed, it can be argued that a style can be a means of constructing a false identity or a means of masking real identity: the affluent person who dresses like a tramp; the bank robber in police uniform. In other words, all sign systems can be used to tell lies as well as the truth. It follows that we cannot simply assume a transparency between appearances and reality.

Generally speaking, style has been less important to design historians than to art historians. The former have often preferred typological histories to stylistic ones. Also, with modern design the importance of style varies according to the objects being scrutinized: it is crucial in dress, where appearance is normally more significant than function, but less important in engineering, where function generally takes precedence over appearance. Early modern design theory assumed – wrongly as it turned out – that the problem of style would be resolved once and for all: the machine aesthetic, technology and principles like 'form follows function' would determine the shape and appearance of buildings and products, as it were, naturally. All the designer had to do was to find the optimum solution to the design problem and the question of style would not arise. Modern designed goods would, in effect, be styleless.

In spite of this, a number of design books discuss buildings and products in terms of style, for example, the several histories of art nouveau, Stephen Bayley's *In Good Shape: Style in Industrial Products 1900 to 1960* (1979) and Peter York's *Style Wars* (1980). If ornament, the decorative arts and crafts such as textiles are considered to be part of design, then two key works of early art history ought to be cited: Gottfried Semper's *Der Stil in den Technischen und Tektonischen Künsten oder Praktische*

Ästhetik (Style in the technical and tectonic arts, or a practical aesthetic) (1860-3) and Alois Riegl's *Stilfragen* (Problems of style) (1893). Unfortunately, neither of these important texts has been translated into English. Early theorists such as Semper tended to be preoccupied with the origins of styles and their evolution. Since hard evidence about the early phases of human culture was difficult to come by, reconstructions were inevitably speculative. The origins of the different modern arts, Semper contended, were to be found in the material/technical bases of the crafts of earliest times. A classification of materials according to their distinctive natural properties gave rise to the 'technical arts' – textiles, ceramics, carpentry and joinery, masonry and carving - which in turn formed the basis for architecture, sculpture, mosaics, and so on. Once a student of mathematics, Semper devised an algebraic formula to explain style: $\gamma = F(x, y, z, \text{etc.})$ in which 'γ' equals style, 'F' equals function or purpose and 'x, y, z, etc.', equal the various factors – materials, tools, religion, character of the artist, and so forth - whose combination determined the nature of the work in question. Semper believed that while factors varied over time human needs remained much the same, hence function did not alter to the same extent as the factors.[8]

Although Semper's theory included human purposes, it subsequently came to be seen as deterministic and materialist in character. Riegl was critical of it on the grounds that artists and designers have the freedom to work against the natural propensities of materials and techniques if they so wish. The latter were perceived as the friction or resistance against which the *Kunstwollen* (will to art or will to form) had to struggle.[9] Any convincing solution to the problem of the multiple determinants of form and style would, surely, have to take into account the interaction of human desires and the available materials and techniques. And to explain the will of individual artists one would also, presumably, need to go beyond individual psychology to invoke social factors.

Styling

When the characteristics of a style are deliberately exaggerated,

we speak of stylization and styling. A famous example of styling occurred in the American car industry from the late 1920s onwards reaching a climax in the 1950s. The process is described in detail by Alfred Sloan, chairman of General Motors, in his memoir *My Years with General Motors* (1965). A large team of designers was employed by the company, the most famous being Harley Earl. Before the 1920s, car design had been dominated by engineers but once the market became saturated with basic, standard cars, new ways of attracting buyers had to be found. Stylists then became more important than product engineers. While the engines and structures of cars changed relatively slowly, their outward appearances altered more rapidly until, eventually, annual model changes became the norm. Styling was used first to distinguish one line of cars from another and secondly to increase sales by creating a sense of psychological obsolescence, that is, making customers feel that their existing cars were out of date because they were out of style.

Earl and other stylists found that the public was resistant to extreme and abrupt changes of style but if the changes were made step-by-step, year by-year, then in the end quite radical shifts of form and taste could be achieved. In 1954 Earl remarked: 'My primary purpose for 28 years has been to lengthen and lower the American automobile ... Because my sense of proportion tells me that oblongs are more attractive than squares ...'![10] Earl's personal aesthetic motivation ignores the economic and marketing imperatives governing the process of stylistic innovation and change.

Automobile design no longer indulges in the tactic of annual model changes. Indeed, fashion is out of fashion. Contemporary motor manufacturers, especially European ones such as Daimler-Benz, now emphasize the functionality of their products. The style of their cars evolves slowly so that it is clear successive models belong to the same 'family'; this design principle is called 'vertical model homogeneity'. A sense of stylistic unity is also required across the whole range of cars produced by the company; hence, 'horizontal model homogeneity'. Designers now seek 'image control' so that car styles will not date so rapidly.

What many car manufacturers now aim for are long model

runs with steady refinements such as engineering improvements and accessory upgradings as a means of persuading customers to replace their old cars with new ones every few years. Since petrol has become more expensive, streamlining has made a comeback. This has created a high degree of conformity in the external forms of mass volume cars because once the most functional shapes have been scientifically identified, further stylistic variations are virtually ruled out.

Zeitstil and Zeitgeist

The history of European art has often been presented as a linear sequence in which style succeeded style. It is certainly true that over the centuries there has been a succession of different styles, but the false impression may have been created that only one style existed per age – the *Zeitstil* – and that this style exemplified the spirit of the age: the *Zeitgeist*. Modern scholars, however, argue that in all but the most monolithic of states there have been several styles coexisting at the same time; so, if one wanted to speak about 'spirit' one would have to refer to several spirits of the age.

Zeitgeist is a concept of Hegelian idealist philosophy intended to explain the ideological and stylistic unity of a given period. In fact, by postulating a single common denominator – the spirit – it occludes the complexity and heterogeneity of past ages. Most historians, especially materialist ones, are sceptical of the concept and refuse to use it. Nevertheless, it persists in the more popular writings on the history of design. For example, in the 1986 text *Design Source Book* by Penny Sparke and others, the time-span covered – 1850s to 1980s – is subdivided into a series of mini-ages: 'Arts and Crafts 1850–1900', 'Art Nouveau 1890–1905', 'The Machine Aesthetic 1900–1930', and so on, each of which is prefaced by a pictures-captions double-page spread headed 'Spirit of Arts and Crafts', 'Spirit of Art Nouveau', etc. In this kind of scheme there appears to be a circular or tautological relationship between styles and ages: different styles give rise to different ages, while different ages give rise to different styles. Only where the ages overlap is it acknowledged that several

styles can exist simultaneously. Exceptionally, the final period – 1975 onwards – is recognized as an age of stylistic eclecticism where no one style prevails. Hegelians can always win the argument by claiming that eclecticism reflects the spirit of the age now.

A popular style is likely to be manifested across a wide range of artefacts and one thing which can be said in favour of stylistic histories is that they often seek to encompass more than one medium or art form. In other words, they avoid the tunnel vision which can afflict histories confining themselves to furniture, or painting, and so forth. Bevis Hillier's *The Style of the Century 1900–1980* (1983), for instance, includes examples of posters, paintings, furniture, dress, vehicles, buildings, textiles, pottery, book jackets, pop music and interior decor. In his introduction Hillier argues that humble objects can in fact convey the spirit of the time more effectively than masterpieces. His aim, he declares, has been to illustrate the pervasiveness of style and also to reveal its close relation to modes of life: 'style and lifestyle are indivisible'. The title of Hillier's journalistic book is surely misleading: has the twentieth century only one style? Is it really one civilization with one spirit? At the Museum of Costume in Bath they deal not in the spirits of centuries but in the spirits of years: every year one new outfit of clothes by a contemporary fashion designer is acquired for the collection on the basis that it epitomizes the spirit of the year in question.

What those who make use of the *Zeitgeist* concept fail to recognize is that if such a dominant spirit of the age prevails, there are always dissenting groups and individuals who seek to oppose or undermine it.

A plurality of styles does not necessarily mean they all exist on the same plane of equality: it is possible to identify dominant and subordinate styles. Do styles coexist harmoniously or do they vie with one another for hegemony? The titles of Rudolf Wittkower's and Peter York's books – *Gothic versus Classic, Style Wars* – suggest the latter. Of course, styles do not struggle with one another, only people do. Nevertheless, style is a marker of social difference and it is therefore one of the means by which enemies recognize one another – witness the conflicts

between subcultural groups such as mods and rockers, punks and skinheads.

Some histories of art and design – those presenting the subject in terms of a sequence of styles – can also be misleading because they suggest a development in which stylistic change takes place in an autonomous realm, each new style being thought of as a reaction against the preceding one. Such reactions do occur as new generations seek to assert their identities by rejecting the styles of their parents but the link between styles and the people who live them out is frequently overlooked in sequence-type histories. This is the particular value of books about subcultures such as Hebdige's *Subculture: the Meaning of Style* (1979). They locate styles in the lives and habits of particular social groups and consider their social functions: it is argued that styles are symbolic or magical resolutions of conflicts which cannot be solved directly; for example, an expression of strength and aggression by a group with little political or economic power.

In this respect, cultural theorists follow the lead of Marxist art historians such as Antal who argued that the existence of several styles in the same place at the same time could only be explained by the presence of several different social classes or class fractions who felt the need to distinguish themselves from each other.

Designers, at the behest of manufacturers, seek to invent new styles (or refine existing ones) which will appeal to specific market segments. The visible form or 'look' they supply is not simply imposed upon helpless victims – the design may well be based on intensive market research to find out what consumers like and want – but nor is it merely a reflection of existing desires. A successful style involves the convergence of the tastes of both designers and consumers. It is the result of a complex combination of factors, one of which is the current aesthetic situation (this limits what the 'next move' in the style game can be).

In other instances, the impulse towards a new style does not come from the design profession but from the grassroots. The punk style of dress, graphics and rock music, for example, was created in the mid-1970s by disaffected urban youths plus the ex-art school tastemakers Malcolm McLaren, Jamie Reid and

Vivienne Westwood. For a time it successfully resisted incorporation and exploitation by the fashion and record industries. Punk is a good example of a style which permitted individual participants to contribute original elements. In this respect the style's ethos was in accord with the political ideology – anarchism – espoused by most punks.

Style and Social Groups

Perhaps the most difficult theoretical issue concerning style is its relation to the larger social context, to social structures, groups, economic conditions, and so forth. Although the metaphor of reflection – 'style reflects . . .' – is commonly employed, many scholars are unhappy with it because it implies a passive and deterministic relationship. Hebdige's remarks about the punk style and its social setting are useful in this regard because they communicate a sense of the complexity of the relationship:

> Punks seemed to be parodying the alienation and emptiness which have caused sociologists so much concern, realising in a deliberate and wilful fashion the direst predictions of the most scathing social critics, and celebrating in mock-heroic terms the death of community and the collapse of traditional forms of meaning.[11]

> Punks were not only *responding* to increased joblessness, changing moral standards, the rediscovery of poverty, the Depression, etc., they were *dramatising* what had come to be called 'Britain's decline' ... The punks appropriated the rhetoric of crisis ... and translated it into tangible (and visible) forms ...[12]

Hebdige's use of words like 'parodying' and 'dramatising' indicates the knowing, active nature of the punks' relationship to the wider society and to other discourses.

Style is a phenomenon which seems to belong to artefacts (a property of objects). We mostly encounter it in its fixed and finished form; consequently, we may overlook the extent to

which style is made and lived out by particular social groups as one of their ways of communicating and asserting their identity in relation to other social groups.

A clearcut historical example of the relation between design and a social group, design and ideology, was the Shaker furniture produced in New England, Ohio, Kentucky and Indiana between 1790 and 1860. The Shakers were a monastic, puritan Christian sect who valued simplicity, order, cleanliness and fitness for use. Labour and workmanship they regarded as acts of worship. Shaker furniture is noted for its plainness, austerity, grace, practicality, fine craftsmanship and modesty. (Fancy, ornamented articles were condemned as signs of human pride and vanity.) Although individual variations in the forms of the furniture did occur, a common style prevailed. The lives of the Shakers were governed by a communal spirit, hence they opposed private property and discouraged individualism: the names of some Shaker joiners are known but signing pieces was generally frowned upon. Thus Shaker religious values permeated every aspect of daily life including the design of their artefacts. The title of a book about Shaker furniture by E. and F. Andrews puts it in a nutshell: *Religion in Wood* (1966). In the case of the Shakers there appears to have been an organic unity between life and syle. Their way of life has not, however, thrived in the twentieth century; it has dwindled as a result of the influence of the urbanized, mass media, commercial culture of the USA. Meanwhile, the Shakers' furniture has become highly prized by collectors who appreciate it for its historic and aesthetic qualities. In modern America and Europe the concept of lifestyle has taken on a new meaning.

Lifestyle

As we have seen in the case of the Shakers, a visual style can be integral to a way of life. In the past, divisions between ranks and classes tended to be much more sharply defined and cross-class mobility far more restricted than today, so the visual styles associated with particular classes were exclusive and remained unchanged for long periods. (Peter York has remarked: 'Compared

to us, people in the past lived in a style prison.')[13] One cannot comprehend, for example, the appearance and layout of the elaborate country houses built by wealthy Englishmen during the nineteenth century without an understanding of the habits and customs of their owners. Consequently, architectural historians such as Mark Girouard, author of *The Victorian Country House* (1971), and Jill Franklin, author of *The Gentleman's Country House and its Plan, 1835–1914* (1981), find it essential to describe the style of life expected of a Victorian gentleman before turning their attention to the houses themselves. Of course, another way of life entirely was prescribed for the large retinue of servants such houses needed for their upkeep and the design reflected this difference by segregating masters and servants as far as possible.

In recent years the word 'lifestyle' has become extremely popular in the discourses of advertising, journalism and design. While it has the virtue of stressing the link between a style and a way of life, it also implies that this link is no longer organic and unconscious but artificial and self-conscious. The major difference between the past and the present is that lifestyles have become more numerous, varied and, above all, free-floating, that is, they are no longer exclusive to particular classes (or at least not to the same extent). Increased affluence and social mobility has enabled whole sectors of society to purchase lifestyles off the peg. Consumer societies, it is argued, offer a diversity of lifestyles from which people can choose in the same way that they choose between products.

Alvin Toffler's *Future Shock* (1970) contains a perceptive analysis of the phenomenon. His premiss is that there is now a 'value vertigo' brought about by the collapse of traditional, stable value systems; there is also a rapid turnover of values. Since the consensus has fragmented, what remains are pockets or niches of values he calls 'subcults'. Toffler explains how people respond to the new situation as follows:

Faced with colliding value systems, confronted with a blinding array of new consumer goods, services, educational, occupational and recreational options, the people of the future

are driven to make choices in a new way. They begin to 'consume' lifestyles the way people of an earlier, less choice-choked time consumed ordinary products.'[14]

A lifestyle, Toffler continues, is the means by which individuals signal their identification with particular subcults. Each lifestyle is constructed from a mosaic of items, hence it is a kind of 'super-product' offering a way of organizing products and ideas. In terms of social function, a lifestyle offers a sense of identity but it is also a device for reducing the anxiety caused by too much choice. Release is likely to be temporary however because 'as we rush toward super-industrialism . . . we find people adopting and discarding lifestyles at a rate that would have staggered the members of any previous generation. For the lifestyle itself has become a throwaway item.'[15]

Contemporary sociologists and market researchers take a close interest in lifestyles. Market researchers are particularly interested because they want to understand the behaviour and psychology of social groups better (hence the 'science' of 'psychographics' which seeks a rounded picture of consumers by collocating all kinds of information about them) in order to design and target advertising at appropriate segments of the market. Arnold Mitchell, in his book *The Nine American Lifestyles* (1983), presents a 'VALS' typology (values and lifestyles) of the American adult population based upon responses to a questionnaire completed in 1980. According to his analysis, there are four basic groups and nine lifestyles:

> Need-driven groups—11%
> Survivor lifestyle—4%
> Sustainer lifestyle—7%
> Outer-directed groups—67%
> Belonger lifestyle—35%
> Emulator lifestyle—10%
> Achiever lifestyle—22%
> Inner-directed groups—20%
> I-am-me lifestyle—5%
> Experimental lifestyle—7%

Societally conscious lifestyle—8%
Combined outer- and inner-directed group—2%
Integrated lifestyle—2%[16]

The limited nature of this typology seems to contradict Toffler's scenario of infinite choice. It is also of little value to the design historian because it gives no indication of style preferences in the visual, formal sense. Nevertheless, design historians may be encouraged by this kind of research to study the phenomena of lifestyles much more systematically in the future.

Let us turn now to 'consumer sovereignty', that is, the idea that consumers exercise power by 'voting' with their money.

In their selection of products from the vast range available in developed societies, consumers appear to exercise free will in constructing their different lifestyles. Manufacturers of single products certainly find it difficult to control the 'collage' of goods a person acquires, though more and more they attempt to do so: the fitted kitchen replaces a jumble of different items; interior designers offer co-ordinated decorative schemes; and advertising supplies images promoting goods as part of a whole setting of clothes, cars and houses linked by style and price. Much journalistic advice is also purveyed via newspapers and magazines encouraging people to live in specific ways and the mass media of cinema, TV and pop music offer potent role models. Even 'alternative' lifestyles, as Toffler points out, are marketed by their advocates via lectures, books and press interviews. It would seem that lifestyle is almost as much a consequence of commercial calculation and design as any other product.

Toffler's account suggests that everyone in society can participate equally in the lifestyle game but this overlooks the fact that social groups still differ in their possession of economic and cultural capital. Crudely, the range of choice available to the poor is far more restricted than the range of choice available to the rich. In an article about lifestyle based upon Pierre Bourdieu's sociology of taste, Mike Featherstone considered whether or not the issue of class is still relevant to the new consumer culture. His conclusion was: 'The new conception of lifestyle can best be understood in relation to the habitus of the new petite

bourgeoisie, who, as an expanding class fraction centrally con-
cerned with the production and dissemination of consumer cul-
ture imagery and information, is concerned to expand and
legitimate its own particular dispositions and lifestyle.'[17] Later
he adds: 'It is not a question of the new petite bourgeoisie pro-
moting a particular style, but rather catering for and promoting
a general interest in style itself, the nostalgia for past styles, the
interest in the latest style, which in an age which itself lacks a
distinctive style ... have a fascination, and are subjected to con-
stant interpretation and re-interpretation.'

Featherstone's point about the existence of an obsession with
style in the 1980s is borne out by the success of magazines like
The Face and *iD* and clothes shops such as the Next chain. It is
also evident in the copy of many adverts. A writer of a Cadbury
Schweppes advert for 'designer chocolates' observed: 'The key to
the market lay with that great totem of the 1980s ... style.'[18]
Another copywriter, in an advert for expensive cars, vaunted
style as the mark of social superiority, as a way of standing out
from the crowd. Quite shamelessly this elitism was justified in
terms of the new entrepreneurial spirit of the decade. A widening
of inequality was also celebrated: 'Style means living in a different
world ... the tenor of the times has changed and success is back
in fashion, and so is elegance, performance, luxury and refine-
ment ... the stolid egalitarianism of the '60s and '70s is gone,
stylish people know that living well is the best revenge.'[19] (Re-
venge for what? one wonders.)

So, it would seem, the dominant spirit of the present age is
not any particular style but a celebration of style as such, the
purpose of which is to enforce a distinction between the 'haves'
and the 'have nots'.

Style and Fashion

Finally, a note on fashion. Distinguishing between the concepts
of style and fashion is somewhat difficult because in everyday
use the words are interchangeable: one dictionary defines 'style'
as 'a mode of fashion' and 'fashion' as 'a prevailing custom or
style of dress'.

A fashion is really a short-lived enthusiasm – a vogue, craze or fad – for something, whereas a style is a form of design with a distinct character. A style may well be fashionable but it can also be unfashionable. A standard light switch has only two possible states: on or off. Similarly, fashion has only two possible conditions: either in or out. Fashions come and go with great speed; there is also a turnover of styles but styles can persist long after being fashionable.

Fashions can refer to many kinds of human behaviour but most often they refer to enthusiasms for particular modes of dress: the fashion industry is the commercial sector devoted to the design, manufacture and selling of clothing for everyday and leisure use. This industry has a vested interest in the dynamic of fashion because a twice-yearly change (autumn and spring collections) ensures constant production and profitability. By regularly introducing new lines, designers outmode existing fashions thereby creating customer dissatisfaction with what they already possess.

Some writers on fashion distinguish it from non or anti-fashion clothes, that is, clothes which ignore the dynamic of constant change.[20] For example, industrial protective clothing designed purely for function and to last as long as possible. Certain 'classic' types of dress – the British city gent's pinstripe suit for instance – resist the cycle of fashion. Such forms of dress are often dubbed 'timeless', though in fact they change by evolving gradually over a number of years.

Since, in the case of clothing, style and fashion are so intimately connected to people's appearance and behaviour, design historians cannot limit themselves to questions of designing and production; they must also address themselves to issues of consumption, reception and taste. Accordingly, it is to these topics that we now turn.

Notes and References

1. N. Hadjinicolaou, *Art History and Class Struggle* (London: Pluto, 1978) p. 104.
2. This point is made by Pat Kirkham in her essay 'Furniture history', in H. Conway (ed), *Design History: a Students' Handbook* (London: Allen & Unwin, 1987) pp. 58–85.

3. M. Schapiro, 'Style' in A. Kroeber (ed), *Anthropology Today* (University of Chicago Press, 1953) pp. 287-312. See also B. Lang (ed), *The Concept of Style* (Philadelphia: University of Pennsylvania Press, rev. edn 1987).

4. F. Antal, *Florentine Painting and its Social Background* (London: Routledge & Kegan Paul, 1948) p. 4.

5. J. Genova, 'The significance of style', *Journal of Aesthetics and Art Criticism* 37 (3) Spring 1979 pp. 315-24.

6. G. Naylor, *The Bauhaus Re-assessed* (London: Herbert Press, 1985) p. 43.

7. Genova, 'The significance of style'.

8. On Semper see: Lawrence Harvey, 'Semper's theory of evolution in architectural ornament', *Transactions of the RIBA New series* (1) 1885 pp. 29-54; L. Ettlinger, 'On science, industry and art: some theories of Gottfried Semper', *Architectural Review* 136 (809) July 1964 pp. 57-60; J. Rykwert, 'Gottfried Semper and the problem of style' in D. Porphyrios (ed), *On the Methodology of Architectural History* (London: Architectural Design Profile, 1981) pp. 11-15; N. Pevsner, *Some Architectural Writers of the Nineteenth Century* (Oxford: Clarendon Press, 1972) pp. 252-68; W. Hermann, *Gottfried Semper: in Search of Architecture* (Mass: MIT Press, 1985).

9. On Riegl see A. Quintavalle, 'Alois Riegl 1858-1905', in *On the Methodology of Architectural History*, pp. 16-19; M. Iverson, 'Style as structure: Alois Riegl's historiography', *Art History* 2 (1) March 1979 pp. 62-71. Discussions of Semper's and Riegl's ideas are also to be found in E. Gombrich, *The Sense of Order: a Study in the Psychology of Decorative Art* (Oxford: Phaidon, 1979).

10. Earl, quoted in, A. Sloan, *My Years with General Motors* (London: Sidgwick and Jackson, 1965) p. 297.

11. D. Hebdige, *Subculture: the Meaning of Style*, (London; Methuen, 1979) p. 79.

12. Ibid., p. 87.

13. P. York, *Modern Times: Everybody wants Everything* (London: Heinemann, 1984) p. 8.

14. A. Toffler, *Future Shock* (New York: Random House, 1970) p. 305.

15. Ibid., p. 317.

16. A. Mitchell, *The Nine American Lifestyles* (New York: Macmillan, 1983).

17. M. Featherstone, 'Lifestyle and consumer culture', *Theory, Culture and Society* 4 (1987) pp. 55-70.

18. Cadbury Schweppes advertisement, *Observer* (business section) 11 October 1987.

19. V. Woods (associate editor of *The Tatler*), Vauxhall Motors advertising copy, *Sunday Times Magazine* 13 November 1983.
20. For example T. Polhemus and L. Proctor, *Fashion and Anti-fashion: an Anthropology of Clothing and Adornment* (London: Thames & Hudson, 1978).

9

Consumption, Reception, Taste

In the main, design historians have focused upon aspects of production – designers, designing, manufacture – and the analysis of products rather than upon an equally crucial dimension – the role of users and consumers. I am including a brief discussion of consumption, reception and taste to correct this imbalance.

So far there is not one comprehensive text dealing with design and consumerism. Anyone proposing to research this subject would need to refer to a wide range of literature touching upon its various facets. For example, writings by political economists about the nature of goods/commodities and their relation to human needs; economic and cultural histories of affluent societies; studies of the mass media and advertising; histories of shops and shopping; publications about leisure and tourism; material on consumer rights and consumer associations; analyses of lifestyles. The challenge would be to bring all these strands together while still keeping design as the central theme.

Given the magnitude and the disparate nature of the literature about consumption and consumerism, a summary will not be attempted. It is also assumed that the arguments for and against the consumer society are familiar, so they will not be rehearsed here. The problem for the design historian with existing publications on consumption is one of specificity. There are numerous highly informative books and articles, for instance, about advertising – semiotic and ideological critiques abound – but since a large proportion of them have been written by sociologists, media and communication theorists, the role played by design tends to be given short shrift. Of course, there are books by designers who have worked in advertising agencies which discuss the design process, but these suffer from the opposite fault: they are weak on history, socioeconomic context and theoretical understanding.

Consumption

Compared to 'customer' or 'user' the word 'consumer' has slightly pejorative connotations. To consume food is to appropriate it and use it up. In the process the food is destroyed or at least broken down and, once the goodness has been extracted via digestion, there are waste products. Similar processes are at work in consumer societies: goods are acquired, used, adapted and, when worn out or obsolete, thrown away. No precise date for the birth of consumer societies first in America and then Europe can be given because they evolved over several centuries. (In Britain most people think of the present consumer society as dating from the 1950s and 1960s.) Even so, their main features are clear: industrial manufacture, mass production methods; a capitalist, free-market economy; a reasonably affluent population with disposable income; developed systems of distribution, marketing, advertising/mass media, retailing, mail order and hire purchase; an incredible number and variety of products, appliances and services from which to make a choice. (One critic has referred to 'the misery of choice' in a consumer society.)

Design historians need to pay attention to consumerism because design plays a vital role within it. Design can improve the functionality of consumer durables (the constant redesign of products can also make them worse), but it is also a means of creating differences between basically similar goods. New inventions and redesigns are essential to the dynamic of consumerism: they create new needs, new desires, dissatisfaction with what already exists via the mechanism of psychological obsolescence.

Exactly what takes place when people consume or use designed goods or environments will be considered shortly under the heading of 'Reception'. The fact that consumers vary in terms of the desires and preferences they bring to the marketplace will be discussed in the section on 'Taste'. But first a word about shops and advertising.

Before consumption proper can take place people have to be informed what products exist and where to acquire them. In other words, between manufacturers and consumers are the

realms of distribution, marketing, advertising, mail order, shops and shopping. Although all these topics are closely related both logically and in daily life, writers tend to treat them in isolation. Even single topics are subject to fragmentation. Shops, for instance, have been discussed as part of the history of business, as part of the history of interior design and display, and as part of the history of architecture. This is unfortunate given the fact that in today's department stores, supermarkets, shopping centres and malls, a total shopping experience, a spectacle of consumption, is offered which brings into play environmental and interior design, narrative themes, commodities, credit cards and entertainment. A 1987 television programme about the huge American shopping malls and the people addicted to them was more effective in describing this phenomenon – because it was visual, because it considered the mall as a totality and because it showed it in operation – than a purely architectural analysis of the buildings.[1] Walter Benjamin's lyrical accounts of nineteenth-century Parisian shopping arcades anticipated the work of these programme makers.[2]

Shops are significant places because they are where use-values are translated into exchange-values, where consumer goods are exchanged for money, that is, become commodities. Since shops and stores compete with one another, design is an important means of increasing their appeal to customers and differentiating themselves from rivals. Customers do not, of course, buy a shop's interior decor and display style, but these factors are part of a shop's 'image', part of the shopping experience, and customers certainly 'buy' this 'image' along with the goods they purchase.

Differently styled goods require differently styled display settings. If the context is inappropriate and unsympathetic, the goods will seem out of place; they may not reach their intended audience either. It was precisely dissatisfaction with the places and manner in which his furniture designs were displayed which encouraged the young Terence Conran to establish his own retailing outlets: the Habitat chain of stores, a detailed account of which is given by Barty Phillips in *The Habitat Story* (1984).

Because of their large purchasing power, chainstores are in a position to influence manufacturers, to insist on good quality

materials, higher standards of workmanship, uniformity of pro-
duction, and to determine the design of the goods they order.
As Goronwy Rees explains in his history of Marks & Spencer –
St Michael (1969) – this was one of the policies which contributed
to the remarkable success of the British chainstore.

Huge department stores were an urban phenomenon of the
mid and late nineteenth century. They marked an important
stage in the modernization of consumption and retailing. Essen-
tially they were business enterprises created by and for the
bourgeoisie. Histories of Bon Marché in Paris and Harrods in
London make clear the close fit between the goods and services
provided by the stores and the lifestyles of their middle-class
clientele. In a sense such emporia were the engines of the con-
sumer culture we know today.[3]

Consumption is so closely associated with the purchase of
commodities from shops by private individuals that there is a
danger of overlooking the fact that, as citizens, everyone uses or
is affected by design decisions taken in the public realm – such
things as town planning, the design of public utilities and build
ings, highways and rail systems, military establishments and
equipment, hospital and welfare services. In these fields the
consumers' spending power can have an influence but to achieve
change they may also need to resort to pressure groups and the
political process. In advanced countries campaigning by both
pressure groups and politicians is now a process which increas-
ingly depends upon the skills of the designer.

Advertising plays a crucial role in consumerism by mediating
between manufacturers, retailers and the public. Like shops,
advertisements provide goods with a context (usually mythical)
and with an image (generally glamorous) which the viewer may
not be able to discount. The vehicle of presentation is also vital:
the adverts in a glossy women's magazine, for instance, are
imbricated in its general look and ethos. Editorial matter and
adverts make a totality which offers readers a specific lifestyle.
Janice Winship has undertaken a critique of the British magazine
Options, launched in 1981, which, she concludes, presents a
particular fantasy-model for its readers to emulate which she
calls 'Superwoman'.[4] It is significant that the title of this

magazine pays homage to the central notion of consumerist ideology – choice.

Visual advertisements are particularly rich objects of study for design historians because not only do they promote and depict designed goods but are themselves instances of design. As aids to selling they can be analysed in terms of their commercial function but as visual signs they can be analysed in terms of their iconography, pictorial rhetoric and aesthetic appeal. Of greatest value to design history are those theorizations which attempt to synthesize these modes of analysis, as in the 'commodity aesthetics' approach developed by the German neo-Marxist writer Wolfgang Haug.[5]

Reception Theory/History

Reception aesthetics dates from the late 1960s. It was developed principally in relation to literature when theorists became interested in the subjective responses of readers, in the multiplicity of readings texts generated, and in the part played in the contemporary experience of a work of art of knowledge of past interpretations. Mainly German scholars were involved: H. R. Jauss, B. Zimmermann, H. Link, G. Grimm, W. Faulstich and W. Iser.[6] This is not to say that the approach was unknown in the visual arts. However, the difference between art and literary criticism is that the theoretical and methodological problems of reception were more explicit and developed in the latter than in the former.

Some theorists make a distinction between reception and impact studies: reception describes the initial phase of assimilation, while impact refers to the effects which follow. Reception theory challenges the autonomy of texts, and by implication designed goods, by arguing that interpretations and evaluations are determined not only by the nature of the texts and goods themselves but also by the character of the receiver or consumer. Readers of Marx will recall he once observed that goods obtain their 'last finish' in consumption.

Empirical studies of psychological responses to works of art and sociological studies of the audience for art have, of course, been undertaken for many years, but reception theory is a

significantly different approach. Reception theorists are willing to make use of the findings of such empirical research but they also consider the wider social processes, institutions, contexts and structures which condition and limit the responses of viewers. One error which reception theorists have been keen to avoid is the 'affective fallacy' identified by the literary critics W. K. Wimsatt and M. C. Beardsley in the 1940s: that is, treating the psychological processes of viewers under the impact of a work of art as the work itself. If this happened the history of art would be replaced by the history of art appreciation. Wimsatt and Beardsley's position is that a work has a material existence external to the viewer which structures the viewer's response. Furthermore, a work cannot be equated with just one person's response because its meaning and significance is objective in the sense of being an intersubjective phenomenon. The challenge facing the theorist is to comprehend the interaction between work and viewers, the dialectical relationship between object and subjects, without losing sight of either polarity.

An earlier concept concerned with the subjective response of viewers was empathy (*Einfühlung*). This notion was developed by Robert Vischer and Theodor Lipps in the late nineteenth and early twentieth centuries. Empathy is a psychological concept which describes the process by which viewers identify with works of art by projecting emotions and muscular sensations into them. Aesthetic pleasure thus becomes objectified self-enjoyment. A fusion of subject and object is postulated. The issue of pleasure will be taken up later.

Reception theory assumes that reading or decoding is involved in the assimilation of a work of art, that subjects take an active not a passive part, though the degree to which readers complete a text or participate in the construction of its meaning is contentious. Reception theory or aesthetics tends to concern itself with the ideal reader implied by each work, whereas reception history tends to focus on actual readers. Of course, it often happens that those who read a text don't match the ideal reader or belong to the presumed constituency for whom it was intended.

As with linguistic ability, individuals vary in their competence

and performance. Each reading or response to a text is called an 'actualization' or 'concretization'. Some critics regard the concretizations of laypeople as partial realizations of the text when measured against the ideal of complete understanding, or when compared against the consensus reached by scholars over many years as to the text's meaning. A central problem of reception theory is that of deciding whether the variant readings and interpretations generated by different individuals and groups can be resolved by reference to a 'true', 'objective' meaning or whether one has to accept a multiplicity of competing interpretations. If one inclines to the latter view, is there any way of judging between discrepant readings? Or are they all equally valid and correct? If so, one could conclude that texts are meaningless because they can mean anything. Most theorists want to retain the idea of a text as an objective structure conditioning and controlling the response of the reader. Variant readings can be explained, rationally, by reference to such factors as ambiguous language, different contexts of encounter, and differences between readers. A text may have many meanings but the number is not infinite. Furthermore, the objectivity of the text is such that some readings can be demonstrated to be false: we have all misread a word and then, at a later time, discovered our error.

Mass communication theorists have argued that messages are encoded with a preferred meaning in mind. This they call the dominant meaning. Besides straightforward misreadings, two other kinds of reading are deemed possible: *negotiated*: that is, readers perceive the dominant meaning but they modify or inflect it according to their personal experience or situation; and *oppositional*: that is, readers understand the dominant meaning but they reject it or interpret it in a highly critical way (this type of response has also been called 'aberrant decoding').

One of the key postulates of reception theory is that all readers approach texts with an ideological frame of reference or horizon of expectations already in place; for example, they may already be familiar with the conventions of a genre. Artists have the choice of confirming or denying the reader's expectations. As Hans Jauss explains, artists sometimes lull the reader by con-

firming expectations at an early stage in order to surprise him or her at a later stage. The majority of texts are produced with a particular readership in mind but, as Jauss points out, there are some radical works 'which at the moment of their publication are not directed at any specific audience' but only at a future, potential audience. Such works 'break through the familiar horizon of literary expectations so completely that an audience can only gradually develop for them.'[7] Jauss goes on to argue that exceptional works of this kind establish a new canon of taste which has the effect of making the older works seem outmoded. Some types of experimental design by artist-designers would also fit this description.

A major difference between empirical studies of response and reception history is the latter's interest in the responses of previous generations. However, reception history attempts to go beyond the sequence-of-events type of history-writing by taking account of the present as well as the past. Modern theorists examining a painting by Leonardo, for example, have the benefit not only of their own concretizations but all earlier ones; thus their understanding of the work is enhanced. As Jauss puts it: 'The repossession of past works occurs simultaneously with the continual mediation of past and present art and of traditional evaluation and current literary attempts.' It might be argued that the experience of design does not normally call forth such complex responses but a design aficionado confronted by a modern reproduction of Marcel Breuer's 1925 Wassily chair might well respond in a comparable way.

In the view of some scholars, reception theory/history ought to concern itself with unpopular as well as with popular works of art. Theodor Adorno, in his 'Theses on the sociology of art', attacks the crudity of those reception studies which fail to consider the fact that there are some works of high quality which, quantitatively, have a negligible social impact. For Adorno, this is a social fact which is just as much in need of explanation as the fact that other works have mass appeal. Adorno had in mind certain avant garde or difficult works the social content of which 'sometimes rests precisely in the *protest* against social reception, particularly in relation to conventional and hardened

forms of consciousness'.[8] Can this argument be applied to design? Again, some forms of anti-design design might fulfil similar critical functions and thus remain unpopular.

How can design historians gather information about the processes of reception? A number of methods can be employed.

1. By self-analysis. Historians have privileged access to at least one consciousness. They can try to reflect critically upon their own responses and behaviour in relation to design.
2. By examining existing critical accounts. The reviews of products, buildings and so on found in newspapers, magazines and history books. These are written by professionals – journalists, experts, critics – and consequently, while their views may be detailed and informed, they may also be unrepresentative.
3. By using existing information. Sales figures, for example, are crude indicators of popularity and consumer trends. The drawback of statistics, of course, is that the information is quantitative not qualitative. Vandalism and graffiti can be considered direct signs of negative responses to advertisements and the built environment.
4. By observing how other people behave in relation to design. Such observation can be open or covert, casual or systematic. TV researchers have persuaded some families to permit a camera to be placed on the TV sets so that their behaviour is filmed whenever the set is on. 'Participant observation' is a method by which the researcher joins the group being studied for a period and seeks to learn by adopting the group's lifestyle.
5. By means of questionnaires and interviews. This method can yield much useful information but is limited by the fact that people may lie, or they may simply lack insight into their own unconscious behaviour. Devising questionnaires and conducting interviews are also specialist skills. In advertising and the social sciences, studies of human behaviour often involve deceiving participants in tests as to what is really being tested.
6. A combination of the above.

Clearly, research of this kind is also done by designers and market research agencies when they are planning new products

or seeking to improve existing ones. It is also the kind of work undertaken by sociologists and anthropologists. However, design historians are more disinterested than market researchers and more concerned with history than sociologists.

Gaining accurate information on the effects of design is difficult because people vary in their characters, tastes, needs, incomes, and so forth; thus, the impact of design is inevitably differential. Also, in everyday life people are exposed to a multiplicity of influences and forces; hence it is hard to isolate the impact of, say, one advertisement – though a sudden increase in sales might indicate a positive impact. It is even more problematical to estimate the global, long-term impact of advertising – what J. K. Galbraith has called 'relentless propaganda on behalf of goods in general'[9] – on a population. The correlation between violence on television and violence in society has proved hard to demonstrate; empirical research often yields contradictory or inconclusive results. Nevertheless, scholars and pundits will continue to draw conclusions and make generalizations on the basis of any evidence they can assemble. Perhaps the most clearcut cases of design's impact are those in which failure occurs: disasters and injuries are eloquent testimonies to poor design.[10]

In experiencing works of art, processes of reading, interpretation and evaluation take place. Emotional, aesthetic and pleasure responses are also involved. Comparable processes occur in relation to designed goods; consumers 'read' products and styles of design; they appreciate or detest the aesthetic and formal qualities of products and they interpret their messages and meanings. Furthermore, the consumer's relation to a product is, in most cases, more active than to a painting or sculpture. People do not just admire the visual appearance of cars, they get into them, drive, wash and mend them. Designed goods may lack the intellectual profundity of works of art but one could argue that the user's involvement with them is more physical and intimate – some designed goods are worn on the body. People who spend a great deal of time and money on the interior decor of their homes function to a considerable extent as designers in their own right. In short, the issue is not only what design does to people, but what people do with design.

An important contribution to the reception history of architecture is Phillipe Boudon's *Lived-in Architecture* (1972). Most accounts of architectural construction end the moment the building is completed; what happens to it subsequently remains a mystery; whether it fulfils the functions for which it was designed is likewise unknown; in other words, the life of the building, its occupancy and use by successive generations is ignored. Boudon's book is unusual precisely because it does consider such questions via a historical and sociological study of a low-cost housing settlement at Pessac, near Bordeaux, designed by Le Corbusier in the 1920s.

In the first part of his book Boudon traces the history of the project and examines the motives of the patron M. Frugès. He also describes Le Corbusier's aesthetic programme and the initial, shocked reaction of the local people to the radically modern design of the houses. In the second half he records, from interviews made 40 years later, the feelings, opinions and experiences of the inhabitants. These interviews are also analysed to discover what kind of criteria residents employ in their evaluation of buildings and these are compared to those favoured by professional architects.

Over the years the inhabitants of Pessac have gradually changed Le Corbusier's design to meet their own needs by altering colour schemes, by adding decoration, trees, shrubs, sheds, pitched roofs, by narrowing windows and converting spaces to other uses. What Boudon's research reveals is not simply the way in which Le Corbusier's architecture was critically received, but the way it was used and transformed. It is a study, therefore, of a secondary form of design by people who are not normally thought of as architects or designers.

Another perceptive example of reception history is Hebdige's article 'Object as image: the Italian scooter cycle' (1981).[11] As its title indicates, this paper argues that products are as much images as objects. It sets out to demonstrate how postwar Italian design in the form of scooters was received in Britain during the 1950s and 1960s – the positive response of the mods and the negative response of the rockers (who identified with British-made motor bikes). These products were regarded as

gendered: motor bikes were equated with masculinity, scooters with femininity. Hebdige also shows how the scooter was represented in various kinds of discourses, particularly advertising, films and tourism, and how the machines themselves were modified via customizing, which was done by specialist shops as well as the owners themselves.

Studies of audiences and consumers are, of course, commonplace in mass communication research. They are often called 'uses and gratification' studies. Such research immediately raises questions about people's desires and needs and whether 'real' or 'authentic' ones can be distinguished from those advertising and the mass media create, promote and satisfy. A spurious sense of individual freedom can be associated with consumerism: if ten packets of different brand washing powders are almost identical chemically, then the consumer's freedom to choose is illusory, especially if the choice itself has been pre-programmed by massive publicity campaigns. The freedom to choose between products also depends upon being able to afford them in the first place. In a consumer society the greater the wealth, the greater the freedom. Choice is also limited by what industry and the media are prepared to offer, by what will make a profit or attract large audiences. What a citizen really needs may not be available on the market at all. Consumer choice is thus a poor substitute for political choice/power.

In an effort to eliminate uncertainty from selling goods, firms, designers and advertisers have increasingly striven to design the consumer to the product. Consumers who are unaware of this process may overestimate their actual freedom of action. At the same time, it is clear that consumers and most design historians want to retain a sense that selecting and combining products allows scope for freedom and the expression of individuality. Certainly, the practice of *bricolage* is more resistant to business control than the selection of separate items.

Pleasure

In view of the fact that pleasure is such a significant ingredient in the appeal of design, fashion, shopping and consumption in

general, it is surprising that little attention has been paid to it by design historians. There is no equivalent in design history of Barthes' *The Pleasure of the Text* (1976) or Freud's analysis of the mechanisms of humour in *Jokes and Their Relation to the Unconscious* (1905) or Laura Mulvey's article 'Visual pleasure and narrative cinema' (1975).[12] Even within the long history of visual arts criticism there is little intelligent discussion of aesthetic pleasure. Valuable, isolated insights can be found in the works of Freud, Walter Benjamin, Pierre Bourdieu and Herbert Marcuse, none of them a design historian. It is generally within journalistic articles and reviews by such writers as Dick Hebdige, Peter York, Judith Williamson, Tom Wolfe and Stephen Bayley that there is a recognition of the importance of pleasure, passion and desire in the consumption of commodities; but a systematic study has yet to be undertaken.

Feminist critiques of pleasure, in particular those associated with the male gaze upon the bodies of women (voyeurism, scopophilia), could usefully be applied to. design. The link between masculine recreations, sexism and patriarchal power is clearly evident in the discourse around automobiles and this is uncritically reproduced in Bayley's book *Sex, Drink and Fast Cars* (1986). Similarly, the pleasure imbalance between the sexes – women, it is argued, take greater pleasure in shopping and fashion than men do as compensation for a lack of power – needs further investigation. Also requiring much more analysis are the precise mechanisms by which pleasure is induced by design. Some studies of how still images, film and television evoke enjoyment have taken place but they need extending to the whole field of designed goods.

Any study of this kind would need to review the various types and phases of pleasure which exist. These can be preliminarily identified as follow?

1. *Pleasures of desire*: that is, the day dreams and fantasies concerning the future possession of designed goods. These are fuelled by advertising, window shopping and envying the possessions of others.

2. *Pleasures of purchase*: that is, the pleasures of shopping, spending money/buying and ownership.
3. *Pleasures of the object itself*: that is, its qualities of newness, perfection of finish, of design and aesthetic/decorative factors – colour, form, texture and so on – which appeal to the senses.
4. *Pleasures of use*: that is, the satisfactions gained when the product is convenient to use and performs as well as promised. These pleasures depend, of course, on the character of the product concerned: in the case of a car, for example, the use-pleasures may be speed and power; in the case of underwear, the use-pleasures may be erotic.
5. *Pleasures in respect of others*: that is, the social impression one makes via the ownership of goods: enhanced image, status or prestige, an impression of wealth or fine taste. Responses of envy, respect or sexual desire.

For every pleasure listed one can, of course, postulate a corresponding displeasure: the frustration at not being able to afford a desired object, the anger and irritation when an expensive product breaks down, is damaged or fails to function as promised; the new clothes which arouse contempt rather than admiration; and so on.

Taste

A key factor in the consumption of goods is the taste of the consumer: thus it is equally important to the design historian. Although taste is always manifested in relation to material things – the choice of a car or a wallpaper – it seems to belong more to the consumer than to the object. We do not speak of the taste of a building in the same way that we speak of the style of a building. (Though in the case of food, we do ascribe the sweetness of sugar to the sugar itself.) The preferences of consumers obviously have a feedback effect on manufacturing, and taste can therefore to some degree be considered a factor in production.

Taste is a puzzling and paradoxical concept: on the one hand,

the sensations of pleasure or displeasure aroused in the mouth by food and drink are physiological, automatic, immediate; on the other hand, people talk of 'an acquired taste' and 'a refined taste'. Whereas taste in the gustatory sense is experienced by everyone, having taste – in the sense of a discriminating ability – is often thought of as something possessed by a small minority. Some people are said to have good taste, while others are said to have bad taste. Several questions arise: is taste innate or learnt? Is taste something everyone has or only a few? What criteria govern the distinction between good and bad taste?

Historically, taste is closely linked with the connoisseur. Connoisseurship depends upon the ability to discriminate: to tell the authentic from the fake, the best from the worst. The taste of the connoisseur was something cultivated and refined over many years through the activity of examining works of art. Without accepting the absurd idea that there can be people without taste, it is possible to acknowledge that certain individuals can develop specialist skills – as in the case of professional wine and tea tasters.

Everyone has tastes in the sense of having preferences – likes and dislikes – in music, food, clothes and so forth, and these vary from person to person and from social group to social group. The apparently infinite variety of tastes produces a resistance to analysis. As the common expression – 'there's no accounting for taste' – indicates, taste is generally considered to be beyond the reach of rational, scientific inquiry. But is this really the case? A key reason for the fear of the study of taste is that it touches on the innermost being, the personal behaviour and values of everyone, including those making the study. Another source of resistance is the fact that a mapping of all the tastes of all the people making up a society would position everyone within particular groups or subcultures, thereby undermining the ideology of individualism – their sense that their tastes are unique, personal and private, having nothing to do with such factors as education, class, profession, and so forth.

There are four main kinds of writing on taste: philosophical-aesthetic studies theorizing about the faculty of judgement; empirical, experimental, psychological studies of artistic preferences

which often seek to explain them in terms of a theory of personality types; sociological studies of the tastes of different groups and strata within society; and historical studies. The third and fourth kinds are most relevant to design historians. Art-historical accounts of taste such as F. Chambers' *The History of Taste* (1932), K. Clark's *The Gothic Revival, an Essay in the History of Taste* (1929), and F. Haskell's *Rediscoveries in Art: Some Aspects of Taste, Fashion and Collecting in England and France* (1976), can be regarded as contributions to reception history since they record the changing patterns of likes and dislikes in respect to the arts, the ins and outs of fashion, and the succession of stylistic revivals, reinterpretations and reevaluations.

Peter Burke's *Tradition and Innovation in Renaissance Italy* (1974) has a chapter on taste in which he considers the methodological problem of how taste is to be studied by art historians. Burke claims that the scholar 'will want to discover the standards of taste current in a particular society in a particular period, in order that we may see works of art, if only momentarily, with the eyes of the artist's contemporaries'.[13] He then goes on to argue that a knowledge of the aesthetic criteria governing standards of taste in Renaissance Italy could be gained by an examination of the critical vocabulary used by artists, scholars and patrons found in the appraisive literature and theoretical treatises of the period. Also included in this chapter is a valuable, if brief, discussion of the sociology of taste and the problems of demonstrating an exact correlation between different levels of social class/status and varieties of taste.

In the cases of texts concerned with contemporary art and design, the issue of taste is further complicated by the fact that the author's preferences are bound to play a part in the selection of the objects featured. Detachment and objectivity are thus much harder to achieve. Stephen Bayley's book *In Good Shape: Style in Industrial Products 1900 to 1960* (1979) was criticized by other design historians on the grounds that Bayley's feeling that the products in question were beautiful in form was not an adequate justification for their inclusion in a history of design. In fact, not all the items he selected were to

his liking: a 1950 British make of radio popular with many working-class families was dismissed with the words 'This strikingly ugly little radio'. One is entitled to ask, in whose eyes was the radio ugly? If the judgement was Bayley's alone then it conflicts with that of all those who bought the radio in the 1950s. In such a clash of tastes whose should prevail? As it stands Bayley's apparently authoritative remark is simply a flat assertion of truth: 'This radio is objectively ugly because my taste says that it is.' The reader learns little from such unsupported remarks. What the historian has to decide, therefore, when constructing a history is whose taste is to be given priority – that of the author, or that of the elite group who promote 'good' design, or that of the masses whose tastes govern the vast majority of goods sold?

A greater awareness of the complexity of taste is evident in the anthology Bayley edited in 1983 to accompany an exhibition held at the Boilerhouse Project entitled 'Taste: an Exhibition about Values in Design'. 'Taste', he claims, 'is really just another word for choice.' It evolved 'when at one moment in the past there was such diversity that it was necessary to make a clear statement about what constituted the "good" in design. Taste is not the whole of design because it ignores function and finance, but it is the most human, immediate and evocative part of it.'[14]

For much of his introduction Bayley uses the word 'Taste' with a capital 'T'. As Raymond Williams points out, this usage dates from the eighteenth century and involved 'the abstraction of a human faculty to a generalized polite attribute, emphasized by the capital letter and significantly associated ... with the notion of *Rules* and elsewhere with *Manners* ...'[15] This elitist notion – a minority have Taste, the majority do not – is of little relevance to a modern consumer society in which everyone with any money to spend can indulge their tastes whether these are, in the opinion of outsiders, good, bad or indifferent.

After a time Bayley recognizes this point. Once mass production made consumerism available to virtually all social classes 'then one single standard of taste could no longer be appropriate to the needs of the entire nation'. As diversity increased, as

products, brands and tastes multiplied, a disturbing relativity of values became evident and disagreements between different factions about what constituted good taste and good design became fiercer. In Britain, museums and councils of design were established by the guardians of 'good' design in an effort to raise standards of public taste to their exalted level.

The guardians of 'good' design tended to designate products they considered to be in bad taste as kitsch. Paradoxically, kitsch was enjoyed by two very different social groups: those who liked it unselfconsciously and considered it good, and those more sophisticated beings who relished it for its very awfulness, i.e. 'camp' taste.[16] Eventually, through an ironic inversion of values, 'good' design came to be regarded negatively, as signifying uninspired, puritanical and dull design.

Bayley's brief history of taste and design oscillates uneasily between the tastes of architects, designers and the tastes of consumers. Clearly, the two are closely linked without being identical. Designers can seek to lead or anticipate public taste but consumers may not agree to follow. Even so, designers are often taste leaders or makers. This was especially true in the realm of fashion in the immediate post-1945 period when the 'line' laid down by Parisian couturiers had the status of a papal edict for millions of women. Other leaders of taste include film, TV and pop music stars and entrepreneur-businesspeople such as Terence Conran (founder of the Habitat chain) and Barbara Hulanicki (founder of Biba).

Several inadequacies marred the exhibition and anthology: the show's focus on objects was misleading because taste is an attribute of people not objects in themselves; there was little attempt to clarify the relation between taste and social class, subcultures and lifestyles; no reference was made to the work of the French sociologist Pierre Bourdieu whose 1979 book *La Distinction* is – in spite of numerous theoretical problems – the most substantial and scientific contribution to the study of taste to date.[17]

If analysts seek to understand taste by concentrating upon individuals, they will be confronted by a mass of variations and differences. The accumulation of such data will reveal little. It is

only by considering individuals as members of social groups and these groups as elements in a total, dynamic system that any coherent picture can emerge. In other words, it is necessary to consider society as a whole and to look at the distribution and pattern of tastes within it in relation to other social factors such as class, profession, wealth and education. This ambitious objective is what Bourdieu attempts in *La Distinction*. He made use of questionnaires plus various records and statistics about the habits of the French people during the 1960s to produce a taste cartography of the whole society at a particular time. His fundamental assumption is that the taste preferences of any group cannot be understood in isolation but only as an assertion of difference relative to the tastes of all other groups. To dress as certain others do is to assert an identity with them but, simultaneously, it is also a choice amongst the total spectrum of ways of dressing which signals a rejection or difference from those other ways. If all the adults of a society owned a Mercedes this make of car could not function, as it does at the moment, as a sign of affluence and middle-class status in relation to cheaper cars such as Ford Escorts or Fiat Unos. Bourdieu's stress on the differential nature of taste derives from the linguistics of Saussure and his structuralism from the work of Lévi-Strauss.

Another striking characteristic of Bourdieu's mode of analysis is that it encompasses all kinds of tastes – in food, drink, clothes, interior decoration, art, sport and so on. The total ensemble of tastes must, he argues, be inextricably bound up with the lifestyle of the group concerned. And these tastes can be correlated with the factors of class fraction, economic capital, symbolic or cultural capital, employment and so forth. Bourdieu's text is far too long and complex to summarize any further here, but any future study of taste and design would have to take note of the findings of *La Distinction*.

Rubbish Theory

Designed artefacts, as everyone knows, are valued by human beings for their usefulness, their aesthetic qualities, their personal emotional associations, and for their monetary worth.

These values are capable of change over time. For instance, the economic value of a new car begins to decline as soon as it is purchased; after a few years it may become worthless; after a few more it may start to become valuable again (e.g. a vintage car). The questions arise: 'Is there a pattern to these value changes? Can they be explained theoretically?'

One writer who thinks so is Michael Thompson, a social anthropologist who has taught in art and design colleges. He is the author of a provocative text entitled *Rubbish Theory* (1979) which is concerned with 'the creation and destruction of value'. Artefacts, he argues, are 'socially malleable': the assignment of value is a social process which is not directly determined by the intrinsic characteristics of the object concerned. The same work of art may be regarded as a masterpiece by one person and junk by another: the object remains the same but the valuations differ.

An initial distinction he makes is between transient and durable objects. The former decrease in value over time and have finite lifespans (e.g. a used car), while the latter increase in value over time and have (ideally) infinite lifespans (e.g. an antique vase preserved in a museum or a private collection). What interests Thompson is how objects transfer from one category to the other. He wants a theory capable of dealing with dynamic processes not just a static situation. For goods to alter their status from transient to durable, he maintains, they must pass through a 'region of flexibility' which is in fact the zone of zero value we call *rubbish*. Rubbish, he argues, is a covert category upon which the whole social process depends. Of course, rubbish which is destroyed after being discarded cannot be restored to value (except by the recycling of its materials). However, at any one time a large number of artefacts exist in store in a kind of value-limbo.

A case study – the history of nineteenth-century woven silk pictures called Stevengraphs – enables Thompson to demonstrate how objects can alter their value over time. During their period of manufacture Stevengraphs were cheap, mass-produced kitsch. Then, for several decades, they were considered worthless junk. Finally, in the 1960s they began to become collectors' items. In

terms of rubbish theory they shifted from transient (decreasing economic value) to rubbish (no economic value) to durable (increasing economic value). A second example – the gentrification of Georgian terrace houses in Islington, London – shows the same process at work in architecture.

Linking his theory to the class/wealth structure of society, Thompson claims that 'those who own and control durable objects enjoy more power and prestige than those who live entirely in a world of transience or worse still, a world of rubbish.'[18] At this point he suggests his categories are associated with particular kinds of lifestyle, but it is not a suggestion which is followed up in any detail. What is clear is that as durable objects ascend in monetary value, so they ascend the class/wealth/power structure.

One of the greatest difficulties in writing history is to account for both persistence and change, and gradual and sudden change. Thompson finds the model he needs in catastrophe theory – derived from a theorem in topology first stated by René Thom – which describes mathematically how a sudden transformation from one situation to another can take place.

Rubbish Theory is a stimulating text which goes some way to explaining the kind of changes in valuation to which designed goods are subject. What remains to be explored are the precise interrelations between the different kinds of value ascribed to artefacts. For example, what correlation if any exists between the aesthetic valuation of an object and its market value?

The prices recorded in auction houses and second-hand shops for old goods over many years are an objective measure of changing valuations. Yet this measure is a limited one: objects of little monetary worth are treasured by their owners for personal reasons. In other words, knowledge of prices does not tell us much about the feelings and attitudes of people towards designed objects.

Human attitudes towards the past are inherently paradoxical and ambivalent: our very identities depend upon our past history and memories but to grow and develop we must change with the times; traditions provide continuity but to innovate we must break with them. (This subject is exhaustively explored in David Lowenthal's monumental study *The Past is a Foreign*

Country (1985).) Our feelings about the past also change as time elapses, indeed there seems to be a pattern to our shifting responses to fashions as they recede into the past. James Laver, the fashion historian, has pointed out that last year's fashion seems 'dowdy', after 10 or 20 years it seems 'hideous, absurd', after 30 years, 'amusing', after 50, 'quaint', after 70, 'charming', after 100, 'romantic', and after 150, 'beautiful'.[19] So the fashion remains the same, but our perception and valuation of it alters. It follows that there are two lines of development for the historian to track: the sequence of fashions themselves in which the new relentlessly replaces the old, and the sequence of valuations placed on these fashions by succeeding generations. From time to time the two lines will intersect as a positive evaluation of an old fashion results in a revival.

Notes and References

1. 'Satellite shopland: shopping centres of the future' *Equinox* series, Channel Four TV, 1 October 1987.
2. W. Benjamin, *Charles Baudelaire: a Lyric Poet in the Era of High Capitalism* (London: New Left Books, 1973).
3. See D. Chaney, 'The department store as a cultural form', *Theory, Culture and Society* 1 (3) 1983 pp. 22-31.
4. J. Winship, 'Options - for the way you want to live now', *Theory, Culture and Society* 1 (3) 1983 pp. 44-65.
5. W. F. Haug, *Critique of Commodity Aesthetics: Appearance, Sexuality Advertising in Capitalist Society* (Cambridge: Polity Press, 1986); *Commodity Aesthetics, Ideology and Culture* (New York: International General, 1987).
6. For introductions to reception theory see R. C. Holub, *Reception Theory: a Critical Introduction* (London: Methuen, 1984); P. Hohendahl, 'Introduction to reception aesthetics', *New German Critique* (10) Winter 1977 pp. 29-63. For a critical assessment of reception theory by a Marxist literary critic see T. Eagleton, *Literary Theory: an Introduction* (Oxford: Blackwell, 1983) pp. 74-90.
7. H. Jauss, 'Literary history as a challenge to literary theory', *New Literary History* 2 (1) 1970 pp. 7-37.
8. T. Adorno, 'Theses on the sociology of art', *Working Papers in Cultural Studies* (2) Spring 1972 pp. 121-8.
9. J. K. Galbraith, *The New Industrial State* (Harmondsworth: Penguin, 1968) p. 213.
10. See, for example, R. Nadar, *Unsafe at Any Speed* (New York:

Grossman, 1965) and P. Hall, *Great Planning Disasters* (London: Weidenfeld & Nicolson, 1980).

11. D. Hebdige, 'Object as image: the Italian scooter cycle', *Block* (5) 1981 pp. 44-64.
12. L. Mulvey, 'Visual pleasure and narrative cinema', *Screen* (16) 1975 pp. 6–18.
13. P. Burke, *Tradition and Innovation in Renaissance Italy* (London: Fontana/Collins, 1974) p. 152.
14. S. Bayley (ed), *Taste: an Exhibition about Values in Design* (London: Boilerhouse Project/Victoria & Albert Museum, 1983) p. 11.
15. R. Williams, *Keywords* (London: Fontana/Croom Helm, 1976) pp. 264-6.
16. See S. Sontag, 'Notes on camp', *Against Interpretation* (London: Eyre & Spottiswoode, 1967) pp. 275-89.
17. P. Bourdieu, *Distinction: a Social Critique of the Judgement of Taste* (Cambridge, Mass: Harvard University Press, 1984; French edn 1979). For reviews see: M. Douglas, 'High culture and low', *Times Literary Supplement* 13 February 1981 pp. 163–4; J. Elster, 'Snobs', *London Review of Books* 3 (20) 5-18 November 1981 pp. 10-12; J. Frow, 'Accounting for tastes', *Cultural Studies* 1 (1) January 1987 pp. 59-73. See also special issues on Bourdieu: *Media, Culture & Society* 2 (3) July 1980 and *Theory, Culture & Society* 3 (3) 1986.
18. M. Thompson, *Rubbish Theory: the Creation and Destruction of Value* (Oxford: Oxford University Press, 1979) p. 45.
19. J. Laver, *Taste and Fashion from the French Revolution to the Present Day* (London: Harrap, rev. edn 1945) pp. 202, 208.

'Conclusion'

This text has attempted to delineate the fledgling discipline of design history and to identify and explore its central theoretical and methodological problems. A wide range of literature from many disparate fields of knowledge has been cited and this has required a synthesis which may not always have been achieved. Any conclusion would be premature because a host of issues remains underdeveloped and unresolved. There is thus plenty of scope for further reflections upon the discipline's problematic and aims.

If a single finding emerges from this study it is the extent to which the issues confronting design historians are comparable to those which have been faced by scholars in other disciplines far more venerable than design history. It follows that design historians can avoid crass errors, gain insight into their own practices, and save themselves time by attending to debates within the social sciences and by studying the writings of major anthropologists, sociologists, general historians, and so on. Such a task should not be antipathetic to them because it is, in large part, one of historical investigation.

What of the future? One dilemma which could well become more acute as time passes is the question of whether or not design history belongs with the humanities or with the social sciences. This argument has arisen in respect of art history, which some scholars regard as a 'humanistic' discipline akin to the study of language, philosophy, literature, the classics, etc., while others think of it as a social science akin to sociology, anthropology, geography, etc. Both sets of disciplines are concerned with humankind and human values but social science aspires to the scientific rigour of the natural sciences. Although this issue cannot be resolved without regard to the institutional contexts within which design history now exists, my own prediction is that the influence of theoretical developments in the

research methods of the social sciences will inevitably pull design history in that direction. A considerable number of design historians already exhibit impatience with the impressionistic and anecdotal history-writing typical of so many design publications.

In recent years a significant growth in the number of design historians has taken place, especially in Britain. Given the British government's present restrictions on education, no more design historians are likely to be appointed; however, employment prospects may be brighter in the realms of book publishing and design journalism. There has certainly been a remarkable increase in the number of books and magazines about design in the 1980s. The British Design History Society annual conference held in Brighton in 1987 was notable for the participation of foreign delegates from a spectrum of countries (though all were advanced countries). No doubt in the near future we shall witness a further internationalization of the discipline. Professional contacts and discussion will also be facilitated by the presence of the specialist journals *Design Issues* (USA) and *Journal of Design History* (UK).

In terms of the discipline's intellectual trajectory, the greatest danger it faces at present is that posed by external pressures to become an adjunct of the commercial system of design. If design history becomes merely a servant of the design system – an instrumental form of history-writing whose only function is to celebrate – then the discipline's critical potential in respect of society as a whole will remain unfulfilled. As Theodor Adorno once remarked: 'The simple existence of disciplines and modes of thought does not amount to their justification.'

FORM/female
FOLLOWS FUNCTION/male:
Feminist Critiques of Design

JUDY ATTFIELD

[*Judy Attfield, a British designer and historian, discusses below the relevance of feminism to the writing of histories of design. It was considered appropriate that women's experience of design should be presented by a female writer. What emerges from her account is that design history cannot simply treat feminism as yet another addition to its range of methodologies for, as Lisa Tickner has remarked, it is a politics rather than a method. This means that feminism, at its most radical, calls into question many of the basic assumptions and practices of the discipline. The challenge of feminism is not restricted just to the lives of women because it is also relevant to men (gender encompasses the masculine as well as the feminine). Consequently, there is a need for male scholars to examine their own social identities and positions. Such a project would serve a self-critical function in respect of male design historians. If men were to take the lessons of feminism seriously, then the predominantly masculine discourse of design history would be transformed. - J. W.*]

It is impossible from a consciously female perspective to attempt any kind of survey of the critiques of design, its practice or its history without questioning the assumptions which have become an established orthodoxy. So I start from a definition of design legitimated by Pevsner's *Pioneers of the Modern Movement* (1936) and which places Giedion's *Mechanization Takes Command* (1948) on its bibliography together with the Open University's *History of Architecture and Design 1890-1939* (1975). What these texts have in common is a shared definition

199

of design which was first formulated at the height of the 'Good Design' movement, based on a set of principles which decreed that in answering functional requirements correctly, Beauty would logically follow.

Design history still suffers from its provenance in the Modern Movement, where to some extent it remains, sealed in a time lock which still considers form the effect of function, and a concept of design – the product of professional designers, industrial production and the division of labour – which assumes that women's place is in the home. Feminist perspectives offer design history a range of historical/critical methods which challenge the mainstream about how it defines design as a practice, about the paramaters of what type of designed objects it should examine, about what values are given priority in assessing it, and even who it calls designers.

It is more difficult, but still necessary, to attempt a definition of 'feminist' in this context, although to do so might imply a dominant, single view of feminism. But the project here is to *displace* dominant definitions in order to make space for the normally silent, hidden and unformulated dimensions of design omitted in its conventional study or literature. Broadly speaking, I refer to a 'feminist perspective' as that which acknowledges that women form a group among many in a multicultural society, with different tastes, needs, values and orders of priority because of the roles they play, the type of jobs they do and the position in society they occupy through the accident of their birth. In this context, feminism is a political position which seeks changes in the interest of women. There is no ultimate agreement as to what those changes should be nor what strategies should be used to pursue them since different cultural groups of women have different interests. It is a sensitivity to this diversity which marks out the distinction between the women's liberation campaign centred in the United States in the late 1960s and early 1970s, from the wider, global women's movement.

To advocate design improvements in the environment and in products mainly used by women at present should not be taken as acceptance of the fact that such improvements can reinforce the traditional, subordinate place of women in society. (Many

BROOKLANDS COLLEGE LIBRARY
WEYBRIDGE, SURREY KT13 8TT

feminist critiques of design point out how a definition of women as a subordinate group is reinforced and made to appear natural through design.) In discussing history and applying a feminist analysis to it, it is particularly relevant to be precise about the historical construction of the term 'feminist' and the changes it has undergone. Without an awareness that change is possible there is little point in taking a feminist perspective in the first place. In the anthology *What is Feminism?* (1987) the general consensus among the contributors is that there is no one fixed definition, but many 'feminisms'. They also ask: 'Can feminism be defined simply by virtue of its object of concern – women? Is it not feminist to profess an interest in human welfare more generally?'[1] Similarly, this text includes work, not necessarily written by feminists, that is sensitive to the interests of women as well as the broader issues of gender relations.

A distinction that needs to be made is between a feminist process of historical enquiry, practice or critique of design, and a 'women-designers' approach which concerns itself solely with adding the names of women designers to the conventional account of the history of design.[2] The latter merely bolts on to an existing framework and does nothing to dismantle the hierarchy which positions women in the domestic area normally seen as subordinate.

It is symptomatic of our post-modern condition that it should be considered important to include a feminist critique of design here.[3] The current tendency to question dominant value systems and interpretations of history indicates a loss of faith in the single unitary view, which in the case of design history has always placed it in the male domain. The dominant conception prioritizes the machine (masculine) over the body (feminine). It assigns men to the determining, functional areas of design – science, technology, industrial production - and women to the private, domestic realm and to the 'soft', decorative fields of design. It places form in the feminine realm where its role is to reflect the imperatives of the 'real'. According to this kind of aesthetic theory then, form (female) follows function (male).[4]

Juliet Mitchell has argued that 'feminism is an ideological

offspring of certain economic and social conditions.'[5] Her interpretation is a positive one which attributes to feminists the ability to imagine 'yesterday's future', i.e. a today in which machines replace gruelling labour, when there is more leisure and more sexual equality. But she also points out that the women's movement emanates from the dominant middle class. Thus, it essentially presents a Western point of view from within a consumer society which requires women as a cheaper part-time, non-unionized workforce, while depending on them as the main bulk of the consuming public. It is this condition which has indeed brought some women more power but has also kept others in positions of subservience. Nicholas Coleridge, in *The Fashion Conspiracy* (1988) illustrates both these extremes in his description of the current condition of the international fashion design world where Tamil girls, under the age of 13, work in a Madras sweatshop to supply the American clothing trade, a country where some women can afford to spend $7,000 for a dress to attend a *charity* ball.

The Politics of Experience

A fundamental starting point for feminist design historians is the fact that women experience the designed world differently from men. One of the most powerful and influential critiques of town planning, Jane Jacobs' *The Death and Life of Great American Cities* (1961), caused a transformation by introducing a critical element into the writing of architectural history which until then had glorified modernism without question.[6] It was precisely her female point of view which brought out new and valuable insights in the relationship between design ideals and lived experience.[7]

Design shapes the environment and makes assumptions about women's place in terms of buildings, public spaces and transport. It also provides the imagery women use to form their identity through fashion, advertising and the media generally. It assumes that particular areas of the design profession are 'women's work', thereby reflecting the predominant division of labour in society. Furthermore, it segregates the sexes through

artefacts by endowing these with unnecessary gender defi-
nitions, while neglecting the special needs of women who want
their own transport, places and spaces.[8] And, as already ex-
plained, it excludes women from the determining spheres of
science, technology and industry.[9]

The role of design in forming our ideas about gender power
relations often remains invisible, while at the same time it makes
them concrete in the everyday world of material goods. 'White
goods' such as washing machines and electric cookers may
reduce the heavy manual labour women perform and those
designed by women may satisfy their needs better than those
designed by men, but such goods are still manufactured with
women in mind – the implicit assumption is that it is they who
will be doing the bulk of the washing and cooking, not men –
hence the division of labour by gender remains unaffected by
product innovation and improvement.

Design reflects our aspirations and arouses our expectations,
but it is also a process and as such has a potential for transfor-
mation. Some professional feminist designers have attempted to
reform gender relations through innovatory designs.[10] Feminist
historians have been and are undertaking research to bring to
light those designers' achievements as well as the achievements
of women working in the field whose contributions remain un-
recognized. It is also vital to consider the impact that women
have had historically, and can continue to exert on design by
means of individual and joint consumption.[11]

'Women-Designers' versus a Feminist Critique

Isabelle Anscombe's *A Woman's Touch* (1984) gives exclusive
attention to women designers who have participated in 'the
history of the major design movements since the 1860s'. It
helps to set the record straight by giving more emphasis to those
women who did manage to penetrate the professional arena –
some of them, like Charlotte Perriand[12] and Eileen Gray,[13]
already known in conventional design history – but who were
often overshadowed by male designers with whom they associ-
ated through professional or personal ties. However, it soon

becomes clear that this 'women-designers' approach does little except confirm the prejudice that women are inferior designers except in the so-called 'feminine' areas such as the decorative arts, textiles, interior design and fashion. Even where there was an opportunity to alter the emphasis by showing how some female designers were prevented from practising in the more exclusively male areas of design, as in the case of Eileen Gray, Anscombe fails to do so.[14]

There are other problems related to looking at women designers as the main focus. For instance, the restrictions of method in the conventional biography place them in a preset, hierarchical framework in which 'great', usually male, designers appear. Is this really because there have been no great women designers? Since Linda Nochlin's essay on women artists, written in the early 1970s, this has become a somewhat rhetorical question.[15] Design is even less of an autonomous activity than art and needs to be examined in close relationship with the social, cultural, economic and technological conditions which have nurtured its development as a practice. However, the historiography which has produced some of the seminal works of design history has established a tradition of pioneers of modern design and an avant garde aesthetic in which few women figure. There is an urgent need, therefore, to bring to light the work of women pioneers of design in order to provide role models for young women embarking upon design careers who, at present, face unwelcoming, male-dominated enclaves in architecture, engineering, product and industrial design, where all that is thought necessary to meet the needs of women is an equal opportunities policy.[16]

A considerable body of work has built up around an object-based study of the history of design, which avoids some of the more overtly sexist problems by not focusing on designers.[17] It also marks out for itself a methodology distinct from conventional art history in which the cult of the artist rubs off on the art work, thereby giving it a particular value distinct from the anonymously designed object. A women-designers approach is based on the traditions of such an art history and cannot cope with anonymous design. This is not to say that object-based

study is innocent and neutral in matters of gender. On the contrary, a hierarchy has built up around types of objects which gives importance to industrial design and the 'machine aesthetic' – i.e. the more obviously masculine – while considering areas such as fashion as trivial and synonymous with 'feminine'. But the limitations of a women-designers approach not only diminishes women, it also devalues design history as a discipline by using a borrowed and inappropriate methodology.[18]

A feminist critique makes it possible to look at women designers in a new light and to assess their work in the context of the history of a profession which has consistently marginalized them. It also suggests a methodology for design history which is not based upon aesthetics or connoisseurship, but upon a concern for people.

Use-value and Feminist Critique

Some feminist design historians are not content to satisfy academic criteria. They want their research to be of value to prac tising designers. They conceive of design history as contributing to an understanding of different groups' needs as part of the design process. *Making Space* (1984) by Matrix (a feminist architects' collective) is one example of an interventionist text which seeks to bring theory and practice together and to relate knowledge of the past to the present and the future.

The problems of defining an object of study appropriate to design history have been fraught by precedents set by art history. Although feminist art history does present us with an excellent body of critique and methodology, it cannot be appropriated and applied directly to design unless we treat design as if it were art. There is some measure of agreement that it need *not* just be about the appreciation of something called 'good design', nor the attribution of authorship to particular designers of certain cult objects, lest the whole exercise deteriorate into one of connoisseurship. But what it *should* be is less clear. Not only is there confusion over *what* should be looked at, but *why*.

A feminist perspective can be quite specific in its focus on use-value. By providing historical explanations for women's lack

of visibility at the production stage, it is possible to understand better why dominant masculine values are constantly reproduced in the material world. Thus a feminist critique of design history can become part of a more general movement of reform. It is at that particular intersection – between what we think and what we do – that the transitive meaning of design as a verb, as an action, can take place.

An example of mainstream history of design, Penny Sparke's *An Introduction to Design and Culture in the Twentieth Century* (1986), avoids defining design because 'available definitions are varied, complex, contradictory and in a state of permanent flux'.[19] But by devoting her attention to industrial, mass-produced goods and the education and practice of professional designers, Sparke represents the conventional high ground of design history, traditionally associated with the mechanized and male-dominated areas of design where women only appear as passive consumers.

In her essay 'Made in patriarchy', Cheryl Buckley uses a critique of patriarchy and capitalism to formulate a method for a feminist history of design.[20] Patriarchy is a useful concept because it explains the dominance of masculine attributes transhistorically as a cultural phenomenon manifested by women as well as men. It serves to explain, for example, why some women contribute to the production of sexist ads which degrade women. Nevertheless, because patriarchy depends on stereotypical definitions of male/female and is basically a-historical, it presents many difficulties as an operative concept, not the least of which is the contradictory task of reconciling rather crude male/female stereotypes with a history of changing gender relations.

In matters of sexual politics where the personal is political, gender neutrality has been proposed as a strategy. In Britain it occupies a central position in recent anti-sexist education initiatives to degender activities such as sewing and woodwork, areas where design is taught in many schools. So gender neutrality has definite advantages, but there is a limit to which it can be used in the history of design when dealing with issues of sexual differentiation.

Part of the debate about what makes design different from

art has been the distinction between the functional object and the merely beautiful. This value system, entirely based on the ideology of modernism, cannot be applied to non-functional or handmade objects, nor to those which do not conform to the rules of good design. This has made it impossible to deal seriously with a whole galaxy of objects, i.e. those falling outside the prescribed category of the 'modern classic'. Omitted are fashion, ephemera and many other areas of design in which women have been most prominent; this omission therefore accounts for their lack of visibility. Contemporary cultural studies, social history and anthropology have provided a way in to a less hierarchical, non-aesthetic analysis of designed objects which allows inquiry in the kind of areas which put women back into the picture and make it possible to examine popular taste. So it is not just a case of looking only at women's concerns, but of using feminism as a starting point, as a means of transcending the limitations of conventional design history.

The purpose of a feminist critique of design and its history should be to discuss women's concerns so that women do not feel segregated or excluded in any way for reasons of gender. Though there are some radical feminists who choose permanent separatism as a form of refusal, this excludes many women as well as men. A gendered view, on the other hand, is a practical way of opening a space for discussion. It forms part of a wider move away from authoritarian, patriarchal values for both men and women. It also allows women to become involved as ungendered beings – as people who consider issues beyond those of gender: i.e. race, class, age, sexuality, religion, occupation and so on.

It should not be 'Woman' who is made the special case for treatment, but the culture which subordinates people by gender, class, race, etc., and does nothing to question the attitudes which position them as 'Other'. The concept of 'the Other' is one used to define the category of 'woman' in a negative relationship to the category of 'man'. ('Man' enjoys the privilege of being the norm – 'the measure of all things' – while 'woman' is that which deviates from it.) The acknowledgement of such a presence with particular needs and interests contests the privileged position of the dominant power. This includes the challenging of mainstream

art which insists on purity and preserves itself from contamination of the ordinary, the everyday and the common. It will also allow traffic across the borders and the entry of the 'minor' arts, the crafts, ephemera, fashion and the popular. By transgressing the normal definition of art, it can redirect the search for an impossible, timeless 'classic' towards a more practical activity.

Design history presents a suitable case for treatment as it struggles to come to terms with its relationship to art and the all-pervasive post-modernism which threatens to shatter its confident, macho value system based on the prime importance of industrial production.

While post-modernism cannot replace the rules it shatters with anything nearly as comforting as the harmony and belief in technological progress offered by the myth of modernism, it does enable a decentred shift in the way in which we look at the world, and how we relate to it – not an unfamiliar experience to women who are accustomed to occupying the margins.[21] Feminist practice in design, history and critique offers a point at which a criterion can be constructed which doesn't refer everything back to market forces or abstract aesthetics.

Objects and Subjects

Having established in general terms what a feminist critique has to offer design history, some specific instances will now be considered.

Lisa Tickner's studies of clothing provide examples of the way in which a feminist analysis can be applied to everyday items. A 1976 essay traces the emergence of trousers as a fashion for women from the 1940s through to the 1960s, viewing them as a symbolic representation of the social changes in the role of women during that period.[22] The rise of the women's liberation movement saw the adoption of masculine dress as a sign that at last women were beginning to enter the male world.

To transcend descriptive analyses of objects it is necessary to seek explanations of the particular forms of objects. In one of a series of articles published by the feminist magazine *Spare Rib*

in 1976, Tickner discussed the physical as well as the social bondage imposed by the fashionable constraints of tightly-laced corsets, foot-binding and other forms of extreme footwear such as the stiletto heel.[23] The images of captivity and eroticism these implied were attributed to the social conditions which placed women under male domination. Another conclusion was that fashion created ideal images of femininity which were 'used to keep women in their place'.[24] In addition she suggested that taking a psychoanalytic view 'may help us to understand why sex distinction in dress is such a universal phenomenon'. She also described several episodes in the history of women's dress in which attempts were made to bring about social change through dress reform.

Yet while Tickner sees the stiletto as an example of bondage, Lee Wright, in 'Objectifying gender', suggests that its popularity was more to do with assertiveness than subservience.[25] This indicates precisely the importance of not thinking of objects as if they existed in a timeless vacuum but looking at the changes in their meanings historically.

Some objects are imbued with a gender identity which appears almost natural, but in our present society many products have it thrust upon them as strategies for improving the market through the introduction of novelty and product diversification. A recent example was made by Ross Electronics, manufacturers of personal hi-fi equipment. They feminized headphones, normally thought of as gender-neutral, by making them into a range of fashion accessories called 'Stylers' and packaging them into compacts with four pairs of interchangeable plastic earpieces coloured pink, blue, green and yellow.[26]

What effect does this world of material goods have in forming our sexual and gender identities? In *The Subversive Stitch* (1984), Rozsika Parker explains how embroidery had a hand in 'the making of the feminine'. Her study is a key example of the feminist thought which has sought to upgrade embroidery, and other forms of applied arts associated with women, to the main rank of art. There has been an ongoing debate on the 'art versus craft' issue since the 1970s when feminist artists became politicized.[27] The validation of an activity like embroidery gives

visibility to the work of many women who would not otherwise be considered artists. But while some seek to be named, others prefer the craft tradition of anonymity.

Although British higher education design courses since the 1960s have tried to break down the hierarchy between art and craft, there still remains a distinct separation. It is, therefore, impossible to deal with object-based studies of design history without considering why certain types of objects have acquired a particular position of status in the hierarchy and how these relate to the areas most populated by women. Textile art and design is one which figures very prominently. In her paper 'An appropriate activity for women', Peninna Barnett quoted the figures: 'According to the Crafts Council in 1983, women make up 87% of all full-time craftspeople working in textiles and 94% of all part-timers.'[28] She observed: 'when men succeed in traditionally female areas ... they receive praise and acknowledgement disproportionate to their achievements – as in the case of painter-turned-knitter Kaffe Fassett who "discovered" the creative potential of knitting in the early '70s.' The idea that knitting did not exist until a man discovered it is clearly untrue, but does show how work is validated by masculine attention.

A feminist perspective reveals just how relevant it is to consider how objects *form* subjectivity. In the case of embroidery, Parker demonstrates how it was both domesticated and feminized at a particular historical period, and how it was used in the education of little girls to inculcate the ideals of femininity. The gender of the designer cannot be ignored once we have been alerted to the possible bias this gives its assessment. Therefore, it is vital to relate objects to subjects by placing the 'things' into the world of people, i.e. the context which gives them meaning. A distinction needs to be made, for the purposes of analysis, between the superimposed meaning – the image invented by the ad-man – and the way that people actually use objects to say things about themselves. The creation of images does not necessarily determine the meaning of their consumption by individual consumers. This will be discussed later in the section on the representation of femininity in the lives of women.

There is a tendency to suppose that an object-based study

can somehow lead to a more 'objective' investigation. But, as Pierre Bourdieu so succinctly put it: 'The objectification is always bound to remain partial and therefore false, so long as it fails to include the point of view from which it speaks and so fails to construct the game as a whole.'[29] Therefore, in studying and writing the history of design, it is necessary to make conscious the subjectivity of the historian, for, to paraphrase E. H. Carr: 'The historian without her facts is rootless and futile; the facts without their historian are dead and meaningless. My first answer therefore to the question "What is history?" is that it is a continuous process of interaction between the historian and her facts, an unending dialogue between the present and the future.[30] The fact that Carr's original was written in the *masculine* third person singular does not detract from the value of what he said then, it just made it sound rather one-sided.

Deconstructing the Man-made Environment

Another way of applying a feminist perspective to design is to consider the role and place of women in the social division of labour and look at how this embodies socio-spatial relations in the form of the built environment.

In 1984 the journal *Built Environment* published an issue entitled 'Women and the environment' in which one of the founding members of Matrix, Jos Boys, asked the question: 'Is there a feminist analysis of architecture?'[31] In her article she discussed the way in which architecture makes a physical representation of society's perception of social relations by the form in which it organizes people in space. Traditional social conventions since the development of the ideology of domesticity have confined women to domestic interior space as the 'proper place'; so that when they find themselves in public spaces there is an underlying feeling of unease, of not belonging, even of threat. Her plea was not for a new set of rules but for conditions to make possible a critical feminist practice of environmental design which will be sensitive to women. For all the benefits derived from better designed kitchens and house interiors generally, this does not really address

the problem of women's *confinement* to the domestic domain unless we can begin to envisage these spaces as inhabited by people rather than women.

In 'The home of woman: a view from the interior', Alison Ravetz traces a history of women's contribution to the design of housing through channels not normally explored: the patronage of model housing which prioritized the importance of good design features to alleviate the work of women.[32] Although it did not question the place of women in the home, it gave precedence to a rational approach to designing over the 'facadism' which characterized so much nineteenth-century housing with its concern for social status.

With the exception of the bicycle, the history of transportation has been singularly silent on the effect it has had on women. The history of the development of the suburb has shown not only the separation of the classes but also of the genders, with transportation networks as the only connecting link between home and work. The suburb in particular is a form which segregated women from the job market and took men far enough away from the home to make it impossible for them to participate in domestic work.[33] Until very recently it has been women only who wheeled the buggies and prams for which public transport is still so ill-equipped. Even today fewer than one-third of women hold driving licences for cars which are rarely designed with them in mind. The assumption has been that public transport must be improved for *women* because it is they who are required to cope with what a recent report called 'multiple roles (paid work, domestic work and childcare)', and therefore have more 'complicated and varied journeys than men's', and that the car is 'the *male* mode of transport'.[34]

In *Home: a Short History of an Idea* (1988), Witold Rybczynski credits American women such as Catherine Beecher with being precursors of the modern rational design movement which was to bring about important changes in house design to make women's work more efficient. In this he agrees with Giedion in attributing innovation to improvements in technology.[35] Later research has revealed that in spite of the fact that innovation in housework technology has made the work more efficient, it has

not emancipated women from it.[36] Some feminists go so far as to say that the home can be identified as 'a significant sphere of the construction of gender difference'; in other words, that it is instrumental in teaching women the ideal of femininity which places them in the home as their 'natural' habitat, rather than in the outside world of paid labour.[37] This, of course, is a vast generalization which is constantly contested and needs to be put into historical perspective. Nevertheless, it does explain how gender specific some types of activities become, so that for men to do them is regarded as emasculating.

The history of the labour-saving movement has a considerable literature in which women figure as the main protagonists.[38] Much of the effort has been to elevate the status of housework to a profession in order to improve women's conditions of work and pay; also to offer them some measure of independence. This movement must be seen alongside the history of class struggle and the attempts of groups to democratize work generally. The rise of the cooperative housekeeping movement in the nineteenth century was largely due to the awareness on the part of women like Mrs H. Ellis who felt strongly that:

> The class and mass war, which is gathering force daily in our midst, is epitomised in every house which boasts a parlour and a kitchen where a sharp line is drawn between those who serve and those who are served.[39]

Dolores Hayden's study, *The Grand Domestic Revolution* (1982), traces the history of feminist home design and community planning in the United States. She focuses on a group called 'material feminists' who believed that through campaigns to end economic exploitation of household labour, and by changing the physical shape of the world through design, women could attain emancipation. The most workable model they produced, among a whole variety of fantastic schemes, was the kitchen-less house. This was widely used in England too, although until recently it remained a relatively forgotten type. Lynn Pearson's account of the history of cooperative housekeeping has brought to light a surprisingly large number of houses along

these lines in which design played an important part in putting feminist ideas into practice in this country, some operating quite successfully as cooperative households until today.[40]

Men and Housewives

The division of labour offers another framework for the study of the history of design in which a number of issues important to women can be discussed. Two areas in which this division is particularly relevant are consumption and the Arts and Crafts Movement.

The Arts and Crafts Movement provided middle-class women in the nineteenth century with an entrée into the professional world of work through creative activities which were considered domestic and therefore 'respectable'. The crafts also allowed women into the arts through a side door by way of the 'minor' or applied arts. But because these produced practical and useful items rather than purely 'art' objects, they do not command as much attention or respect. Anthea Callen's study of the Arts and Crafts shows the effect of the division of labour on women in the movement and concludes that, although it created employment for middle-class women, it also reflected the social prejudice of the time which kept both class and gender in place.[41] The Art Workers' Guild, the most influential of all the Arts and Crafts organizations, barred women by statute from 1844 to its revocation in 1964.

The Arts and Crafts Movement, however, is seen more positively in Lynne Walker's study 'The Arts and Crafts alternative'.[42] She emphasizes the excellent alternative it provided for women, enabling them to become financially independent. At the same time it gave them an entry into the male-dominated world of the arts just when they were beginning one of the most politically active periods of the women's movement.

Since the nineteenth century, there have been a number of craft 'revivals' in the United States and Britain which can be seen as part of a wider movement in highly industrialized countries where craft has become a luxury and now competes with fine art for prestige. It has also provided a vehicle for challenging

the commercialization of art and the male-dominated values of both the fine arts world and the exclusively masculine world of technology and mass production. Embroidery, patchwork quilts and other female domestic skills have been presented as alternative media in feminist art.[43]

In 'Made in patriarchy' Buckley observes that Reyner Banham identified two sexes in his history of the first machine age: men and housewives.[44] This is fairly typical of the attention which women have received in design history. Their importance as consumers has been noticed where there has been an awareness of their role at the receiving end of the marketing of designed objects.[45] Just as we have seen that women's place was assumed to be in the home, so the division of labour in our society has traditionally assumed that production is men's work while women are the natural consumers. Apart from the home, therefore, the department store or supermarket is one area which has been identified as more 'naturally' female than any other public space. Remy G. Saisselin describes the department store of the nineteenth century as a 'cultural space' in which 'shopping was integral to the identity of the new woman. Shopping was liberation'[46] Some feminists have actually identified shopping as a form of power through which the consumer can wield influence through organized purchasing groups, through campaigning for health, safety, non-sexism and other requirements.

But women are not born with a natural ability to be consumers. It is a skill which is learnt together with the formation of taste through a process which starts in the home and goes on through life. Although taste is apparently a purely individual matter, it is generally a means of identifying with a social group. Females acquire their discriminating skill through a number of cultural channels: peer groups, girls' and women's magazines, the media and advertising generally.[47] It was also learnt more directly at school in courses on home economics, in evening classes on arts appreciation, and practical instruction in housekeeping skills, crafts and accomplishments such as embroidery and flower arranging in organizations like the Women's Institute and the Cooperative Women's Guild which cater exclusively to women.

Even though crafts and their history are now gaining some credibility as an area worthy of study, there is still a lot of snobbery and resistance to considering the amateur category. This may be because the design does not conform to a particular avant garde aesthetic, but also because it derives from the extension of a primarily female activity such as knitting. When women pursue crafts in the home they are classed as hobbies rather than as professional activities and are still treated with ridicule and derision. Pat Kirkham has examined this area in her essay 'Women and the inter-war handicrafts revival', in which she records how the ideas of the Arts and Crafts Movement were carried on into the twentieth century through women's amateur pursuits.[48] There have been cases where such activities, initiated in the domestic sphere, have developed into successful businesses. A case in point is the multinational enterprise of Laura Ashley who started out making screen-printed tea towels on her kitchen table.

Suzette Worden's essay 'Women and electricity' examines the influence of women on the design of domestic appliances both through professional engineering channels as well as by bringing pressure to bear through consumer groups in the 1920s and 1930s [49] while Angela Partington's article 'Design knowledge and feminism' suggests that feminism was articulated through consumption during the 1950s.[50] This is a view which is highly contested among feminists who believe that being a 'good consumer' is just acceding to the status quo. There are many problems in discussing consumption in the context of feminism which by definition is a political stance which contests the commercial stereotype of 'femininity' used for marketing. However, feminism has a history of its own and a criticism of 1950s stereotypes made in the 1980s has the benefit of hindsight. Therefore the kind of criticism which suggests that the women of the 1950s allowed themselves somehow to be duped into being housewives devalues their work. It is not possible to uncouple the history of feminism from the particular social and economic conditions which gave rise to its existence. Juliet Mitchell has speculated that because feminism has been made possible by the conditions of capitalism, a possible outcome of

such an economy, whose goal is the endless circulation of exchange objects, might be to produce a 'social androgyne'.[51] Indeed, the expanding requirements of mass production are fast putting paid to the exclusion of men from the world of consumption where such a division actually prevents half the population being recruited as potential buyers. This is certainly proving the case in fashion where the most recent area of growth has been men's wear.

Images of Gender

In the 1960s the term 'unisex' entered the English language. It described a style of fashion which blurred the edges between male and female clothes and hairstyles. Handbags, jewellery and long hair, which had been unequivocally feminine, were now seen as suitable for either sex, ushering in a new concept in marketing with shops and hairdressers catering interchangeably for men and women.

The representation of an idealized femininity through images of fashion and beauty in the media has been an area which feminists have studied in the attempt to unwrap the myth of an essential woman and to expose it as an historical and culturally-specific fabrication. It would be impossible to review even a part of the vast literature which has dealt with this area of feminist thought in the last decade. The use of semiotics, structuralism and psychoanalytic criticism has been crucial to the development of a highly sophisticated and theoretical body of knowledge which can cope with unravelling the meanings embodied in an increasingly complex material world.[52]

There are a number of important debates relevant to the representation of femininity which cluster around the highly charged issue of pornography.[53] These need to be confronted when dealing with the history and critique of fashion, beauty and the circulation of images of women generally. In her powerful critique of pornography, Susanne Kappeler identifies 'the fundamental problem of the root of men's behaviour in the world, including sexual assault, rape, wife battering, sexual harassment, keeping women in the home and in unequal opportunities, treating them

as objects for conquest and protection – the root problem behind the reality of men's relations to women, is the way men see women, is Seeing.'[54]

More unusual have been analyses of gender from the masculine point of view. One example is Roger Cranshaw's critique of the exploitation of men's sexuality through the phenomenon of the centrefold.[55] Although rather rigid in its characterization of *Playboy* and *Penthouse* as instruments of the 'ideological state apparatuses', nevertheless it does provide a perceptive account of the way in which this type of masturbatory masculine culture developed within an increasingly alienated society in the post-war period which at the same time, paradoxically, saw itself as 'liberated'.

The only way in which men can begin to understand some of the problems of women's subjectivity is through their own experience of being masculine. It is not enough to 'deconstruct' advertisements, spot sexism and analyse stereotypes. In most cases, if the analytic exercise is objective, it only serves to remove the observer even more from the direct experience of identification, so that 'seeing' the way it works makes it appear that those who don't must be stupid and gullible.[56] We are all, to some extent, formed by the culture that surrounds us; both men and women build their sexual identities around images and behaviour which are socially prescribed. There is no such thing as a complete and identifiable set of totally feminine or masculine attributes which make up the 'essential' man or woman. The human psyche is made up of both 'male' and 'female' characteristics. As women redefine their femininity, it calls into question how men define their gender identity.[57]

The women's movement has conducted a protracted campaign to outlaw exploitative images of women, i.e. those which treat them as sex objects. In Britain at present attempts are being made to pass a bill which would ban the type of nude photographs which appear in certain popular newspapers as a matter of course. The issue is still regarded with derision by the majority of male MPs, so it is unlikely to become law in the foreseeable future. Even so, the fact that it has reached the Houses of

Parliament indicates some measure of recognition that such representations are a problem.

Elizabeth Wilson's *Adorned in Dreams: Fashion and Modernity* (1985), deals with the issue of gender within the larger context of cultural politics as well as reviewing the debates around feminism and fashion. She regards fashion as a 'language' through which women can express themselves. This enables her to avoid patriarchal explanations which see fashion as an aspect of women's subordination to men, and which do not explain why so many women find pleasure and fulfilment in fashion. Some feminists have found ways of indulging in fashion by adopting an 'anti-style' mode which does not betray their principles. If we take a dynamic view of fashion, that is, one which holds that the meanings of objects can change over time, then by the same token 'woman' need not always signify 'oppressed subject'.

While the fantasies and lifestyles purveyed by marketing and advertising agencies, and associated with products and fashions, certainly influence people's imaginations and behaviour, they do not correspond fully to lived experience. Like desire, they exist in a permanent state of expectation. It is here that the task of recording the history of women and their lives becomes vital in order to counter the effect of the myths propagated by commercial interests. Such accounts are largely missing from design history which has seen itself as a discrete discipline recording the history of the design profession rather than as a part of a larger history. Where a more inclusive definition has been adopted it becomes legitimate to use oral and social history, economic and business history, contemporary cultural studies, anthropology, literature, feminist theory and so on. It can thus go beyond objects to look at such issues as – how does design affect women once it has entered their lives in the form of products, clothes, transportation and homes? What can women do to help design a world more amenable to their needs, one which recognizes the particularity of female culture?

Feminists have maintained that 'the personal is political' and nowhere is it more personal than in the way we construct our

identities through interrelating with the world of things.[58] It is possible that as women become more assertive, their ability to be objective will increase and as a result they will be better able to articulate their needs and desires. Wilson suggests as much. In order to be more objective it is necessary to distance ourselves from the material goods which surround us and to discover how we interact and communicate through them. Advertisers, fashion designers and marketing directors are probably among those best placed to exploit such knowledge. However, if we can begin to understand more about how the system works, we should be in a better position to control design. Ephemeral kinds of design such as fashion are clearly more accessible and open to rapid transformations than the more intractable, monumental kinds such as architecture.

The theory which explains everything simplistically by the so-called imperatives of the market economy does not attend to people's needs adequately, although it does address their desires. The depressing prospect which such a commercially orientated interpretation of design and its history presents us with is that of the imperialistic rule of 'Things' over a passive audience who conform to manipulative stereotyping without either questioning or consciously forming judgements. Unless we can go beyond a static, object-based approach based on an aesthetic analysis, it is not possible to see that there is a dynamic dimension of symbolic representation in artefacts which is more akin to language and which can be used to articulate a material world.

Daniel Miller's theory of consumption suggests that: '... in certain circumstances segments of the population are able to appropriate industrial objects and utilise them in the creation of their own image. In other cases, people are forced to live in and through objects which are created through the images held of them by a different and dominant section of the population.'[59] If cultural transformations are possible through the material world of mass consumption, design could play a positive role in the lives of women.

A feminist analysis in the discipline of design history is of key significance in the process of bringing to light the efforts women have made to shape the world in a more female image in

spite of the limitations imposed by economic imperatives and social conventions. It can also supply evidence of the changing image of women as made manifest in the material world throughout history. The interactive power of design working through objects and representations has been shown to generate change as well as to reproduce patterns of dominance. Such knowledge is vital if we are to believe and go on working for equality in gender relations. Feminist historians working in the history of design may not agree on all points of detail, method or strategy, but there is a general consensus that our efforts are directed towards a future which will not be modelled on the needs of 'Man' but which could, one day, be called 'the people-made environment'.

Notes and References

1. J. Mitchell and A. Oakley, *What is Feminism?* (Oxford: Blackwell, 1987). p. 3.
2. See J. Attfield, 'Defining the object and the subject', *Times Higher Educational Supplement* 1 Feb 1985 p. 36.
3. J. Attfield, 'Invisible touch', *Times Higher Educational Supplement* 19 June 1987 p. 26.
4. 'Form follows function' is a catchphrase associated with the Modern Movement in architecture and attributed to the American architect Louis Sullivan. See 'The tall office building artistically considered', in T. and C. Benton and D. Sharp (eds), *Form and Function* (London: Crosby Lockwood Staples, 1975) p. 13.
5. J. Mitchell, 'Reflections on twenty years of feminism', in Mitchell and Oakley, *What is Feminism?*, p. 48.
6. The critique of modern town planning has become associated with a simplistic, reactionary post-modernism which is only to do with styling for the market, and a loss of faith in designing as a practice concerned with people's needs. Jacobs' critique is not about the so-called 'failure of modernism' but about an interventionist approach to designing in which the designer teams up with users and works with them to achieve an environment more in keeping with their needs. Whereas Robert Venturi's *Complexity and Contradiction in Architecture* (1966) which presented an aesthetic critique of modernism and a celebration of historical styles without considering social implications has been much more influential.
7. Marshall Berman acknowledges this in his book *All that is Solid Melts into Air* (London: Verso, 1985) pp. 312–29.

8. See A. Karf, 'On a road to nowhere', *Guardian* 8 March 1988.
9. See C. Cockburn, *Brothers: Male Dominance and Technological Change* (London: Pluto, 1983) and *Machinery of Dominance* (London: Pluto, 1985); T. Gronberg and J. Attfield (eds), *A Resource Book on Women Working in Design* (London: London Institute/ Central School of Art, 1986).
10. See, for example, S. Torre, 'Space as Matrix', *Heresies* (11) 1981 pp. 51-2; D. Hayden, *The Grand Domestic Revolution* (London: MIT Press, 1982).
11. See, for example, S. Worden, 'A voice for whose choice?', in Design History Society, *Design History: Fad or Function?* (London: Design Council, 1978).
12. C. Benton, 'Charlotte Perriand: Un Art de Vivre', *Design History Society Newsletter* (25) May 1985 pp. 12-15.
13. Both have been associated with Le Corbusier and have suffered from having their designs attributed to him, or having work ignored if – as in the case of Perriand – it was not done in association with him.
14. See Peter Adam's biography, *Eileen Gray* (London: Thames & Hudson, 1987).
15. L. Nochlin's essay first appeared in V. Gornick and B. Moran (eds), *Women in Sexist Society. Studies in Power and Powerlessness* (New York: Basic Books, 1971) pp. 480-510. For an overview of feminism and art history see T. Gouma-Peterson and P. Mathews, 'The feminist critique of art history', *Art Bulletin* LXIX (3) Sept 1987 pp. 326-57.
16. Some design departments have responded to the needs of women by adopting a policy of positive discrimination in recruitment and in access courses, but this is still uncommon. For example, the 'Women into architecture and building' course (1985-) in the Department of Environmental Design, North London Polytechnic.
17. Represented by such texts as Hazel Conway (ed), *Design History: a Students' Handbook* (London: Allen & Unwin, 1987).
18. For example see A. Forty, 'Lucky Strikes and other myths', *Designer* November 1985 pp. 16-17.
19. P. Sparke, *An Introduction to Design and Culture in the Twentieth Century* (London: Allen & Unwin, 1986) p. xiii.
20. C. Buckley, 'Made in patriarchy: towards a feminist analysis of women and design', *Design Issues* 3 (2) 1987 pp. 3-15.
21. I refer here to what Hal Foster calls 'a post-modernism of resistance' which is concerned with 'a critical deconstruction of tradition, not an instrumental pastiche of pop- or pseudo-historical forms, with a critique of origins, not a return to them. In short, it seeks to question rather than exploit cultural codes, to explore rather than conceal social and political affiliations'; from his introduction to *Postmodern Culture* (London: Pluto, 1985).

22. L. Tickner, 'Women and trousers: unisex clothing and sex role changes in the twentieth century', Design History Society, *Leisure in the Twentieth Century* (London: Design Counc'l, 1977) pp. 56-67. Annual Conference papers of 1976.

23. L. Tickner, '... and they sewed fig leaves together', *Spare Rib* (45) April 1976; 'Fashionable bondage', *Spare Rib* (47) June 1976; 'The attraction of opposites', *Spare Rib* (49) August 1976; 'Why not slip into something a little more comfortable', *Spare Rib* (51) October 1976.

24. L. Tickner, *Spare Rib* (45) April pp. 14–16.

25. L. Wright, 'Objectifying gender: the manufacture of the stiletto heel', in J. Attfield and T. Gronberg (eds), *A View from the Interior: Feminism, Women and Design* (London: Women's Press, forthcoming 1989).

26. J. Myerson, 'Live connections', *Designweek* October 1986.

27. See T. Gouma-Peterson's and P. Mathews' review of the art versus craft debate in their paper 'The feminist critique of art history', pp. 332–4.

28. P. Barnett, 'An appropriate activity for women', in T. Gronberg and J. Attfield (eds), *A Resource Book.*

29. P. Bourdieu, *Distinction: a Social Critique of the Judgement of Taste* (London: Routledge & Kegan Paul, 1984) p. 12.

30. E. H. Carr, *What is History?* (London: Macmillan, 1961) p. 30.

31. J. Boys, 'Is there a feminist analysis of architecture?', *Built Environment* 10 (1) 1984 pp. 25–34.

32. In Attfield and Kirkham (eds), *A View from the Interior.*

33. See L. Davidoff and others, 'Landscape with figures. home and community in English society' in A. Oakley and J. Mitchell (eds), *The Rights and Wrongs of Women* (Harmondsworth: Penguin, 1976) pp. 139–98.

34. A. Karf, 'On a road to nowhere', *Guardian* 8 March 1988.

35. See S. Giedion, *Mechanization Takes Command*, part 6: 'Mechanization encounters the household: the feminist movement and the rational household'.

36. There is much literature on this topic. See, for example, C. Bose, 'Technology and changes in the American home', in E. Whitelegg and others (eds), *The Changing Experience of Women* (Milton Keynes: Open University Press, 1982); L. Davidoff, 'The rationalisation of housework', *Dependence and Exploitation in Work and Marriage* (London: Longman, 1976); A. Oakley, *The Sociology of Housework* (London: Martin Robertson, 1974); P. Bereano and others, 'Kitchen technology and the liberation of women from housework', in W. Faulkner and others (eds), *Smothered by Invention: Technology in Women's Lives* (London: Pluto, 1985); M. Roberts, 'The fireside and

the kitchen: domesticity and rationality in twentieth century British family housing', in R. Langdon and N. Cross (eds), *Design and Society* (London: Design Council, 1984).

37. P. Goodall, 'Design and gender', *Block* (9) 1983 pp. 50–61.
38. See, for instance, E. Malos (ed), *The Politics of Housework* (London: Allison & Busby, 1980); R. Schwartz-Cowan, 'The industrial revolution in the home: household technology and social change in the twentieth century', *Technology and Culture* (17) 1976.
39. H. Ellis, *Democracy in the Kitchen* (Pamphlet of a lecture, c. 1890).
40. L. Pearson, *The Architectural and Social History of Cooperative Living* (London: Macmillan, 1988).
41. A. Callen, *The Angel in the Studio* (London: Astragal, 1979).
42. For two interpretations of the Arts and Crafts Movement see A. Callen, 'Sexual division of labour in the Arts and Crafts movement', and L. Walker, 'The Arts and Crafts alternative' in J. Attfield and T. Gronberg (eds), *A View from the Interior*.
43. This area has been discussed extensively in feminist art history and criticism. See, for example, R. Parker, *The Subversive Stitch* (London: Women's Press, 1984); P. Barnett, 'Art or Craft ... who decides?', *Craft Matters: Three Attitudes to Contemporary Craft* (Southampton: John Hansard Gallery/University of Southampton, 1985); P. Mainardi, 'Quilts: the great American art', in N. Broude and M. Garrard (eds), *Feminism and Art History* (New York: Harper & Row, 1982); R. Parker and G. Pollock, 'Crafty women and the hierarchy of the arts', *Old Mistresses: Women, Art and Ideology* (London: Routledge & Kegan Paul, 1981).
44. R. Banham, *Theory and Design in the First Machine Age* (London: Architectural Press, 1960).
45. See, for example, J. Woodham, 'Women, design and the home', *The Industrial Designer and the Public* (London: Pembridge Press, 1983); J. Heskett, 'Mass-production and individual choice', *Industrial Design* (London: Thames & Hudson, 1980). A. Forty, 'The electric home', *British Design* units 19 & 20 of *History of Architecture and Design 1890–1939* (Milton Keynes: Open University Press, 1975); A. Forty, 'Housewives' aesthetic', *Architectural Review* 969 November 1977 pp. 284–6; A. Forty, 'Labour saving in the home', *Objects of Desire* (London: Thames & Hudson, 1986).
46. R. Saisselin, *Bricabracomania: the Bourgeois and the Bibelot* (London: Thames & Hudson, 1985) p. 39.
47. See, for example, R. Coward, *Female Desire* (London: Paladin, 1984); J. Winship, 'Woman becomes an "individual": femininity and consumption in women's magazines' (Birmingham: Centre for Contemporary Cultural Studies, 1981) stencilled occasional paper SP no 65; K. Myers, 'Tu: a cosmetics case study', *Block* (7) 1982 pp. 48–58;

M. Ferguson, *Forever Feminine: Women's Magazines and the Cult of Femininity* (London: Heinemann, 1983).

48. P. Kirkham, 'Women and the inter-war handicrafts revival', in Attfield and Kirkham (eds), *A View from the Interior*.

49. ◄ S. Worden, 'Powerful women: women and electricity 1919-40', in Attfield and Kirkham (eds), *A View from the Interior*.

50. A. Partington, 'Design knowledge and feminism', *FAN (Feminist Arts News)* 2 (3) 1985 pp. 9-13.

51. J. Mitchell, *What is Feminism?*, p. 48.

52. See, for example, R. Coward, *Female Desire*; J. Williamson, *Decoding Advertisements* (London: Marion Boyars, 1978); *Consuming Passions* (London: Marion Boyars, 1986); E. Cowie, 'Woman as sign', *M/F* (1) 1978; S. Levrant de Brettville, 'Feminist design', in R. Langdon and N. Cross (eds), *Design and Society* (Design Council, 1984).

53. J. Root, *Pictures of Women: Sexuality* (London: Pandora/Channel 4, 1984); Everywoman Magazine (ed), *Pornography and Sexual Violence: Evidence of the Links* (London: Everywoman, 1988).

54. S. Kappeler, *The Pornography of Representation* (Oxford: Polity Press, 1986).

55. R. Cranshaw, 'The object of the centrefold', *Block* (9) 1983 pp. 26-33.

56. See J. Williamson, 'How does girl number twenty understand ideology?', *Screen Education* (40) Autumn-Winter 1981-2 pp. 80-7.

57. See also H. Franks, *Goodbye Tarzan: Men after Feminism* (London: Allen & Unwin, 1985).

58. See B. Sichtermann, *Femininity: the Politics of the Personal* (Oxford: Polity Press, 1986).

59. D. Miller, *Material Culture and Mass Consumption* (Oxford: Blackwell, 1987) p. 175.

Bibliography

Adam, P. *Eileen Gray: Architect/Designer, a Biography* (London: Thames & Hudson, 1987).

Althusser, L. and Babibar, E. *Reading Capital* (London: New Left Books, 1970).

Anderson, B. *Imagined Communities* (London: Verso, 1983).

Andrews, E. and F. *Religion in Wood* (Bloomington: Indiana University Press, 1966).

Anscombe, I. *A Woman's Touch: Women in Design from 1860 to the Present Day* (London: Virago, 1984).

Antal, F. *Florentine Painting and its Social Background* (London: Routledge & Kegan Paul, 1948)

Arts Council and Victoria and Albert Museum. *Thirties: British Art and Design before the War* (London: Arts Council/Hayward Gallery, 1979).

Association of Irish Art Historians. *The Teaching of Art and Design History to Students of Art and Design* (Dublin: Association of Irish Art Historians, 1986).

Attfield, J. and Kirkham, P. (eds). *A View from the Interior: Feminism, Women and Design* (London: Women's Press, forthcoming 1989).

Banham, R. *Theory and Design in the First Machine Age* (London: Architectural Press, 1960).

—. *Design by Choice* (London: Academy Editions, 1981).

Barman, C. *The Man who Built London Transport* (Newton Abbot: David & Charles, 1979).

Barthes, R. *Elements of Semiology* (London: J. Cape, 1967), French edition 1964.

—. *The Fashion System* (London: J. Cape, 1985), French edition 1967.

—. *Mythologies* (London: J. Cape, 1972), French edition 1957.

—. *The Pleasure of the Text* (London: J. Cape, 1976), French edition 1973.

Baudrillard, J. *For a Critique of the Political Economy of the Sign* (St Louis: Telos Press, 1981), French edition 1972.

Bayley, S. *Art and Industry: a Century of Design in the Products We Use* (London: Victoria & Albert Museum/Boilerhouse Project, 1982).

—. *Harley Earl and the American Dream Machine* (London: Weidenfeld & Nicolson, 1984).

—. *In Good Shape: Style in Industrial Products 1900 to 1960* (London: Design Council, 1979).

—. *Sex, Drink and Fast Cars: the Creation and Consumption of Images* (London: Faber & Faber, 1986).

—. (ed). *Taste: an Exhibition about Values in Design* (London: Victoria

& Albert Museum/Boilerhouse Project, 1983).

Benjamin, W. *Charles Baudelaire: a Lyric Poet in the Era of High Capitalism* (London: New Left Books, 1973).

——. *Illuminations* (London: J. Cape, 1970).

——. *Reflections* (New York: Harcourt, Brace, Jovanovich, 1978).

Benton, T. and C. and Sharp, D. (eds). *Form and Function: a Sourcebook for the History of Architecture and Design 1890-1939* (London: Crosby Lockwood Staples, 1975).

Berman, M. *All that is Solid Melts into Air: the Experience of Modernity* (London: Verso, 1985).

Bicknell, J. and McQuiston, L. *Design for Need: the Social Contribution of Design* (Oxford: Pergamon Press, 1977), Proceedings of the ICSID Symposium at the Royal Colleg of Art in April 1976.

Blackwood, B. *The Classification of Artefacts in the Pitt Rivers Museum* Oxford (Oxford: Pitt Rivers Museum, 1970).

Boilerhouse Project. *The Car Programme: 52 months to Job One or how they Designed the Ford Sierra* (London: Victoria & Albert Museum, 1983).

——. *National Characteristics in Design* (London: Victoria and Albert 1985).

Bonta, J. *Architecture and its Interpretation* (London: Lund Humphries, 1979).

Boudon, P. *Lived-in Architecture: Le Corbusier's Pessac Revisited* (London: Lund Humphries, 1972)

Bourdieu, P. *Distinction: a Social Critique of the Judgement of Taste* (London: Routledge & Kegan Paul, 1984), French edition 1979.

Braudel, F. *Civilization and Capitalism 15-18th Centuries* 2 vols (London: Collins, 1981-2).

——. *The Mediterranean in the Age of Phillip II* 2 vols (London: Collins, 1972-3).

Broadbent, G and others (eds). *Signs, Symbols and Architecture* (Chichester: John Wiley, 1980).

Broude, N. and Garrard, M. (eds). *Feminism and Art History: Questioning the Litany* (New York: Harper & Row, 1982).

Built Environment and Bowlby, S (eds). *Women and the Environment* (Oxford: Alexandrine Press/The Regional Studies Association, 1984).

Burke, P. *Sociology and History* (London: Allen & Unwin, 1980).

——. *Tradition and Innovation in Renaissance Italy* (London: Fontana/ Collins, 1974).

Burnett, J. *A Social History of Housing, 1815-1985* (London: Methuen, 2nd edn 1986).

Callen, A. *The Angel in the Studio: Women in the Arts and Crafts Movement* (London: Astragal, 1979).

Carr, E. *What is History?* (London: Macmillan, 1961).

Chambers, F. *The History of Taste* (New York: Columbia University Press, 1932).

Clark, K. *The Gothic Revival: an Essay in the History of Taste* (London: John Murray, 1974), first issued in 1929.

Clark, T. *Image of the People: Gustave Courbet and the 1848 Revolution* (London: Thames & Hudson, 1973).

Clarke, D. *Analytical Archaeology* (London: Methuen, 2nd edn 1978).

Clifton-Taylor, A. *The Pattern of English Building* (London: Faber & Faber, new edn 1972).

Cochrane, A. and others (eds). *City, Economy and Society: a Comparative Reader* (London/Milton Keynes: Harper & Row/Open University Press, 1981).

Cockburn, C. *Brothers: Male Dominance and Technological Change* (London: Pluto, 1983).

—.*Machinery of Dominance: Women, Men and Technical Know-How* (London: Pluto, 1985).

Coleridge, N. *The Fashion Conspiracy* (London: Heinemann, 1988).

Connerton, P. (ed). *Critical Sociology* (Harmondsworth: Penguin, 1976).

Conway, H. (ed). *Design History: a Students' Handbook* (London: Allen & Unwin, 1987).

Coward, R. *Female Desire: Women's Sexuality Today* (London: Paladin/Granada, 1984).

Craft Matters: Three Attitudes to Contemporary Craft (Southampton: John Hansard Gallery/University of Southampton, 1985).

Culler, J. *Structuralist Poetics* (London: Routledge & Kegan Paul, 1975).

Davidoff, L. *Dependence and Exploitation in Work and Marriage* (London: Longman, 1976).

Design History Society. *Leisure in the Twentieth Century* (London: Design Council, 1976).

—. *Design History: Fad or Function?* (London: Design Council, 1978).

Doblin, J. *One Hundred Great Product Designs* (New York: Van Nostrand Reinhold, 1970).

Douglas, M. (ed). *Rules and Meanings: the Anthropology of Everyday Knowledge* (Harmondsworth: Penguin, 1973).

—. and Isherwood, B. *The World of Goods: Towards an Anthropology of Consumption* (London: Allen Lane, 1979).

Dyer, R. *Stars* (London: British Film Institute, 1979).

Eagleton, T. *Literary Theory* (Oxford: Blackwell, 1983).

Eco, U. *A Theory of Semiotics* (Bloomington: Indiana University Press, 1976).

Engels, F. *The Condition of the Working Class in England* (St Albans: Panther, 1969), first German edition 1845.

Farr, M. *Design in British Industry: a Mid-Century Survey* (Cambridge: Cambridge University Press, 1955).

Faulkner, W. and Arnold, E. (eds). *Smothered by Invention: Technology in Women's Lives* (London: Pluto, 1985).

Ferguson, M. *Forever Feminine: Women's Magazines and the Cult of Femininity* (London: Heinemann, 1983)..

Fletcher, B. *Sir Banister Fletcher's 'A History of Architecture'* (London: Butterworths, 19th edn 1987).

Forty, A. *Objects of Desire: Design and Society 1750-1980* (London: Thames & Hudson, 1986).

Foster, H. (ed). *Postmodern Culture* (London: Pluto, 1985).

Foucault, M. *Discipline and Punish* (London: Allen Lane, 1977), French edition 1975.

Franklin, J. *The Gentleman's Country House and its Plan 1835-1914* (London: Routledge & Kegan Paul, 1981).

Franks, H. *Goodbye Tarzan: Men after Feminism* (London: Allen & Unwin, 1985).

Freud, S. *Jokes and Their Relation to the Unconscious* (London: Hogarth Press, 1960), first German edition 1905.

Galbraith, J. *The New Industrial State* (Harmondsworth: Penguin, 1968).

Gellner, E. *Nations and Nationalism* (Oxford: Blackwell, 1983).

Giedion, S. *Mechanization Takes Command: a Contribution to Anonymous History* (New York: Oxford University Press, 1948).

Girouard, M. *The Victorian Country House* (Oxford: Clarendon Press, 1971).

Gloag, J. *Victorian Comfort: a Social History of Design from 1830-1900* (London: A. & C. Black, 1961).

Gombrich, E. *The Sense of Order: a Study in the Psychology of Decorative Art* (Oxford: Phaidon, 1979).

Gorb, P. (ed). *Living by Design: Pentagram* (London: Lund Humphries, 1978).

Gornick, V. and Moran, B. (eds). *Women in Sexist Society. Studies in Power and Powerlessness* (New York: Basic Books, 1971).

Green, J. *A Short History of the English People* (London: Macmillan, rev. edn 1888).

Gronberg, T. and Attfield, J. (eds). *A Resource Book on Women Working in Design* (London: London Institute/Central School of Art & Design, 1986).

Hadjinicolaou, N. *Art History and Class Struggle* (London: Pluto Press, 1978).

Hall, P. *Great Planning Disasters* (London: Weidenfeld & Nicolson, 1980).

Hamilton, R. *Collected Words* (London: Thames & Hudson, 1982).

Harris, M. *The Rise of Anthropological Theory* (London: Routledge & Kegan Paul, 1968).

Haskell, F. *Rediscoveries in Art: Some Aspects of Taste* (Oxford: Phaidon, 1976).

Haug, W. *Commodity Aesthetics, Ideology and Culture* (New York: International General, 1987).

—. *Critique of Commdity Aesthetics* (Cambridge: Polity Press, 1986).

Hawkes, T. *Structuralism and Semiotics* (London: Methuen, 1977).

Hayden, D. *The Grand Domestic Revolution: a History of Feminist Designs for American Homes, Neighborhoods and Cities* (London: MIT Press, 1982).

Hebdige, D. *Subculture: the Meaning of Style* (London: Methuen, 1979).

Hennessy, V. *In the Gutter* (London: Quartet, 1978).

Henrion, F. and Parkin, A. *Design Co-ordination and Corporate Image* (London: Studio Vista, 1967).

Hermann, W. *Gottfried Semper: in Search of Architecture* (London: MIT Press, 1985).

Heskett, J. *Industrial Design* (London: Thames & Hudson, 1980).

Hillier, B. *The Style of the Century 1900-1980* (London: Herbert Press, 1983).

Holsti, O. *Content Analysis for the Social Sciences and Humanities* (Reading, Mass: Addison-Wesley, 1969).

Holub, R. *Reception Theory: a Critical Introduction* (London: Methuen, 1984).

Horne, D. *The Great Museum: the Representation of History* (London: Pluto Press, 1984).

Institute of Contemporary Arts. *The British Edge* (Boston, Mass: ICA, 1987).

Instituto per la Collaboration Cultural. *Encyclopedia of World Art* 15 vols (New York: McGraw-Hill, 1958-68).

Jacobs, J. *The Death and Life of Great American Cities: the Failure of Town Planning* (Harmondsworth: Penguin, 1961).

Jay, M. *The Dialectical Imagination: a History of the Frankfurt School* (London: Heinemann, 1973).

Jencks, C. *Modern Movements in Architecture* (Harmondsworth: Penguin, 1973).

—. and Baird, G. (eds). *Meaning in Architecture* (London: Barrie & Rockcliff, 1969).

Jervis, S. *The Penguin Dictionary of Design and Designers* (Harmondsworth: Penguin, 1984).

Jhally, S. *The Codes of Advertising* (London: F. Pinter, 1987).

Jones, O. *The Grammar of Ornament* (London: Studio Editions, 1986), first published 1856.

Kappeler, S. *The Pornography of Representation* (Oxford: Polity Press, 1986).

Katz, S. *Classic Plastics: from Bakelite to High-Tech* (London: Thames & Hudson, 1984).

—. *Plastics: Designs and Materials* (London: Studio Vista, 1978).

King, A. (ed). *Buildings and Society: Essays on the Social Development of the Built Environment* (London: Routledge & Kegan Paul, 1980).

Kirkham, P. *Furnishing the World: the East London Furniture Trade 1830-1980* (London: Journeyman Press, 1987).

Kleinbauer, W. (ed). *Modern Perspectives in Western Art History* (New York: Holt, Rinehart, Winston, 1971).

Kleinmann, P. *The Saatchi Story* (London: Weidenfeld & Nicolson, 1987).

Krippendorf, K. *Content Analysis: an Introduction to its Methodology* (San Mateo, California: Sage Publications, 1980).

Kroeber, A. (ed). *Anthropology Today* (Chicago: University of Chicago Press, 1953).

—. and Richardson, J. *Three Centuries of Women's Dress Fashions* (Berkeley & Los Angeles: University of California Press, 1940).

Kubler, G. *The Shape of Time: Remarks on the History of Things* (New Haven: Yale University Press, 1962).

Kuper, A and J. (eds). *The Social Science Encyclopedia* (London: Routledge, 1985).

Lang, B., (ed). *The Concept of Style* (Philadelphia: University of Pennsylvania Press, rev. edn 1987).

Langdon, R. and Purcell, P. (eds). *Design Theory and Practice* (London: Design Council, 1984).

—. and Cross, N. (eds). *Design and Society* (London: Design Council, 1984).

Laver, J. *Taste and Fashion from the French Revolution to the Present Day* (London: Harrap, rev. edn 1945).

Le Corbusier. *Towards a New Architecture* (London: Architectural Press, 1970), first published in 1923.

Lévi-Strauss, C. *Structural Anthropology* (New York: Basic Books, 1963).

Leymore, V. *Hidden Myth: Structure and Symbolism in Advertising* (London: Heinemann, 1975).

Lowenthal, D. *The Past is a Foreign Country* (Cambridge: CUP, 1985).

Lucie-Smith, E. *A History of Industrial Design* (Oxford: Phaidon, 1983).

—. *The Story of Craft: the Craftsman's Role in Society* (Oxford: Phaidon, 1981).

MacCarthy, F. *All Things Bright and Beautiful: Design in Britain 1830 to Today* (London: Allen & Unwin, 1972).

Malos, E. (ed). *The Politics of Housework* (London: Allison & Busby, 1980).

Marwick, A. *The Nature of History* (London: Macmillan, 1970).

Marx, K. *A Contribution to the Critique of Political Economy* 2nd rev. edn (London: Kegan Paul, 1904), appendix: Introduction to the critique of political economy (1857-9).

—. *Grundrisse: Foundations of the Critique of Political Economy* (Harmondsworth: Penguin, 1973).

Matrix. *Making Space: Women and the Man-made Environment* (London: Pluto Press, 1984).

Mauss, M. *The Gift* (New York: Norton, 1967), first published in French in 1924.

Medvedev, P. and Bakhtin, M. *The Formal Method in Literary Scholarship* (Baltimore: Johns Hopkins University Press, 1978).

Mercer, F. *The Industrial Design Consultant* (London: The Studio, 1978).

Middleton, M. *Group Practice in Design* (London: Architectural Press, 1967).

Miller, D. *Material Culture and Mass Consumption* (Oxford: Blackwell, 1987).

Miller, M. *The Bon Marché: Bourgeois Culture and the Department Store 1869-1920* (London: Allen & Unwin, 1981).

Mitchell, A. *The Nine American Lifestyles* (New York: Macmillan, 1983).

Mitchell, J. and Oakley, A. *What is Feminism?* (Oxford: Blackwell, 1987).

Momigliano, A. *Essays in Ancient and Modern Historiography* (Oxford: Blackwell, 1977).

Morita, A. and others. *Made in Japan* (London: Collins, 1986).

Morris, D. *Manwatching: a Field Guide to Human Behaviour* (London: J. Cape, 1977).

Nadar, R. *Unsafe at Any Speed* (New York: Grossman, 1965).

Naylor, G. *The Bauhaus Re-assessed: Sources and Design Theory* (London: Herbert Press, 1985).

Oakley, A. *The Sociology of Housework* (London: Martin Robertson, 1974).

——. and Mitchell, J. (eds). *The Rights and Wrongs of Women* (Harmondsworth: Penguin, 1976).

Olins, W. and Wally, M. *The Corporate Personality: an Inquiry into the Nature of Corporate Identity* (London Design Council, 1978).

Open University. *History of Architecture and Design 1890-1939* 24 units (Milton Keynes: Open University Press, 1975).

——. *Mass Communication and Society* 15 units (Milton Keynes: Open University Press, 1977).

O'Sullivan, T. and others; *Key Concepts in Communication* (London: Methuen, 1983).

Papanek, V. *Design for the Real World: Human Ecology and Social Change* (London: Thames & Hudson rev, edn 1985).

Parker, R. *The Subversive Stitch: Embroidery and the Making of the Feminine* (London: Women's Press, 1984).

——. and Pollock, G. *Old Mistresses: Women, Art and Ideology* (London: Routledge & Kegan Paul, 1981).

Pearson, L. *The Architectural and Social History of Cooperative Living* (London: Macmillan, 1988).

Pentagram. *Pentagram: the Work of Five Designers* (London: Lund Humphries, 1972).

Pevsner, N. *Buildings of England* 46 vols (Harmondsworth: Penguin, 1949-1949-74).

——. *The Englishness of English Art* (London: BBC, 1955).

——. *A History of Building Types* (London: Thames & Hudson, 1976).

——. *Pioneers of the Modern Movement* (London: Faber, 1936), revised edition published as *Pioneers of Modern Design* (Harmondsworth: Penguin, 1960).

——. *Some Architectural Writers of the Nineteenth Century* (Oxford: Clarendon Press, 1972).

——. *Studies in Art, Architecture and Design* 2 vols (London: Thames & Hudson, 1968).

Phillips, B. *The Habitat Story* (London: Weidenfeld & Nicolson, 1984).

Physick, J. *The Victoria and Albert Museum: the History of its Building* (Oxford: Phaidon/Christies, 1982).

Polhemus, T. and Proctor, L. *Fashion and Anti-Fashion: an Anthropology of Clothing and Adornment* (London: Thames & Hudson, 1978).

Popper, K. *Conjectures and Refutations* (London: Routledge & Kegan Paul, 4th edn 1972).

——. *The Poverty of Historicism* (London: Routledge & Kegan Paul, 2nd edn 1960).

Porphyrios, D. *On the Methodology of Architectural History* (London: Academy Editions, 1981), Architectural Design Profile.

Pugin, A. *Contrasts: or a Parallel Between the Noble Edifices of the 14th & 15h Centuries and Similar Buildings of the Present Day* (London: The Author, 1836; Dolman, 2nd edn 1841).

Rand, A. *The Fountainhead* (New York: Bobbs-Merrill, 1943).

Rees, G. *St Michael: a History of Marks and Spencer* (London: Weidenfeld & Nicolson, 1969).

Riegl, A. *Stilfragen: Grundegungen zu einer Geschichte der Ornamentik* (Berlin: R. Schmidt, 2nd edn 1923), first published in 1893.

Robson, G. *Metro: the Book of the Car* (Cambridge: P. Stephens, 1982).

Root, J. *Pictures of Women: Sexuality* (London: Pandora Press/Channel 4, 1984).

Rudofsky, B. *Architecture without Architects* (New York: Museum of Modern Art, 1965).

——. *The Prodigious Builders* (London: Secker & Warburg, 1977).

Runes, D. (ed). *Dictionary of Philosophy* (New York: Philosophical Library, 1960).

Rybczynski, W. *Home: a Short History of an Idea* (London: Heinemann, 1988).

Saint, A. *The Image of the Architect* (New Haven: Yale University Press, 1983).

Saisselin, R. *Bricabracomania: the Bourgeois and the Bibelot* (London: Thames & Hudson, 1985).

Saussure, F. de. *Course in General Linguistics* (London: Fontana/Collins, rev. edn 1974).

Scalvini, M. *L'Architettura Comme Semiotica Connotativa* (Milan: Bompaini, 1975).

Schaff, A. *History and Truth* (Oxford: Pergamon Press, 1976).

Schilpp, P. (ed). *The Philosophy of Karl Popper* (La Salle, Illinois: Open Court, 1974).

Science Museum; *German Design: Images of Quality* (London: Science Museum, 1987), poster/catalogue.

Semper, G. *Der Stil in den Technischen und Tektonischen Künsten* 2 vols (Munich: 1860-63), 2nd edn 1879; reprint: Mitterwald, Mäander Kunst Verlag, 1977.

Sichtermann, B. *Femininity: the Politics of the Personal* (Cambridge: Polity Press, 1986).

Sills, D. (ed). *International Encyclopedia of the Social Sciences* 18 vols (New York: Macmillan & Free Press, 1968-79).

Sloan, A. *My Years with General Motors* (London: Sidgwick & Jackson, 1965).

Sontag, S. *Against Interpretation* (London: Eyre and Spottiswoode, 1967).

Sparke, P. *Consultant Design: the History and Practice of the Designer in Industry* (London: Pembridge Press, 1983).

——. *An Introduction to Design and Culture in the Twentieth Century* (London: Allen & Unwin, 1986).

——. *Electrical Appliances* (London: Unwin Hyman, 1987).

——. and others. *Design Source Book* (London: Macdonalds, 1986).

Steadman, P. *The Evolution of Designs: Biological Analogy in Architecture and the Applied Arts* (Cambridge: CUP, 1979).

Stewart, R. *Design and British Industry* (London: J. Murray, 1987).

Sturt, G. *The Wheelwright's Shop* (Cambridge: CUP. 1923).

Sudjic, D. *Cult Objects* (St Albans: Paladin, 1985).

Swenarton, M. *Homes Fit for Heroes: the Politics and Architecture of Early State Housing in Britain* (London: Heinemann, 1981).

Teymur, N. *Environmental Discourse* (London: Question Books, 1982).

Thackara, J. (ed). *New British Design* (London: Thames & Hudson, 1986).

Thompson, M. *Rubbish Theory: the Creation and Destruction of Value* (Oxford: OUP, 1979).

Toffler, A. *Future Shock* (New York: Random House, 1970).

Trevelyan, G. *English Social History* (London: Longman, 1978).

Venturi, R. *Complexity and Contradiction in Architecture* (New York: MOMA, 1966).

Watkin, D. *The Rise of Architectural History* (London: Architectural Press, 1980).

White, H. *Metahistory* (Baltimore: Johns Hopkins University Press, 1973).

Whitelegg, E. and others (eds). *The Changing Experience of Women* (Milton Keynes: Open University Press, 1982).

Whiteley, N. *Pop Design: Modernism to Mod* (London: Design Council, 1987).

Whiter, L. *Spode: a History of the Family Factory and Wares* (London: Barrie & Jenkins, 1970).

Williams, R. *Keywords: a Vocabulary of Culture and Society* (London: Fontana/Croom Helm, 1976, rev. edn 1983).

—. *Marxism and Literature* (Oxford: OUP, 1977).

Williamson, J. *Decoding Advertisements* (London: Marion Boyars, 1978).

—. *Consuming Passions: the Dynamics of Popular Culture* (London: Marion Boyars, 1986).

Wilson, E. *Adorned in Dreams: Fashion and Modernity* (London: Virago, 1985).

Wittgenstein, L. *Philosophical Investigations* (Oxford: Blackwell, 1953).

Wittkower, R. *Gothic versus Classic: Architectural Projects in 17th Century Italy* (London: Thames & Hudson, 1974).

Wolff, J. *The Social Production of Art* (London: Macmillan, 1981).

Woodham, J. *The Industrial Designer and the Public* (London: Pembridge Press, 1983).

York, P. *Modern Times: Everybody wants Everything* (London: Heinemann, 1984).

—. *Style Wars* (London: Sidgwick & Jackson, 1980).

Index